Drawing and Painting on Location

A guide to *en plein-air*

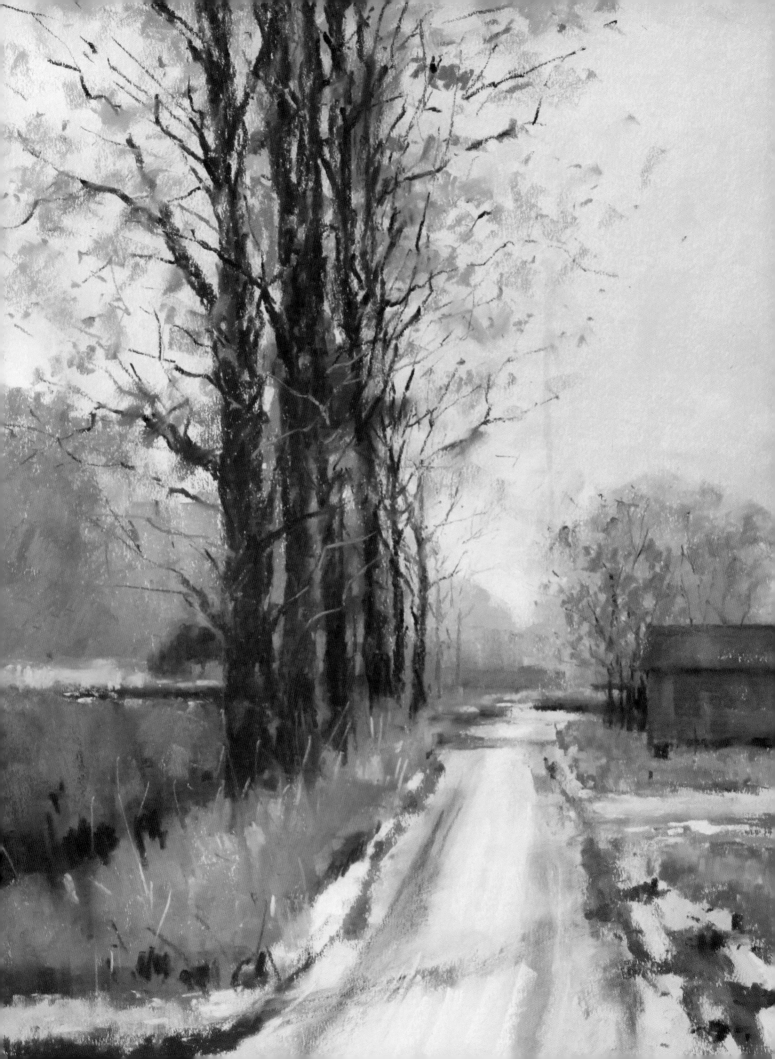

Drawing and Painting on Location

A guide to *en plein-air*

Kevin Scully

THE CROWOOD PRESS

First published in 2017 by
The Crowood Press Ltd
Ramsbury, Marlborough
Wiltshire SN8 2HR

www.crowood.com

British Library Cataloguing-in-Publication Data
A catalogue record for this book is available from the British Library.

ISBN 978 1 78500 240 3

Graphic design and layout by Peggy & Co. Design Inc.
Print and bound in Malaysia by Times Offset (M) Sdn Bhd

Frontispiece:

The Road to Bothampstead, Kevin Scully (pastel on paper). The season suggested in this painting is unmistakable, and has been created by the use of warm colours in the sky, the road and the buildings, which contrast with the cool colours of the trees and foliage. The emphasis on colour has therefore been reversed, but the effect created still conveys the mood and atmosphere of a sunny, autumnal day.

Contents

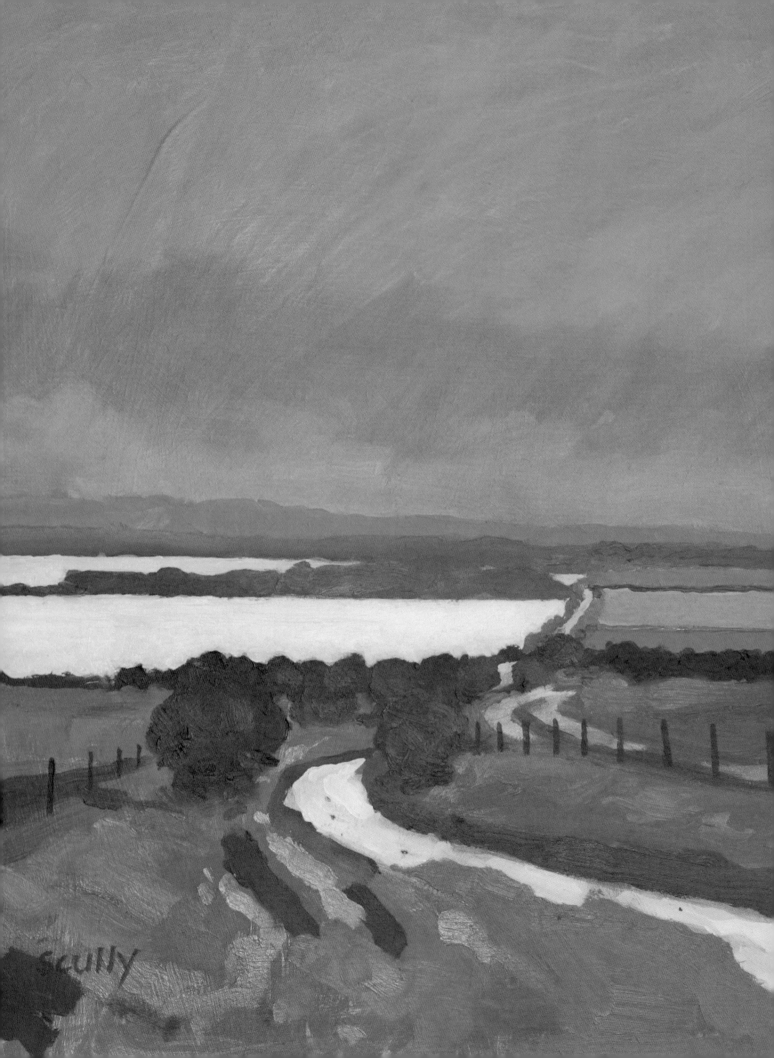

Introduction

Everything that is painted directly and on the spot has always a strength, a power, a vivacity of touch which one cannot recover in the studio... three strokes of a brush in front of nature are worth more than two days of work at the easel.

EUGENE BOUDIN

A Brief History

For both the amateur and professional artist, drawing and painting are totally enjoyable and absorbing pastimes. You can become completely immersed in your subject matter, spurred on by that initial sensation that inspired you to want to capture a particular scene at a certain moment. To the exclusion of all else, your entire focus is on re-creating a three-dimensional image on paper or canvas in two dimensions. This in itself is a challenge, and sometimes the results can be frustrating and even disappointing, even though the process has been pleasurable. However, when you have created something that you're pleased with, the sense of fulfillment that you experience more than makes up for all the unsatisfactory results. There is nothing more important than practice, and the more you draw and paint, the more confident you become in making the right decisions about subject matter, composition, and the manner in which you go about your work.

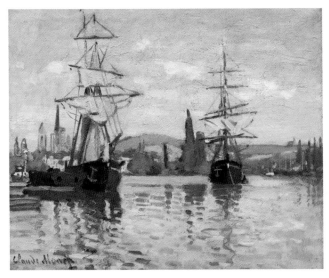

Ships Riding on the Seine at Rouen, Claude Monet (oil on canvas). Monet created many paintings near the Seine, and this picture is an example of an earlier work that displays his interest in the effects that light has on colour, and how he attempted to evaluate how he perceived this, by painting from direct observation. (Courtesy National Gallery of Art, Washington)

That Yellow Time of Year, Kevin Scully (oil on board). Detail of a painting highlighting the amazing colour produced by fields of rape in flower, on The Ridgeway in early spring. The composition leads the viewer's eye along the meandering track and into the landscape beyond.

For obvious practical reasons, most people are in their comfort zone when working from home or in their studio. This can often mean working from photographs, sketches, memory, imagination, or a combination of all four. This is fine, but sometimes work produced in this way can lack integrity, particularly if it's obvious that it has been created almost directly from a photograph. When you are drawing or painting something from life, you automatically study things in greater detail, and you notice things that you wouldn't see or give a second thought to if you were taking a multitude of shots with a digital camera. A photograph is useful if you want to refer to a particular detail at a later stage, but unless you are a professional photographer, your photographic image will not capture the true colours or depth of perspective that you see in front of you.

Not that you necessarily have to copy precisely what you see when painting from life – after all, it's your picture and you can interpret it as you wish. Your own personal reaction to a scene will always lead you to emphasize certain areas, whilst other parts may receive less attention. What you should be aiming for is to capture successfully the essence of what you see in front of you, whether it's a landscape, seascape, buildings or people. Painting directly from life is all about what you saw and experienced at a particular time on that particular day. The memory of it will always be much more intense than if you had simply photographed it.

There is a movement afoot at present that suggests there should be a self-imposed limit on the amount of time in which a painting should be produced. The reasoning behind this is to resist the temptation of fiddling with, and over complicating a painting. This is something you might like to try, and you may find that this suits your style of painting – but there is no reason why you should restrict yourself in this way.

Drawing or painting from life, particularly in the open air, can be an exhilarating experience. Not only are you seeing things in three dimensions, but you are also absorbing atmosphere, sound, smells and climate, with all of its variations. By simply recording that which you see, whether it's with a spontaneous quick sketch or a more detailed painting, you are making a visual note of the sensation of your encounter with the real world with a far greater authenticity than can be achieved when working from a secondhand image.

How you record this response to what you have chosen to draw or paint is entirely up to you. If you are happy just to make rapid drawings in a sketchbook you will need very little equipment, but the chances are that you will soon become hooked on working 'en plein air', and the temptation to take up the paintbrush will be irresistible.

Beginnings

Without colours in tubes, there would be no Cézanne, no Monet, no Pizarro, and no Impressionism.
PIERRE AUGUSTE RENOIR

It is often mistakenly believed that the Impressionists were the first artists to pick up their paints and wander off optimistically into the countryside in the latter half of the nineteenth century. Although they were certainly the first movement of painters who more or less wholeheartedly abandoned the notion of the established method of classical, studio-based painting, there were others before them who felt the need to paint from life, rather than the generally accepted way of painting landscapes in the studio.

The 'Romantic' landscape painters were considered to be the pioneers of working 'en plein air', although much of their output consisted of sketches made outdoors with the finished paintings completed in the studio. Among these artists in England were John Constable and J.M.W. Turner, and in France, Eugène Delacroix and Théodore Géricault.

Painters of the 'Barbizon' school in France were greatly influenced by the 'Romantics', and developed a distinctive naturalism in their plein-air painting.

The group was led by Théodore Rousseau, and included Camille Corot, Jean-François Millet and Charles-François Daubigny. This school of artists is considered to be the precursor of the French Impressionists, the most famous of the plein-air painters. What is thought to be quite unremarkable today, was received by the establishment of the art world in the late 1800s as quite revolutionary.

In the middle of the 1840s, a young French painter called Eugène Boudin, who ran a stationery and picture framing shop in Le Havre, came into contact with the Dutch painter Johan Jongkind. Jongkind had already made a name for himself as an artist in Paris, and persuaded Boudin that the way forwards was for him to paint outside. In 1859 Boudin met Gustave Courbet, an established artist who introduced him to Charles Baudelaire, the art critic who recognized his talents when he exhibited at the Paris Salon Exhibition in the same year.

Boudin had already met and become friends with the young Claude Monet, who was living with his family in Le Havre, and earning a meagre living drawing caricatures. Boudin persuaded him to abandon his caricatures and take up landscape and seascape painting instead. His influence on Monet was profound, and the two remained lifelong friends. Boudin encouraged Monet to use bright colours, and to

The Towpath, Johan Barthold Jongkind (oil on canvas). This painting is probably an example of the way in which Jongkind preferred to work. He would produce a preliminary watercolour painting en *plein-air*, and then would re-create the scene in oils back in his studio. The composition is typical of the artist, who often favoured a low horizon, giving the sky a far greater dominance. (Courtesy National Gallery of Art, Washington)

Salisbury Cathedral from Lower Marsh Close, John Constable (oil on canvas). Alongside J.M.W. Turner, Constable is considered one of England's greatest landscape painters, influencing the Barbizon School and the French Romantic movement. Unlike his other contemporaries, he preferred to paint more humble, country scenes depicting the beauty of nature. (Courtesy National Gallery of Art, Washington)

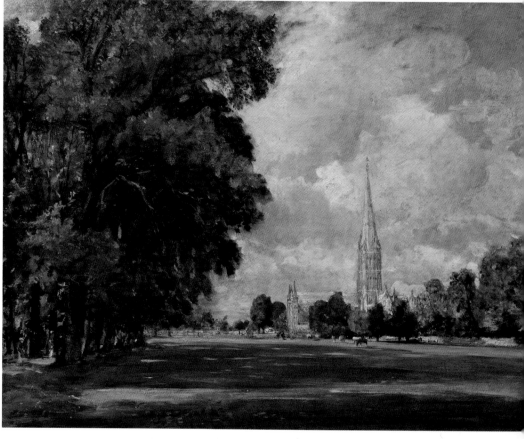

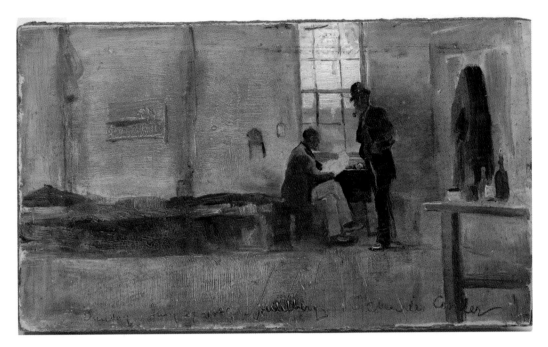

concern himself with light and form rather than realism; this is particularly evident in much of his later work depicting the play of light on water.

Monet moved to Paris, where he was influenced by the painters of the 'Barbizon' school, and attended classes at the Académie Suisse. During this period he met Camille Pissarro, and a little later Auguste Renoir, Alfred Sisley, Frédéric Bazille and Johan Jongkind. These artists, together with others – including Berthe Morisot, Paul Cézanne, Camille Pissarro and Edouard Manet – were to be the cornerstone of the Impressionist movement that championed a style of painting depicting light and its ever-changing qualities, using brighter hues applied with lighter brushstrokes. Rather than becoming a passing trend, this movement gave birth to a completely new approach to painting, and extolled the virtues of working outside.

Work at the same time on sky, water, branches, ground, keeping everything going on an equal basis... Don't be afraid of putting on colour... Paint generously and unhesitatingly, for it is best not to lose the first impression.

CAMILLE PISSARRO

There were, of course, other movements in other countries that adopted this new concept of painting en plein air, many of their artists having travelled to France to be influenced by the Impressionists. From the St Petersburg Academy in Russia, a group of artists known as 'The Itinerants' was travelling around the countryside painting rural scenes, and the idea of painting outside had already been established in Russia by the landscape artist Ivan Shishkin.

In Australia, the first real movement of painting in the open air to be founded had at its helm Tom Roberts: he assembled a group of like-minded artists who painted at 'Artist Camps', where they pitched their tents or occupied deserted farmsteads and set about painting the unexplored landscape. There was great comradeship in these camps, and they brought together a colourful and disparate collection of artists whose styles, though varied, were united in their love of outdoor painting. This group of artists became known as the 'Heidelberg School', Heidelberg being an area close to Melbourne where the camps were set up. They also painted at locations in Victoria and in New South Wales. As well as Tom Roberts, the group included Arthur Streeton, Charles Conder and Fred McCubbin.

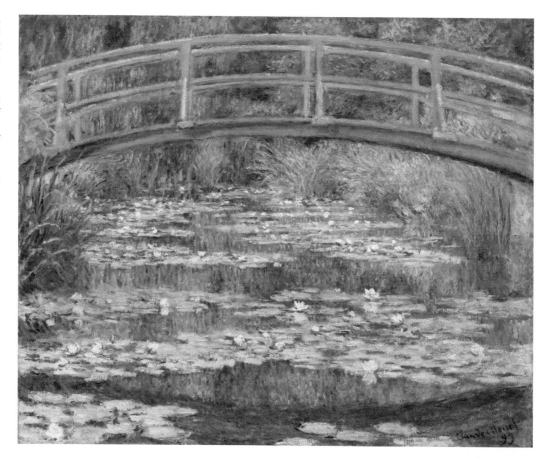

The Japanese Footbridge, Claude Monet (oil on canvas). Monet transformed his garden into an oasis of cool greens and tranquil water, which inspired him to set up his easel at the edge of the water-lily pond where he produced a series of paintings that he worked on over several sessions. (Courtesy National Gallery of Art, Washington)

A groundbreaking exhibition of 1889 entitled '9 × 5 Impression Exhibition' took place in Buxton's Saleroom in Melbourne, where 183 paintings of about 9 × 5in were displayed, mostly painted on the cedarwood lids of cigar boxes of roughly that size. They were on the receiving end of scathing criticism by the press, but were enthusiastically greeted by a partly perplexed general public. The cover of the catalogue, designed by Charles Conder, included the quote by Jean-Leone Gerome: 'When you draw, form is the important thing, in painting the first thing to look for is the impression of colour.'

With its long history of emigration, many artists from Ireland travelled to the continent to study painting in either Antwerp or Paris. Some spent time in Brittany, including Augustus Nicholas Burke, Aloysius O'Kelly, and some time later Roderic O'Conor. They were certainly influenced by the Impressionist movement in France, and it was here that many developed an interest in landscape painting outdoors. Stanhope Alexander Forbes was a Dublin-born painter whose father was English and his mother French. He, too, travelled to Brittany, and spent time studying the Impressionist style of landscape painting whilst staying at St Malo, Pont-Aven and Quimperle. Here he was in the company of other Irish plein-air artists, including Nathaniel Hill and Norman Garstin.

When Impressionism and the concept of painting outside reached the United States through artists who had studied painting in France, it was a revelation to many, how attractive a picture painted in natural light could be. This notion of painting outdoors was embraced by many, and several artists' colonies and art schools were established in areas where the diverse effects of light were perfect for painting. Several American artists who were attracted to the idea of working in the open air made frequent trips to Europe, as well as spending time painting on home soil. William Merritt Chase embraced the plein-air method of painting, and when he opened The Shinnecock Hills Summer School on eastern Long Island, New York, he often taught his students outdoors. Childe Hassam painted several New York scenes, and managed to capture the mood and colour of that city with its hustle and bustle and ever-changing skyline. He also painted the landscapes of the East Coast and California, as well as making drawings of colonial churches in Charleston, South Carolina.

But perhaps the person who had one of the greatest influences on all of these artists who took their brushes and paints out into the big wide world was a resourceful American portrait painter living in London in 1841, named John Goffe

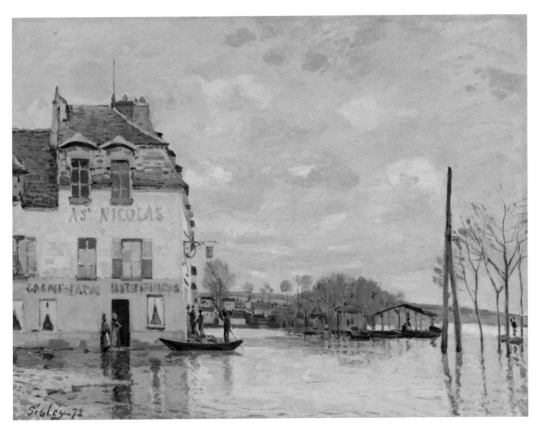

Flood at Port-Marly, Alfred Sisley (oil on canvas). Painted quickly *in situ*, probably in one single session, Sisley used a muted palette in a wide range of colours, applying them in thin layers to describe the individual elements in the scene. Rather than creating a dramatic or picturesque painting, his interest was purely in the visual effects of rain-laden clouds and water-covered streets. The tranquility of the painting and the directness and simplicity of Sisley's observation are reminiscent of the work of Corot, whom Sisley had met during the 1860s. (Courtesy National Gallery of Art, Washington)

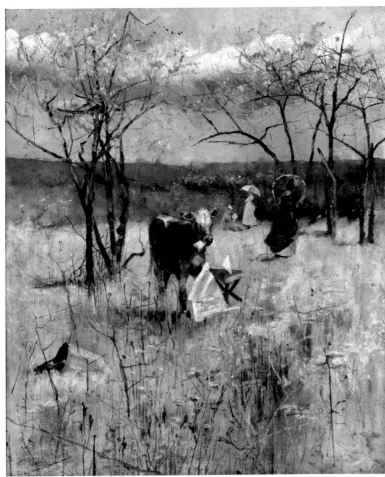

An Early Taste for Literature, Charles Conder (oil on canvas on paperboard). Although some of this painting was created outside, it seems that certain elements were added back in the studio. Conder often added figures to his landscapes at a later stage, and it seems more than likely that neither the woman nor the cow were painted in situ. (Collection: Art Gallery of Ballarat)

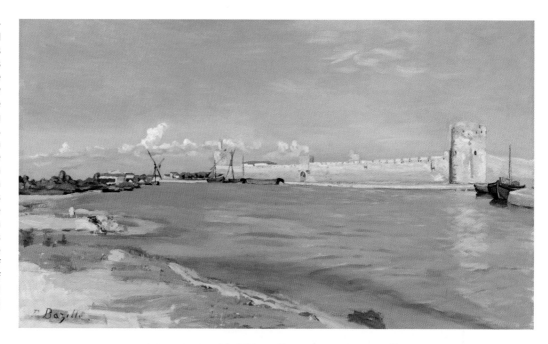

The Ramparts at Aigues-Mortes, Frederic Bazille (oil on canvas). One of Bazille's surviving sketchbooks reveals that he made many sketches of this view from different vantage points, before settling down in this position. Great care has been taken with deciding upon the composition, and then the painting has been executed with effortless and fluid brushstrokes. The bright blue sky and warm colours of the ramparts and riverbank, suggest the heat and intense light of Provence in the South of France. (Courtesy National Gallery of Art, Washington)

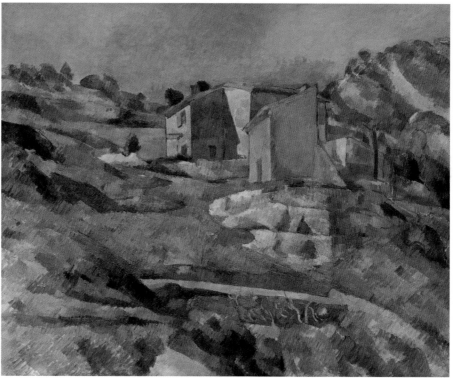

Houses in Provence: The Riaux Valley near L'Estaque, Paul Cezanne (oil on canvas). Under the guidance of Pissarro, Cezanne created many paintings directly from nature, and exhibited with the Impressionists in 1874 and 1877. However, his work came under heavy fire from the critics, and he began to drift away from the movement in order to pursue a path that eventually led to him painting in his own particularly individual style. (Courtesy National Gallery of Art, Washington)

Rand. Up until this time, the conventional way of storing paint was either in jars or glass syringes, or in a lightweight pig's bladder. As the jars were rather heavy to carry around and the syringes too fragile, it was the pig's bladder that was normally used when painting outside. It was tied with string to stop the colours drying out, and when the paint was needed the bladder was punctured with a tack and the paint squeezed out on to the palette. The difficulty then was how to stop the paint from leaking out once it had been resealed with the tack.

Rand's ingenious solution to this dilemma was to produce a squeezable tube made from tin that could be sealed with a screw cap. The invention was slow to catch on at first, as this increased the cost of the paint and made it unaffordable to many a starving artist. It did, of course, eventually become popular, and for the first time allowed the artist to complete an oil painting outdoors without having to go back to the studio to finish it.

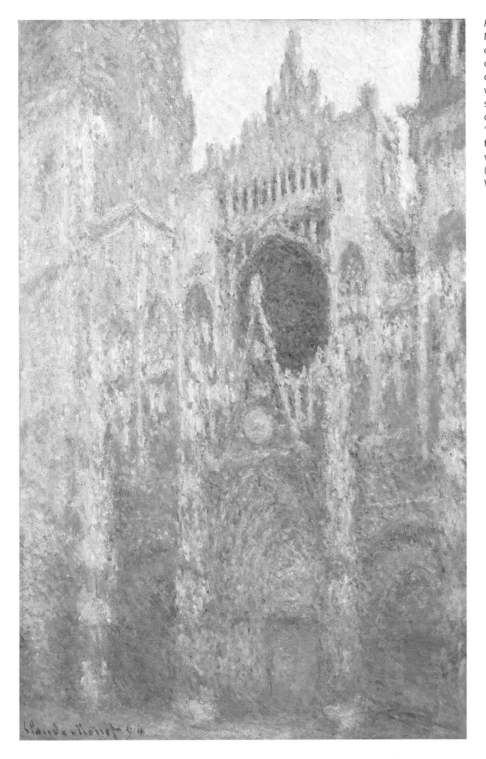

Rouen Cathedral, West Façade, Claude Monet (oil on canvas). One of the thirty or so paintings that the artist produced during his time spent in rented rooms opposite the cathedral. These paintings were extensively reworked back in the studio. It was during this period in his career that he was quoted as saying: 'To me the motif itself is an insignificant factor. What I want to reproduce is what exists between the motif and me.' (Courtesy National Gallery of Art, Washington)

Industrial chemists had also produced new, vibrant pigments during the nineteenth century, and these colours, now in portable tubes, allowed the Impressionists to pull out all the stops in creating light-filled, atmospheric paintings. Up until this time, the pigments available to artists had remained virtually unchanged for about two hundred years.

Contemporary Plein-air Painting

Whilst there have always been artists drawing and painting in the open air, and certainly more so in the last couple of centuries, there is at present a more highly visible movement of painters who encourage others to leave the studio and to take their sketchbooks and paints outside. This has perhaps been more evident in the United States, but more recently,

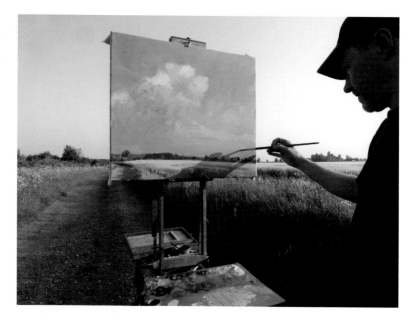

Barley Field, Roy Connelly (oil on stretched canvas). Painted in one session on a very pleasant evening in late May. The towering cloud caught the artist's eye and he worked fast to capture it. He painted the sky first, and by the time he had finished the rest of the painting, there wasn't a cloud to be seen anywhere.

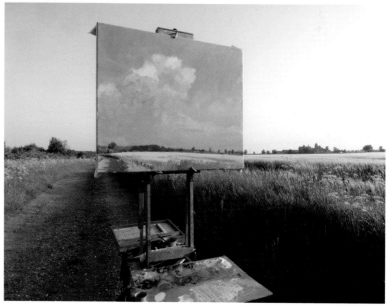

groups of plein-air painters have been established in many countries, particularly in Europe. The groups provide mutual support and camaraderie for those who regard drawing and painting outside as a way of life.

There are also several groups of 'urban sketchers' who meet up regularly in cities and towns and set off looking for subjects to draw. They may meet up at the end of the day to compare their work, or just simply display their drawings on one of the many websites that have been set up.

Recent years have also witnessed the emergence of 'paint-outs'. These events are competitions that attract both amateur and professional artists where the entrants have to complete a painting 'en plein air' within a certain time frame. There are often monetary prizes up for grabs, so competition can be quite fierce!

On a gentler note, there are those artists who just enjoy drawing and painting outside simply for the pleasure of it. They may be individuals who wander off on their own looking for just that right composition, or they may be those who prefer the more social side of working that can be provided by workshops, courses or painting holidays.

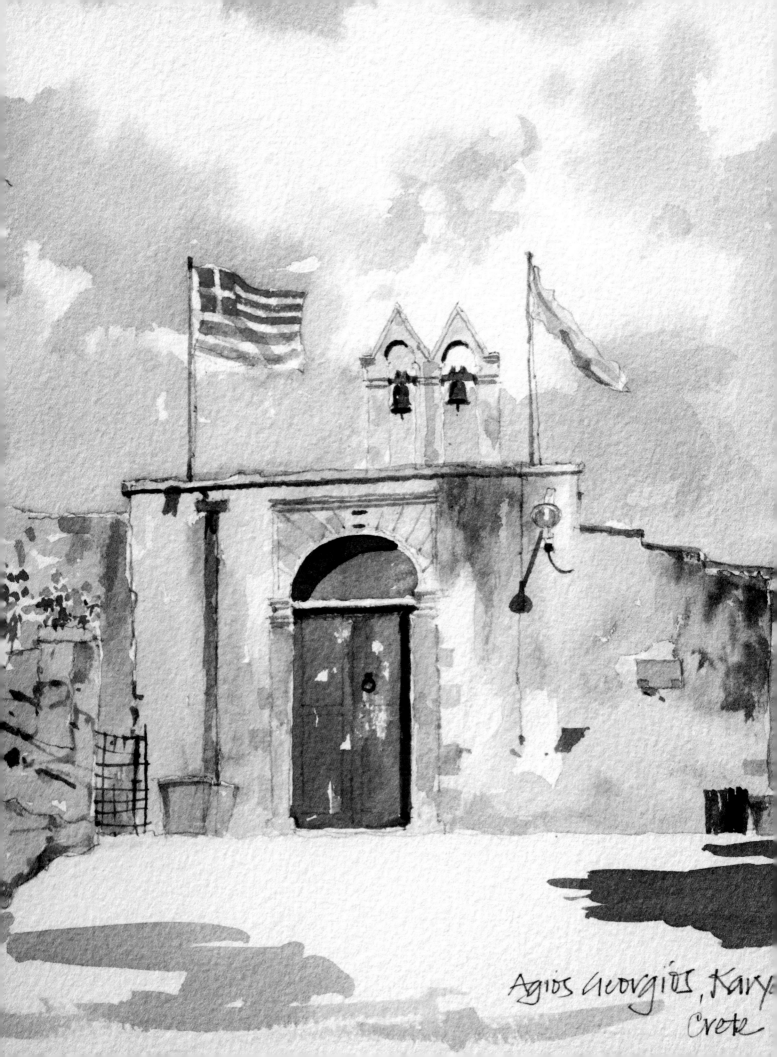

Agios Georgios, Karyo
Crete

Subject Matter and Locations

Painting en plein air presents the artist with a unique set of challenges. Light changes constantly, altering the subject hour by hour, minute by minute. Clouds can plunge a scene into darkness. Sunlight throws a figure into sharp relief. Tides rise and fall. People come and go. The plein-air painter must seize upon these moments – distilling from this evolving scene a permanent record of time and place.

THE PLEIN-AIR BROTHERHOOD

You don't necessarily have to go too far to find something to draw or paint. A view from a window, a car in the street, an interesting corner of the garden or a cat asleep on a wall, are all possibilities, if not for a finished painting then maybe for a simple sketch.

You may be drawn to a particular subject matter, but there may also be some things that just don't interest you. Whilst some people may get excited about bustling street scenes, others may be greatly underwhelmed by them, but instead may be enthusiastic about a quiet landscape or seascape. Turning an empty landscape into an interesting picture can be quite tricky, but by including a track leading to a farm building and an interesting cloud formation, you will have something on which to hang your composition.

Similarly, a painting of an empty seascape probably won't have enough going on in it to engage the viewer's attention for very long, but by adding a headland, some boats and a stretch of shoreline, the different elements within the picture will lead the viewer's eye into and around the image. It's

The Monastery at Agios Georgios, Kevin Scully (watercolour sketchbook). A watercolour sketch created on a painting holiday to Crete. The shadows in the foreground cast by some tall, overhanging trees tell us that this was painted when the sun was at its highest, and that the unseen tree on the left was taller than the one on the right, because its cast shadow is rather diffused.

Late Afternoon, Bath, Felicity House (pastel, underpainted in watercolour on Colourfix card). The city of Bath always provides terrific subject matter for painting, and having spotted this composition, the artist set about working from the pavement edge. She chose a dusky blue Colourfix card, and with neutral watercolour washes blocked in the various subtle tones. The fabulous light was recorded quickly in broad blocks of colour, and some detail was added in pastel pencil, as seen in the man on the right of the picture. By including the human element a sense of scale is introduced, which also gives the painting a real-world feel. She likes a scene where people and dogs come and go, and with pastels it's possible to add these immediately – and if they don't work, they can be removed with a dry brush or wet rag.

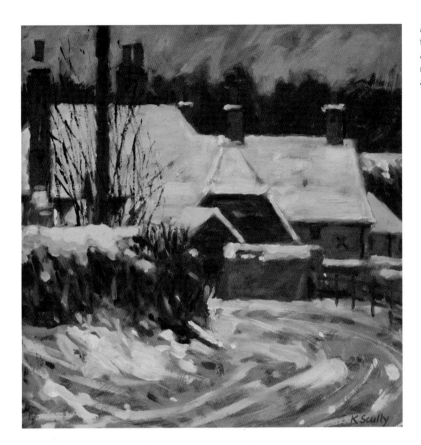

Dunworth Farm, February, Kevin Scully (oil on board). A fairly monochrome painting created on a dark and grey afternoon when the snow was beginning to melt and the mud on this farm track was beginning to turn the snow to a dirty slush.

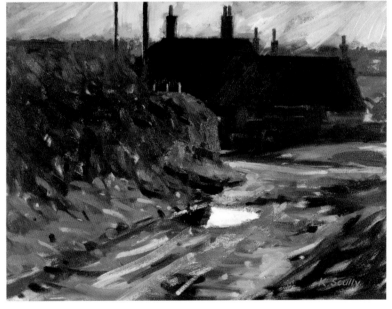

Dunworth Farm, January, Kevin Scully. Painted rapidly on a late wintry afternoon, in an attempt to capture the slightly bizarre colours that the threat of snow sometimes brings. The cool colours have been exaggerated to help convey the feeling of the intense cold and eerie atmosphere that was experienced.

always a mistake to begin work on something that doesn't really inspire or motivate you, and these pictures are usually not going to succeed. If you find absolutely nothing to fire you into action it's probably best to wait until you do.

If a particular location inspires you, then try making drawings or paintings of it at different times of the day or from varying viewpoints. If possible, view the scene from a higher or lower vantage point, and stalk the spot thoroughly before settling yourself down. By familiarizing yourself with a particular spot you will eventually be able to gain an understanding of what works visually and what does not. There is a risk, of course, that repetition will dull your creative senses, and when this happens it's time to move on.

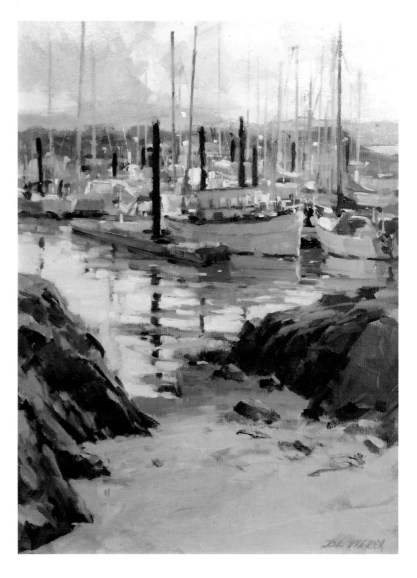

Marina in the Morning, Deborah Tilby (oil on panel). This often visited marina, close to the artist's home and studio, is one of her favourite painting locations. Her easel was set up early in the morning to capture the sensation of a gradually brightening sky. Typical of this type of scene, there is plenty going on for an artist to get his or her teeth into: sky, distant landscape, boats, water, reflections and foreground. The two rocks in the foreground lead your eye towards the main focus of the composition, which is the large boat, moored beside the jetty. Although the mass of boats and the rocks are two separate elements in the painting, they are connected visually by the inclusion of similar colours in both areas. The position of the white highlights indicates the emerging light to the right of the painting.

Inspiration can also be found in the company of others. By venturing out with other artists, either with a just a few friends or with fellow painters on a more structured outdoor workshop or painting trip, you may be introduced to subject matter that you may not have previously considered.

Study the work of other artists both past and present whose drawings and paintings you admire. Try to ascertain what it was that inspired them to choose a particular subject, and decide for yourself whether or not it was successful. Was the inspiration for a picture the dramatic perspective of a building, or perhaps the play of sunlight across a patchwork of fields?

There are some locations that are naturally inspiring, but there are others that are more elusive and have to be tracked down and investigated. Estuaries and harbours contain a wealth of subject matter, and there will be something to interest most people among the boats, reflections, wharfs, jetties and general nautical paraphernalia.

Older buildings are generally more aesthetically attractive to paint than modern ones, as they often possess a charm and intricacy of detail that can be utilized to great effect in a picture. However, a misty, early morning city skyline viewed across a stretch of water with a few utilitarian river craft bobbing around can be equally as charming. Add to this a dramatic sky, and there you can have a scene to get excited about. There are some scenes that could never be classed as beautiful, but the drawing or painting that depicts them with a degree of imagination and sensitivity can be beautiful in itself, so don't dismiss subject matter just because it isn't immediately attractive. Indeed, a painting of an overly idyllic scene can sometimes be just too much to bear.

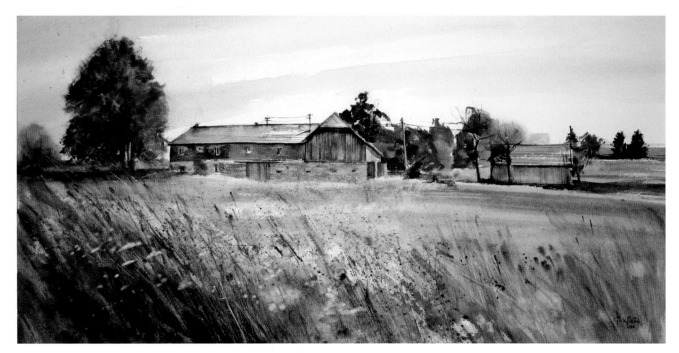

Farmhouse in Habruck, John Owen (watercolour on Bockingford NOT paper). Habruck is a hamlet in Upper Austria, not far from the artist's studio. This farmhouse stands alone just off the road, and it makes a simple statement about life on the land here – hard, tough, and down to earth. He has tried to reflect this in choosing a low viewpoint. Half the picture shows the grasses and fields, which are the foundations of the farm's existence, and above the farm buildings is a plain, streaked sky, typical of the area, which together with the simply painted buildings, contrasts well with the very textured grasses in the foreground.

The Pleasures of Working Outside

As an artist there is nothing more pleasurable than being outside with sketchpad or paints doing something that you enjoy. You are placing yourself within the scene: the sun, the wind, the sounds, the smells and the colours are all around you. You have immersed yourself in your subject and no number of photographs can replicate this sensation.

Producing a painting from a photograph and producing one from life are two dissimilar experiences, and it could be argued that each has its place. Each discipline is different, but perhaps one is better than the other.

It's perfectly possible simply to use a photograph as a springboard for producing a drawing or painting of quality in the studio, and just because you are working outside from life, it doesn't mean that you are going to produce a brilliant work of art. Working outside is a challenge, but the experience is thoroughly worthwhile once you have resigned yourself to the idea that if you want to paint outside, you will probably have to adopt a different approach to your normal working method. Unless you plan on returning to the same spot each day to paint your picture, over a period of time you will almost certainly have to implement an alternative

modus operandi. That is, you will need to work fairly briskly and decisively. This is especially true on those sunny days when the shadows move all too speedily. But this is no bad thing. A few confident brushstrokes in the right places give a painting vibrancy and spontaneity. The aim is to capture the spirit of the scene rather than to paint every blade of grass or pebble on the beach.

Even though you may not realize it at first, drawing and painting encourage you to be more observant. Things that you may once have taken for granted – a shadow under a tree, the reflection of a boat on water, the highlight on a rooftop – suddenly become the objects of a great revelation. Even the most mundane things suddenly appear unendingly fascinating, and you find yourself examining, dissecting and analysing everything. This can be both enlightening and uplifting, and never more so than when you are working outside. When faced with a photograph, you take for granted what is there in front of you, but when you are working outside you will find yourself questioning everything you see. Why has that shadow changed colour now that the sun has come out? Why has the tarmac road suddenly turned a deep blue-grey now that the prowling storm clouds are overhead and it's beginning to rain?

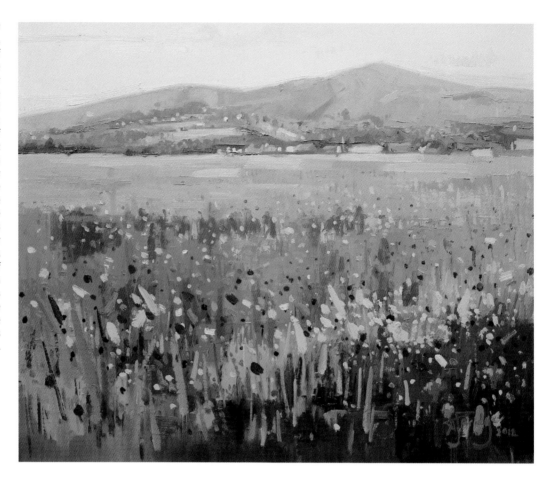

Malvern Flowers, Antony Bridge (oil on board). Painting such a mass of wild flowers in a landscape can sometimes be rather daunting, but here the artist has simplified their form by indicating them with a variety of brushstrokes in different shapes and sizes, and a juxtaposition of randomly distributed colours. The warm colours of the foreground flowers give way to those of the fields behind, and the cooler hues of the distant hills. A more subdued version of some of the colours seen in the foreground has also been added to the buildings and hills in the distance, which connects the two separate areas.

With a bit of thought you may be able to work out logically why these things occur, and in which case it may help you in the way that you capture them. But these things will happen and can be the subject of endless fascination. As an artist, you should be forever curious about everything you see, and endlessly seeking out new subject matter, and it's all out there in the big wide world. There you will find architecture, people, harbours, boats, vehicles, landscapes, flowers, seascapes, cityscapes, animals, skies and even still life.

As well as all this, what could be more pleasant and absorbing than spending time drawing or painting outside on a beautiful day?

Landscapes

Out of all the possibilities of subject matter, landscapes are probably the most appealing. If you are drawing a landscape composition rather than painting one, you will have the advantage of speed. Even in strong sunlight, you will have completed your drawing before the shadows have altered too drastically. Your drawing may simply have been made focusing on a particular element that has inspired you, in which case, other elements in the composition may be indicated with just a few Spartan lines, leaving out irrelevant detail. Even if you choose to fill your whole page with a detailed drawing, the shadows can be left until the end. The style of drawing that you adopt may only require a linear approach, and so you may not want to include any shadows at all.

Your chosen subject might cry out for a particular treatment. A dewy morning with misty distant hills of indistinct colour and no sunlight would probably suggest watercolour as the ideal medium for capturing the essence of the mood. However, a derelict farm building in a parched landscape beneath a bright blue Mediterranean sky would probably be best rendered in either oils or acrylics. You can, of course, use any medium for any subject matter, and the success of the drawing or painting will depend more on the way it has been executed, rather than the choice of medium.

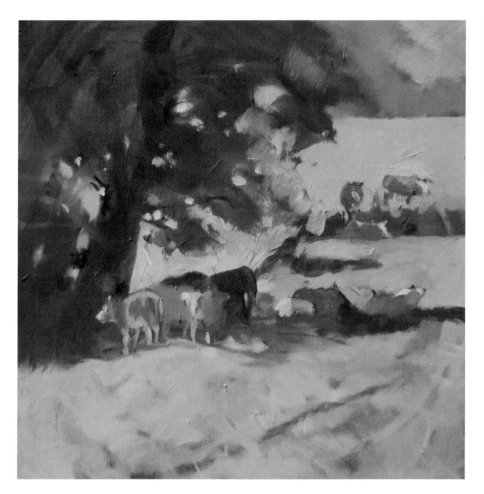

Silchester Cows, Jenny Halstead. The painting was made very rapidly, the artist having been attracted by this group of cows standing almost motionless and virtually undetectable in the shade. The scene is one of strong sunlight and shadows, with a flicker of light catching them every now and then. The cows in the distance were painted in later in the studio, to add weight to the composition and to further emphasize the subject matter.

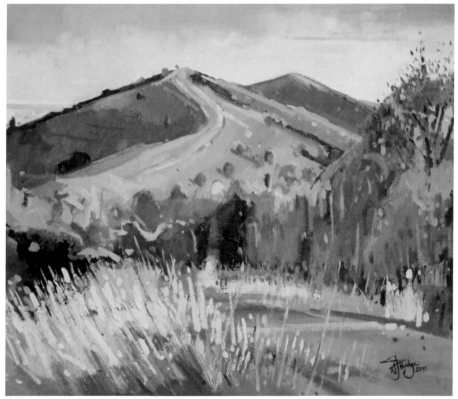

Beacon Road, Malvern Hills View, Antony Bridge (oil on board). In this picture, painted on a beautiful summer evening, the eye is directed first left and then right, and finally taken on a sweep up to the summit of the hill, typical of the topography of this part of the country. The immediate foreground has been painted simply and briskly, and without too much detail, so ensuring that it doesn't detract from the road that climbs up to the hill.

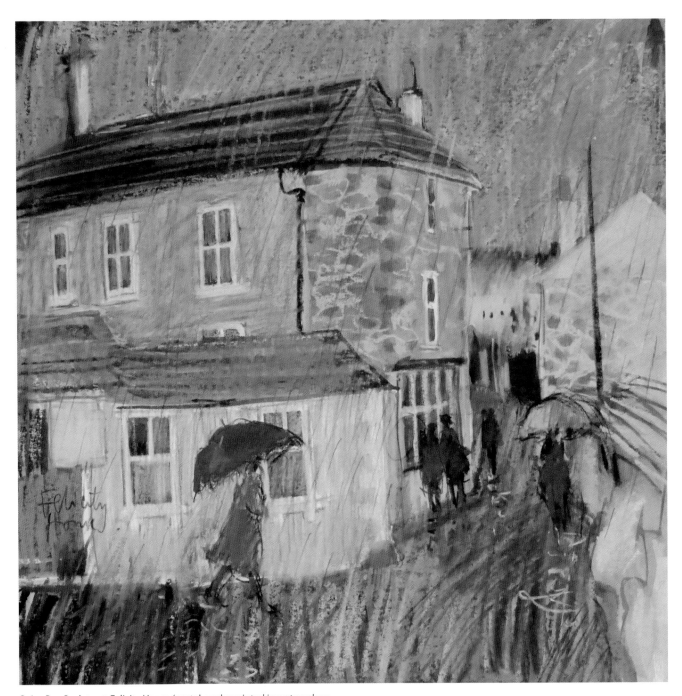

Rainy Day Backstreet, Felicity House (pastel, underpainted in watercolour on mountboard). Painted whilst sheltering on a damp day in St Ives, which meant that the artist had to work very fast. Available time was limited, so she used energetic, lively mark making to convey the essence of the scene as quickly as possible. The coloured accents on the umbrellas and chimneys were added later.

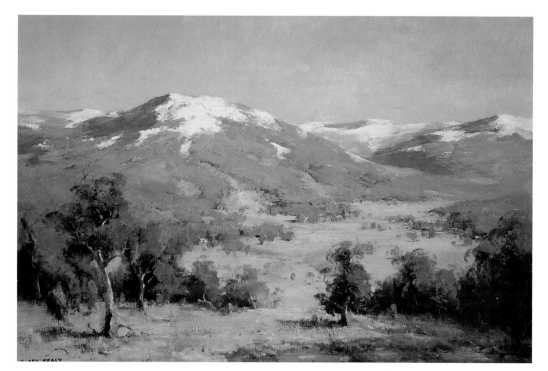

Snowy Tops, Mount Morgan, Kasey Sealy (oil on hardboard). This painting was first blocked in 'en plein air' and then completed later, back in the studio. The artist wanted to capture the crisp morning light in Australia's high country, and was fascinated by the frost in the shadows, contrasting with the warmth of the grasses. He has made use of both the warm and cool colours and the grand panoramic valley view, to create the illusion of distance.

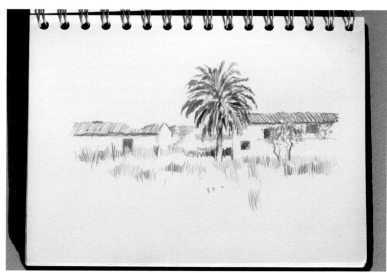

Sketchbook, Algarve, Portugal; Kevin Scully (coloured pencil). A simple sketch depicting the tonal variations observed in this deserted farmhouse scene in the midday sun. Looking at this sketch brings back memories of the deafening sound of cicadas and other buzzing insects.

Water

The nature of water means that it is certainly going to move about, which means you won't have the luxury of drawing or painting a stationary subject as you would with a landscape or a building. This, then, calls for a different approach. You will have to be decisive regarding its colour and form. It's no good changing the shape or colour of a wave every time a new one rolls in, as every one will be different from the last and you will be at the seaside all day! At some stage you will have to draw or paint the water in a particular way that suggests how it appeared at a given moment. This takes practice and can only be achieved by studying the way in which a wave behaves. This can take a considerable amount of time, but once you have understood the manner of the sea's movement, it can be committed to memory and painted almost intuitively, and sometimes away from the subject itself.

There is more chance of the water in a river or estuary being fairly still, and although there may be some waves created by moving rivercraft, at least there won't be any huge waves crashing in.

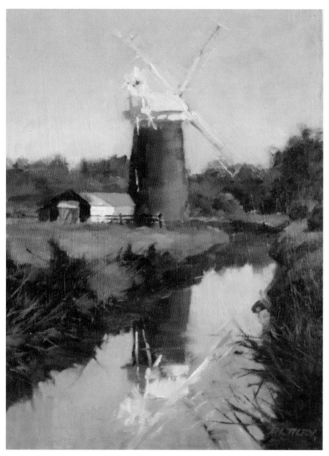

Windmill in the Morning, Deborah Tilby (oil on panel). This Norfolk windmill, in its peaceful, idyllic setting, was painted very early one summer's morning with only the cows for company. The reflection of the windmill in the water has been beautifully painted in a colour that is in a slightly lower key than the building itself. A sense of distance between the windmill and the trees behind has been achieved by creating a soft blend where they meet the sky. We can tell just how distant they are by their colour. Had they been further in the distance, they would have contained more than just the hint of blue that the artist has added.

Towns and Cities

If you like to draw or paint architecture, towns and cities will provide an infinite amount of material for you. The obvious place for you to locate yourself is at street level, from where we all view most architecture, but by adopting a vantage point at a higher level, some interesting pictures can be created by making use of the exaggerated perspective.

Drawing buildings can be very time-consuming, but many people find pleasure in this and relish the challenge of tackling some ornate and intricate architecture. The inclusion of some figures will add a more human element, as well as giving your work a sense of scale. If the detail contained in buildings doesn't particularly fire you with enthusiasm, a simple pencil or ink sketch, together with the addition of a watercolour

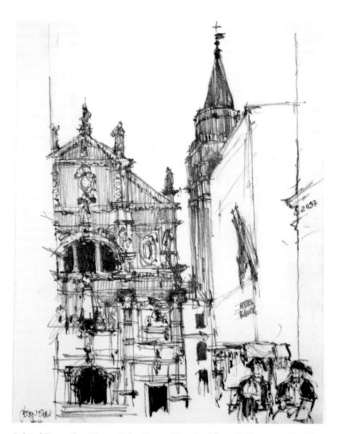

Behind Piazza San Marco, John Owen. Sketched fluently from a café table in about ten minutes, where the mid-tone complexity of the church façade is counterbalanced by the featureless hotel block. The similar shape of the black windows and doors keeps the eye's main attention on the façade, whilst smaller black rectangles lead the eye to the hotel and dark tower above. The figures add human interest and balance to the composition. The sketch has been drawn speedily and intuitively, and includes sensitive lines along with some vigorous shading.

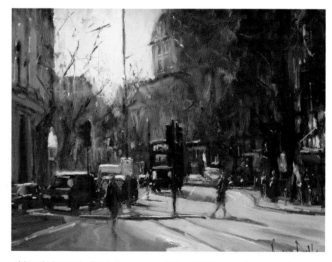

Aldwych, Roger Dellar (oil on canvas). The artist has made a conscious decision to reduce the buildings into silhouette so that the emphasis is placed on the activity represented by the cars and the figures in the middle distance. The painting is all about light and shade rather than detail, and the way in which the colours have been blended together captures the bright but hazy lighting conditions perfectly. Although the traffic lights have been placed in the centre of the composition, this strong vertical line is counterbalanced by the tall lamp-post to its left.

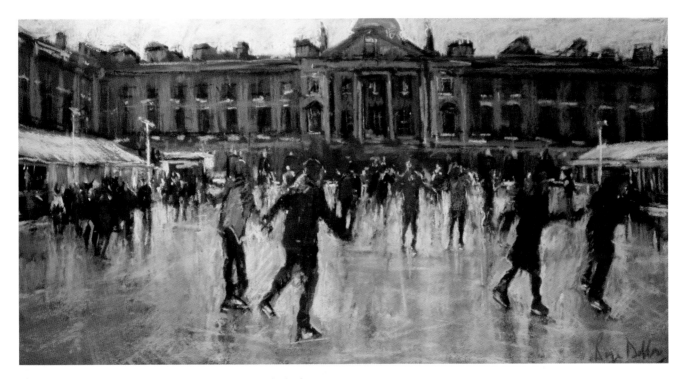

Skating, Somerset House, Roger Dellar (pastel on board). In this lively seasonal scene, the way in which the pastel marks have been applied intensifies the dynamics of the figures. Their edges have been blurred and unnecessary detail has been eliminated whilst some strong and interesting negative shapes have still been retained. The fairly monotone colour palette has been lifted by the touches of red and blue dotted throughout the picture.

wash, is a possible alternative, and may be all that is needed. A cityscape viewed from a distance, with a town square or some trees in the foreground being the focus of attention, can provide sufficient material for an interesting drawing.

Don't disregard the possibilities provided by street furniture, as lamp posts, road signs, street signs, post boxes and so on can all add interest to an urban scene. Some colourful street art or graffiti can make for a great image in itself, and may need nothing more than the addition of a passing pedestrian. Look also at cars, buses, lorries, vans, motorbikes and cycles.

People

The inclusion of figures in your work can add an extra element of interest and scale, providing of course they are of genuine interest and of the correct scale. Attempting to draw or paint a busy street scene will undoubtedly benefit from a sprinkling of figures in movement. This can be tricky, and the ability to develop a kind of shorthand way of rendering people on the move has to be developed. A figure drawn badly can ruin an otherwise successful picture, so great care must be taken in its execution. If the figures are to be an integral part of the drawing or painting, they must be drawn or painted as such and not simply included as an afterthought.

As a general rule figures should be painted with as few brushstrokes as possible and in the same way as the rest of the painting so that they don't jump out and appear incongruous in the overall scheme of things. There is often a temptation by the less experienced to try and paint features on a face which are only really seen in peripheral vision from a distance, and therefore should be indistinct.

Half Term Holiday, Jenny Halstead. This pen-and-wash sketch was made during October in Bournemouth with everyone enjoying the last of the summer warmth and light. The artist loves working *contre jour* (against the light), and the groups of figures almost in silhouette was something she desperately wanted to capture, enjoying the negative spaces and the hint of colour. This was sketched as a tonal piece and worked up later in pastel.

There are times when stationary figures can add interest, and the same rules apply here. There are mixed thoughts on the inclusion of figures in the landscape, and this is perhaps a question of preference and relevance. If you decide to add a figure or two they must be depicted in relevant clothing, so a suited man strolling along a country lane, or appearing as if he has taken a wrong turning, strolling through an Alaskan snow scene, just won't ring true.

Travelling at Home and Abroad

It's possible that you may not have to go too far to find some suitable location for working outdoors, and if you have never tried it before, it's best to begin with a fairly simple scene. Don't be too ambitious initially, and don't be too disappointed if your first attempt at working outdoors isn't entirely successful. You will see from some of the early Impressionists' attempts at working en plein air that their results weren't entirely without faults either.

If you have a garden or outdoor space it would be a good idea to conduct a trial run there. You may find that you don't have some piece of vital equipment you need, in which case you can just pop into the house to retrieve it. This initial foray outdoors will go a long way towards helping you decide what you are going to need as far as equipment is concerned.

At some stage you will want to travel further afield, and if you have a car there will be endless locations for you to choose from. Even if you have to travel by public transport, and providing you are not overburdened with too much in the way of equipment, there will be many inspirational places at your disposal. It's possible that you will be happy working without the need to travel abroad, but don't dismiss this idea outright. If you have been used to producing paintings on home ground with perhaps a limited colour range, a trip to a different country might open your eyes to other possibilities and give you the opportunity to experiment with a more exciting palette.

A foreign holiday will give you the chance to try your hand at drawing or painting in a different environment, and will

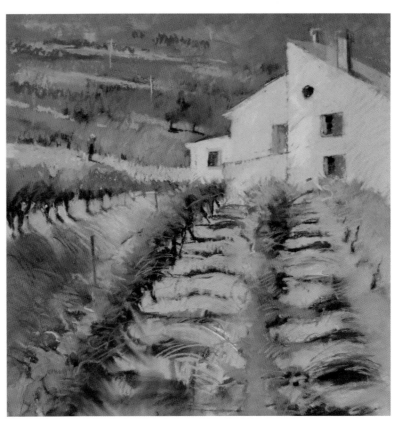

The Vine Tender, Jenny Halstead. A colour sketch made in France and worked up later in pastel on Colourfix pastel paper. Keeping the buildings simple, the artist used the shadows of the vines to describe the contours of the ground, which in turn gives rhythm to the horizontals. By taking the hillside upwards and out of the picture, the eye is forced down towards the figure below, whose size adds scale and a certain kind of dialogue to the image, further strengthened by the title of the painting, which invites the viewer to locate the worker.

also produce some images to act as a permanent reminder of your trip. You can even add some words in note form to your drawings and paintings, so that your sketchbook takes the form of a travelling journal. Joining an organized painting holiday in the company of other like-minded people is something else you might like to consider.

Preliminary Preparations

Before you eventually venture out with sketchbook or paints, you should have some idea in your head about what you actually want to achieve. Begin by conducting a recce, and choose a subject that you are particularly interested in. There is no point tackling a detailed pen and ink drawing of the houses of Parliament if you would be far happier painting a simple landscape in watercolour.

If you are an organized person, begin by making a list of some possible locations that may inspire you. Presumably you will have already considered drawing or painting outside, so you may by now have several potential sites lined up. If you don't feel confident enough to jump straight in at the deep end, you could start by taking some photos of your chosen areas of interest. Be sure to stalk the site thoroughly, as the viewpoint that first inspired you may not turn out to be as interesting as an alternative spot viewed from a position elsewhere. By taking several images from different angles, you can then view them at leisure whilst deciding on the most favourable composition. However, hardly any viewpoint will be perfect, so you will normally have to compromise and make adjustments by moving things around or even by leaving parts out completely.

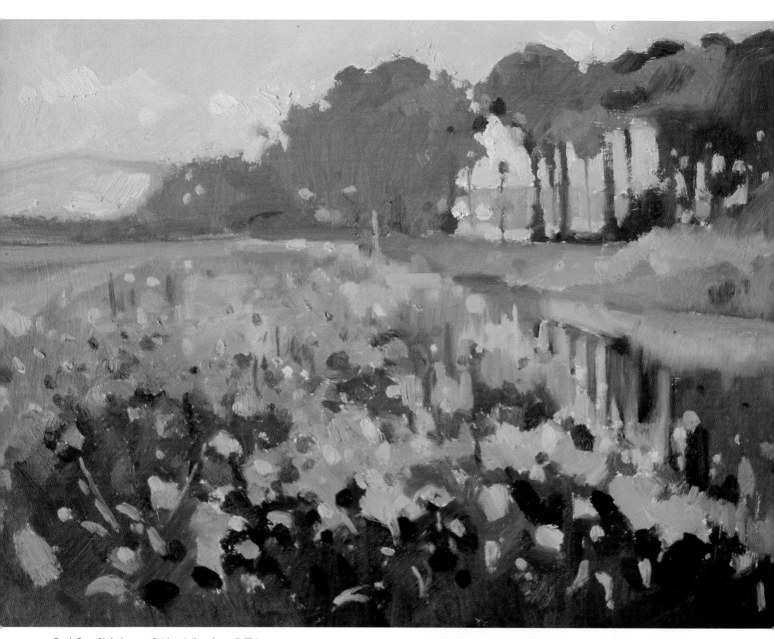

Dusk Over Pink, Antony Bridge (oil on board). This was painted at perhaps the best time of day, when the sun is about ready for bed. The artist has captured the atmosphere perfectly, thirty minutes before sunset, with a simplicity that would be hard to improve upon. The notion of distance has been suggested in an uncomplicated way with the liberal introduction of blue into the hills and trees, whilst the flowers in the foreground diminish in size and intensity as they recede into the background.

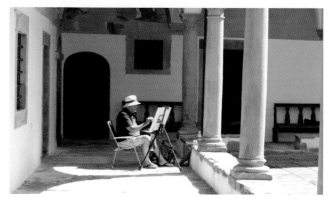

A peaceful moment for the artist Geoff Harcourt, painting in oils at a convent in Tuscany whilst on a painting holiday.

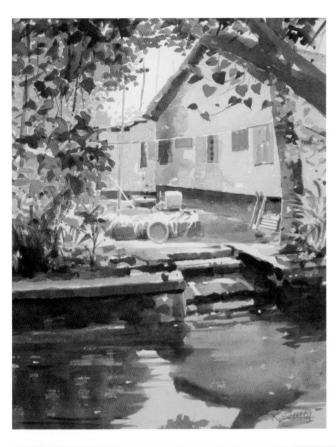

Kerala Sketchbook, Kevin Scully (watercolour). A region in India intersected by a network of waterways, where the local people live, work and sustain themselves along its banks. Lush greens in a thousand different shades are the predominant colours in this area, relieved occasionally by the vibrant hues of washing, hanging on the line to dry.

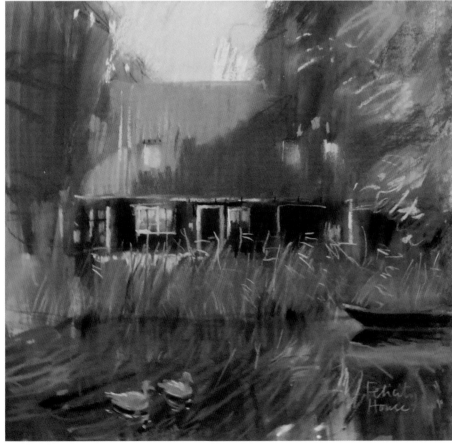

A Canal in Holland, Felicity House (pastel, underpainted in watercolour). The support was first painted in neutral tones to block in the rich, dark passages of the composition. The scene was simple but charming, with sunlight catching the roof of the house, the leaves and the boat. The painting was executed rapidly to capture the moment, and soft pastels have an immediacy that is perfect for the task. The artist had fun suggesting the movement and reflections of the water and reeds in the foreground, with some fast, energetic marks.

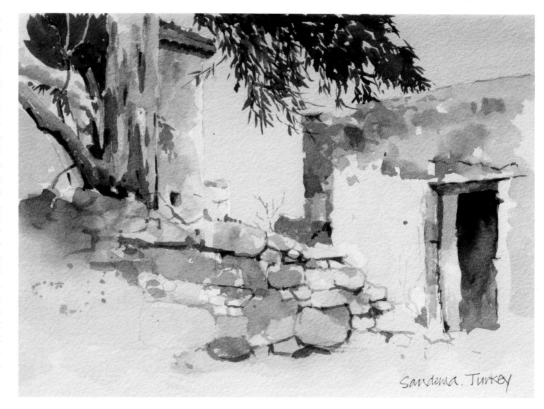

Sandema, Turkey, Kevin Scully (watercolour sketchbook drawing). Painted in the ruined hilltop village of Sandema, abandoned in the 1960s and now deserted except for an artist and his wife. The only other occupants of the village now are the goats and lizards. The bright blue sky was painted first in a graduated wash and was dry in less than a minute. The buildings were laid in wet-in-wet, with a few simple washes added later when this was dry. As the foliage of the tree formed a deep green silhouette, this was painted last along with some detailing on the stones. The viewpoint chosen suggests that what remains of these forlorn buildings stands on a hill.

Alternatively you can make some quick compositional sketches in situ to help you to decide where you wish to position yourself. When you return later to start drawing or painting, you may find that your view has been blocked by a truck, or spoilt by road works, so you might have to switch to plan B. On the other hand you might want to just pack up some essential materials with which to work, and go out to see what you can find that stimulates you.

FACING THE SUN

As with amateur photographers, the inexperienced artist, for practical reasons more than anything else, will tend to be drawn to a view with their back to the sun, rather than facing it. But if you face the sun, you'll find much more interesting possibilities for painting. The contrasts will be sharper, distances will be hazier, silhouettes will be more dramatic and shadows more intense. With your back to the sun, the image before you will often be lacking in contrast and interest and a landscape can appear rather dull and flat. So try placing yourself facing the sun, or slightly to one side and in shade if possible. You can either wear a hat to shield your eyes and work from the glare, or position yourself under a large white umbrella. This, of course, is dependent on whether or not the sun is actually out!

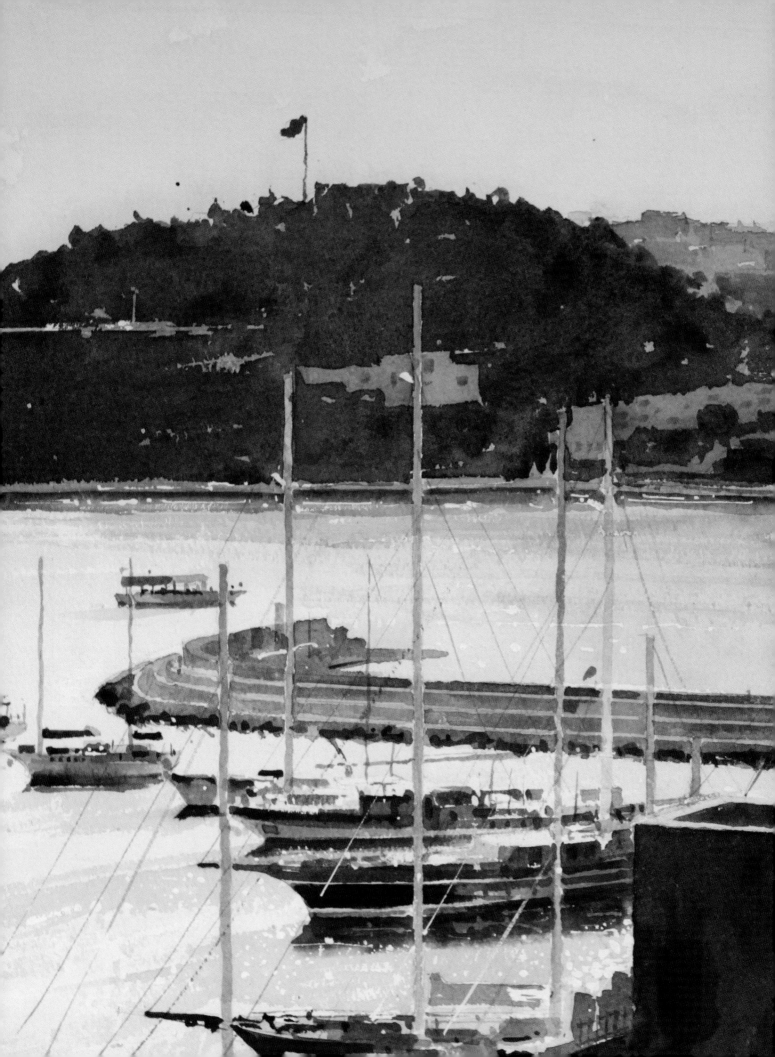

What to Take and What to Leave Behind

What to take and what to leave behind is a problem that we have all grappled with when trying to decide what to pack for a holiday, and no matter how many times we do it, the experience is always a challenge. For those lucky enough to be able to have frequent holidays instead of just one or two a year, the task would be less tortuous. Gathering together what is needed for drawing or painting outside can at first seem quite confusing, but the more often you do it, the better organized you become.

Travelling Light

Although you don't want to be burdened down with too much equipment, there are certain things that you will need. If you're going to be working for any length of time outside, you will probably want something to sit on. Many people prefer to stand whilst they are painting, but occasionally there will be a better viewpoint to be had lower down. There may be a convenient bench or wall to sit on, but if the view is better elsewhere you will need a lightweight stool. If you are simply drawing, or just producing small watercolours, it's possible to work with a sketchbook on your lap, but if you are painting, particularly on a larger scale, you will need an easel of some kind. If you have to walk any distance, a heavy easel and a bagload of equipment can become rather tiresome, so restrict yourself to lightweight items.

Different mediums demand specific materials, so don't be tempted to empty your studio of its contents and leave home with a supply of everything you might need. Instead, decide beforehand what medium you are going to work in, and take only what is necessary. By limiting yourself in this way, you won't have to fret about whether or not you should be using watercolour, acrylic, oils, pastel, ink, pencil, markers or any other medium. You can always come back another day if you feel your picture would have been more successful in some other medium.

Certain practical or climatic conditions may lead you to choose one medium over another, and if you are limited for time, you won't want to start painting a huge canvas in oils. If the weather forecast predicts rain, it is probably not advisable to be using pencils or pastels on soggy paper.

Afternoon Light, Kevin Scully (watercolour). As the sun was thinking of setting, these distant hills were turning from a mauve-blue colour to a deeper indigo, with the white houses tinted a distant blue. The tops of the terraced harbour wall and some of the ships' masts and rigging were painted carefully with a ruling pen dipped in masking fluid. Other areas in the painting where white appears were left either as white paper, or scratched out with a scalpel. Some of the highlights in the water were added with white gouache.

Make yourself comfortable. If you're going to be working for any length of time on a painting that contains a fair amount of detail, you might as well make yourself comfortable. Here, Geoff Harcourt is seated on a fold-up picnic chair with all his materials close at hand. These are resting on a back-pack that incorporates a folding stool into its design, and has the capacity to carry everything needed for a painting excursion.

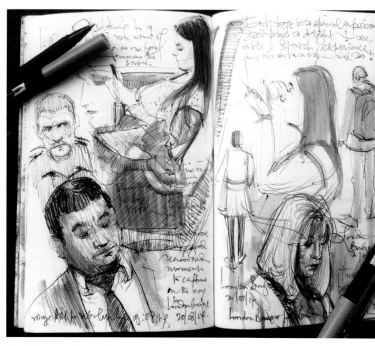

Sketchbook, Adebanji Alade. Action-packed sketchbook pages of people drawn rapidly with a variety of pens and markers, with added notes, thoughts, locations and dates.

With experience you will eventually know what equipment you are going to need, and certain mediums will suit your way of working more than others. There is a vast variety of materials available these days for artists and much of it is of very good quality, but it's all too easy to be seduced into buying things just because they may seem functional and are beautifully packaged – so don't spend money on things that you don't really need. A wise policy is to buy things of the very best quality, and only when you need them. So if you only ever intend painting in watercolours, don't go out and buy a very expensive all-singing, all-dancing French box easel. It might look good, and you might look good standing in front of it, but you will probably never use it.

Bear in mind also, that some mediums are going to weigh you down more than others, and such is the case with oils and acrylics. Tubes of these paints are rather heavy, whereas watercolours, pencils, pens and pastels are relatively light. Also, the equipment needed for you to function effectively will also vary in weight.

Providing you have the essentials, keep your kit to a minimum. Even if you have a vehicle for transporting everything, too much equipment can lead to confusion.

Choosing a Drawing Medium

The tools available for drawing are numerous, and undoubtedly you will have experimented with some of them, but it is only through trial and error that you will discover which ones suit your way of working best. It may be one particular material that allows you to express your intentions, or it may be a combination of two or three.

Pencils

The user-friendly pencil, although probably the most humble of all the mediums, is also infinitely versatile. It can produce anything from simple, linear sketches to highly complex and detailed drawings. It can create tone by applying varying degrees of pressure, and can be rubbed, smudged and erased. It can also be used beneath or on top of a watercolour wash.

Sometimes, all you need to create a successful drawing are a few gestural lines that encapsulate the essence of a subject. If you are intrigued by the complexities of ornate architecture, then a pencil is perhaps all you will need.

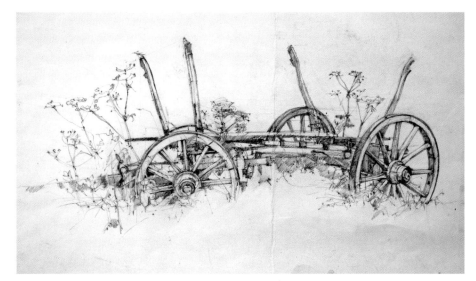

Old Cart, John Owen. The artist loved the challenge of drawing this old hand-built cart standing in a field. The main elements were positioned faintly on the paper to get the relative proportions correct, and then detail was added working across the page from left to right, using his mind's eye to compare mentally the size of each part in relation to the dimensions of the front wheel.

Good quality pencils are relatively cheap, but be sure to buy artist's quality ones, as cheaper varieties will mean that the graphite contained in the lead casing is liable to break too easily, particularly when being sharpened.

Pencils come in a variety of grades of tone. An H after a numeral indicates that the pencil is hard and therefore produces a rather grey line, whereas a B after a numeral signifies the degree of blackness. An HB pencil will give a line that is neither too grey nor too black. In the B range, the higher the number, the greater degree of blackness. In the H range, the highest numbers denote the degree of hardness, which means that a 9H pencil will produce a very light grey line. It will also go right through your paper if you press too hard! A good range of pencils to start with would be a 2H, an HB, a 2B and a 4B.

A mechanical pencil is one that can hold different grades of graphite, and because it can produce a line of a regular thickness, it is often used for drawings of a technical nature – but as with all pencils, it can perform many tasks.

A good quality, metal pencil sharpener that comes with spare blades is a good investment. The downside of a pencil sharpener is that it can only produce a point at the end of your pencil. Pencils can also be sharpened with a craft knife or scalpel to produce a chisel edge that can be used to give a greater variety of pencil marks. A 'carpenter's pencil' is flat and wide, which prevents the graphite from breaking too easily when marking wood, and also comes in a variety of grades of blackness. These pencils will have to be sharpened with a knife, and are excellent for quickly shading large areas of a drawing.

Sketchbook drawing, Otranto, Puglia, Italy; Kevin Scully. A simple HB pencil drawing, using a combination of line and shade to suggest the contrast between the crumbling walls in the foreground with the smooth stone blocks of the building in the background.

Graphite sticks have no wooden outer casing and are available in different thicknesses. The larger sizes of these can also be used to cover large areas of your paper fairly rapidly.

Water-soluble graphite pencils are a useful addition to your drawing kit, as a wash of clear water over your quick sketch or drawing will partly dissolve your lines and produce some interesting tonal variation. They can also be used to add further marks to your drawing whilst it is still wet.

There are also wax- and oil-based pencils available, which produce a very black line indeed. The disadvantage of these is that they wear down very quickly and need to be sharpened constantly – and before you know it, your six-inch long pencil will be worn down to a stub. If you like the effect that these pencils create, make sure you have more than one to hand.

Neocolour drawings on watercolour paper, Kevin Scully. Neocolours are water-soluble wax crayons available in a fairly limited range of colours, which are excellent for producing very fast tonal drawings. The colour can be diluted with a brush charged with water, and can then be pushed around the page to produce washes. These colours are perfect for producing quick compositional ideas, as well as finished paintings on a larger scale.

Charcoal

Natural charcoal made from vine or willow is ideal for covering large areas fairly rapidly, and can produce a variety of tones ranging from fairly dark to soft, light grey. It can be smudged with your finger, and areas can be lifted out to create highlights. Charcoal is fragile and not perhaps the most practical medium for drawing outside, particularly if you are using a small sketchbook. If you do choose charcoal, it's best to work on a slightly larger scale, and you will have to protect your finished drawing as it smudges very easily. You can spray it with fixative, or cover it with a protective sheet of clear glassine paper.

Charcoal pencils come in soft, medium or hard grades, and are a better alternative for working outdoors. They have

a peel-off paper coating that is removed to expose fresh charcoal as the end is worn down. The soft grade of these pencils gives a good, dense black.

Coloured Pencils

Coloured pencils come in a bewildering number of varieties. Before investing in a set of these, first buy a few that appeal to you from a range of different brands. The manufacturers will make all kinds of claims regarding their strength of pigment, their covering power, and the vastness of their colour range. The way these pencils behave varies greatly: some are hard, some are soft, and some are rather 'waxy', making it difficult to lay one colour over another. Some of them are more successful than others when blending colours together, so depending on what your requirements are, it's better to try a few different brands first. On occasions I have found that a cheap range of children's coloured pencils has been superior to some of the more reputable brands, though of course their colour range is rather limited.

Watercolour Pencils

These pencils are a convenient way of combining a coloured pencil drawing with watercolour washes, without the need for carrying a set of paints. There are several brands available, and as with ordinary coloured pencils, the manner in which they behave varies from brand to brand.

Once your sketch or drawing has been completed you can wash over areas of it with a brush loaded with clear water. An alternative to this is a 'waterbrush', a tool that has a chamber for holding water, and a flexible brush-like head that is available in a variety of shapes. The water is distributed through a non-drip valve, and the pressure applied at its tip controls the amount of water released. These brushes are convenient, easy to clean, leak-proof and ideal for working outside.

Watercolour Crayons

Just a few manufacturers produce these products, which are water-soluble, wax-like crayons. They are ideal for covering large areas quickly, but are perhaps not ideal for intricate drawing. As with watercolour pencils, you can wash over your drawing with water to produce subtle gradations of colour, and then your image can be drawn into again with the crayon whilst still damp.

Pastels

Pastels are perhaps not the first choice of medium to work with outside because of their rather fragile nature, but with a bit of care there is no reason why they can't be used. There

are basically three different types of pastel: oil pastels, soft pastels and hard pastels.

Oil pastels are less suited to small-scale work, and their colour range is often quite limited. Soft pastels, on the other hand, are available in a wide range of colours and although they are called 'soft', their degree of softness varies greatly from brand to brand. They can be bought individually or in sets, and some brands produce themed sets of landscape colours, portrait colours, greys, darks, lights and so on. Hard pastels are exactly what the name suggests, and can be sharpened with a knife to a fine point, which makes them ideal for fine detail work. These can also be bought singly or in sets.

Pastel pencils generally fall into the hard pastel category, and can be sharpened with either a knife or a pencil sharpener made specifically for that purpose.

Pens

There are countless types of pen widely available for drawing, ranging from the ubiquitous biro and fibre-tipped pens, to markers and steel pens for use with Indian ink. Very detailed, accurate drawings can be made with technical pens, and very loose, vibrant effects can be created with broad-edged markers.

There are waterproof pens that are ideal for pen and watercolour drawings, as well as water-soluble pens that can be used to create watercolour-like washes with the addition of just water.

There are permanent, spirit-based markers, water-soluble markers and watercolour markers, many of which come with dual and sometimes triple nibs. Some have a fine nib at one end and a brush-like nylon tip at the other, and many also incorporate a broad nib into the pen as well.

Calligraphic pens will create some interesting effects, and these are available with fibre-tipped or steel nibs. Steel-nibbed dip pens can be used in conjunction with a wide variety of liquid colours including watercolour, ink and acrylic ink.

The list of drawing materials is endless and is being added to constantly, so if the choice is too bewildering, perhaps it's a good idea to begin a drawing with a simple pencil.

Choosing a Painting Medium

When you first venture outside to paint, it's best to go equipped with the type of paints you are familiar with. If you have only ever painted with watercolour, it wouldn't be sensible to take a set of soft pastels with you and hope for an instant masterpiece having never used them before.

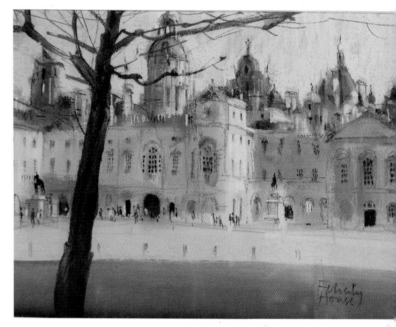

Horseguards, London, Felicity House (pastel, underpainted with watercolour). The artist chose a shady spot to stand at her easel and paint a lovely, big and familiar building lit by warm sunshine. The tiny figures in the distance add scale and colour to the composition. Buildings such as this need to be recorded accurately, no matter how loosely they are portrayed, because such a famous place must be recognizable. The contrasts in the painting work well tonally, with the light foreground and sky, the mid-tone of the building, and the dark foreground grass, whilst the really dark tree trunk painted in watercolour sets everything else further into the background, adding an element of perspective.

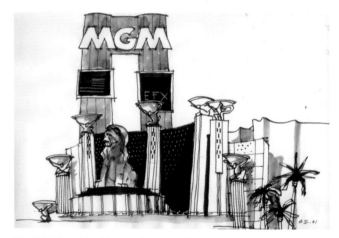

The MGM Grand, Las Vegas, Colin Moore (fountain pen, wash and white crayon in an A4 Daler Rowney sketchbook). The scale of this building has been suggested by the palm trees drawn in the bottom right-hand corner of the sketch, and the exaggerated perspective of the vertical lines of the hotel. The wording on the screens and the lights in the glass-fronted hotel rooms have been indicated in white crayon.

Grazalema, Andalucia, Spain; Kevin Scully (watercolour sketchbook). An exercise in watercolour, to demonstrate how a painting can contain both a reasonable amount of detail as well as loose, lively brushstrokes. The buildings have been drawn carefully in pencil, making sure that the perspective is correct, before painting them with a small sable brush. The rest of the image has been added with a large brush in rapid strokes to suggest the different levels on the hillside.

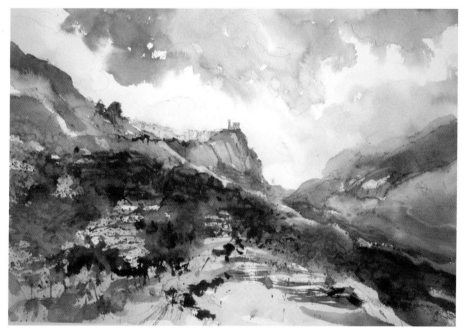

Greek Wind, John Owen (watercolour). The artist knelt on all fours to paint this in a very strong wind, with a rock at each corner of his sheet of paper to hold it to the ground as his stool literally flew away behind him. It was painted spontaneously and with gusto, and he relished the challenge. When you paint 'en plein air' you will relive the moment again every time you see your painting. This intensity of emotion can never be recalled by copying photos in a studio. Outside, nature will feed you constantly with inspiration, energy and enthusiasm.

Watercolour

Watercolour is generally the people's first choice for painting on location, mainly because of its portability. The medium certainly lends itself to quick colour sketches, and a scene can be created fairly rapidly with a few atmospheric washes with a minimum of fuss. Very little equipment is needed for watercolour painting, and as it is also lightweight, it can be carried in a small bag.

You will only need a few colours, and these can be in tubes or watercolour pans incorporated into a palette. You will also need a watercolour pad or block, a jar and a supply of water. Add a pencil and a sable or synthetic watercolour brush or two to the list, and this is basically all you need.

Even if you are a beginner, you should use 'artist's quality' paints from a reputable brand and good quality watercolour paper.

Unless you intend painting on a large scale, you can paint seated and your pad or block can be rested on your lap. For larger paintings you will need a watercolour easel that can be tilted at various angles, and if you are using sheets of paper, you will require a drawing board on to which you can fix your paper as a support.

Acrylic

Painting in acrylic requires rather more equipment than watercolour, even though it is also a water-based medium.

The tubes of paint will be larger than those of watercolour, and consequently heavier, something to be considered if you have to walk any distance.

You will have to support your painting on a sturdy easel if you are painting on canvas, canvas panels or boards of any kind. It is possible to work with acrylic on paper, but this should be attached to a board and supported on your easel.

Acrylic paint dries fairly rapidly and even more rapidly in warm weather, so if you need to slow down the drying process you will need a gel retarder, the addition of which allows the paint to remain workable over a longer period of time.

You will need a palette on to which you can mix your paint, and the ideal product is a 'stay-wet palette'. This palette has a semi-permeable working surface that is kept moist by a reservoir of damp paper below it. This allows the paint to remain moist for a considerable length of time, and a plastic lid is used to cover the palette when you have finished painting.

An alternative to this is a tear-off, waterproof palette consisting of sheets of paper that can be discarded as the acrylic paint becomes unworkable, or at the end of a painting session when the paint is no longer needed. You will also need a palette knife for mixing your paints on the palette, some water, a jar, and some rags or kitchen towel.

There are special brushes available on the market suitable for use with acrylics, as they need to be more robust than the kind of brushes for use with watercolour. There are many mediums and additives on sale that can be added to create certain effects with acrylic paint, but if you are a beginner they will add an unnecessary complication, and also mean extra kit to cart around.

Oil Paint

If you wish to paint in oil, you will need to carry more or less the same amount of equipment as you would with acrylic. The tubes of paint will be heavier than those of watercolour, and you will need a sturdy easel. You can mix your paint on a wooden or perspex palette that can be scraped clean when you have finished painting. You will need white spirit and a jar for washing out your brushes, and a painting medium such as turpentine for thinning your paint as required whilst working. Your painting medium can be contained in a metal dipper clipped to the edge of your palette.

As with acrylic, you can paint on canvas, canvas boards or panels. Hog-hair brushes are ideal for applying oil paint and are sturdy enough to cope with the more physical approach associated with painting in oil. For finer detail, smaller, synthetic brushes are ideal. A palette knife can be used to mix your colours and for cleaning your palette of unwanted paint.

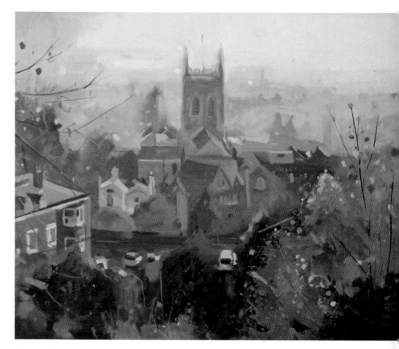

Malvern Priory, Antony Bridge (oil on canvas). Mist generates some amazing atmospheric effects, and can even make it easier to suggest distance by means of aerial perspective. The hazy, mauve colours used in the top half of the painting immediately push these elements into the distance, whilst the strong, rich colours of the foliage in the foreground tell us that this area is directly in front of us.

Oil painting is usually a messy business, so a few rags are essential. You will also require a pencil or coloured pencil to draw out your image before you commence painting.

One disadvantage of using traditional oil paint has always been the length of time it takes to dry, and consequently the risk of damaging your painting when transporting it home. But there are additives on the market that speed up the drying time and will allow the paint to be relatively touch-dry at the end of a painting session.

Quick-drying Oil Paint

One alternative to traditional oils is quick-drying alkyd oil paint, which contains an alkyd resin that speeds up the drying time considerably. This product is also thinned with white spirit or turpentine, and there is an extensive range of colours available.

Water-soluble Oils

For those who dislike the smell of oil paint, and in particular the fumes of white spirit, you might like to try water-soluble oils. These paints can be mixed with and washed out in water, so there are no toxic fumes to contend with; however, they don't have a particularly speedy drying time.

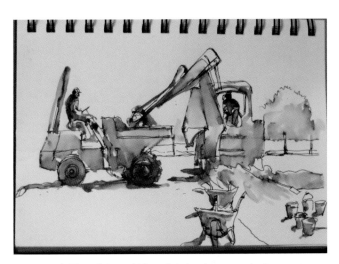

Removing the Topsoil, Jenny Halstead. A drawing created using a water-soluble pen and water-brush, which softens the line and allows the artist to create an area of tone. This meant she could work quickly as the diggers trundled back and forth, turning and moving the soil. The digger on the left in shadow is itself casting a shadow, which allows a certain amount of light to sneak through the negative area under the vehicle.

A Pyramid at Palenque, Mexico, Colin Moore (fountain pen and gouache in an A5 Moleskin sketchbook). A quick sketch drawn using the bold line produced by a fountain pen, which perfectly suits the solidity of the subject, whilst washes of varying tones describe the form of the massive structure.

Drawing and Painting Surfaces

Sketchbooks

There are many sketchbooks available on the market, and they come in a vast array of types and sizes. Choosing a sketchbook will depend on the kind of drawings you want to fill it with. Will you be working in a landscape or portrait format? If you intend focusing on landscapes you will probably opt for a sketchbook of that orientation, but if you are going to be drawing cityscapes and buildings, you might consider both formats. If you are going to be using a lot of wet media, you should buy a watercolour sketchbook.

If you are intent on using dry media with only the addition of occasional watercolour or ink, the best sketchbooks to buy are those made from good quality cartridge paper of a weight that, if necessary, will take a certain amount of liquid colour. If the paper is too thin there will be a degree of 'show-through', which means that parts of your sketches will be seen through the reverse side of the page. Even on a fairly thick paper of good quality, spirit-based markers will bleed through, so if you like to use these, then perhaps you should invest in the marker pads specifically produced for these products. These pads contain a smooth, bleed-proof, high-white paper, designed to be used on one side only.

The pages of spiral-bound sketchbooks lie flat when open, but if you are right-handed the spiral binding can be a bit of a hindrance when drawing on the left-hand page, and vice versa if you are left-handed. There are 'lie-flat' sketchbooks and watercolour books available that have the advantage of allowing you to draw or paint uninterrupted right across the two pages. These are ideal for capturing panoramic landscapes, seascapes and cityscapes.

Taking this concept a stage further, there are concertina-style sketchbooks that open out to give you even greater panoramic possibilities.

You may wish to use sketchbooks that have perforated pages so that you can tear them out, but this paper sometimes tends to be of an inferior quality.

Size is also something to be considered. You might just need a small sketchbook that will fit into a jacket pocket or handbag, but if you tend to draw in a more uninhibited style you might find its scale restricting; however, an over-large sketchbook can sometimes be rather unmanageable when balanced on your lap.

Sketchbooks come with a variety of covers, ranging from hardback with superior binding to soft, flexible plastic. The stiff, durable covers are more protective of your sketches, but the flexible ones will slip more easily into a pocket. The softback variety can be a bit on the slippery side, and the ones with a plastic cover even more so.

Think also about the colour of the paper inside the sketchbook. Moleskine is a company that produces a sketchbook with cream paper: this is a well made book with a durable hard-back cover with rounded edges, and an elasticated band that holds the pages open.

The weight and type of paper inside the book is important, and again choose one that will be appropriate for the kind of sketches you will be making. If you are determined to tackle

Kerala, India; Kevin Scully. It's an interesting exercise to make a drawing using two different types of pencil. In this sketch both a 3H and a 2B pencil have been used; alternating between the two when drawing the coconut palms creates a sense of movement as well as suggesting the weight of the fronds. The reflections have been hinted at by rendering the water with both vertical and horizontal pencil marks. The light-coloured washing hanging on the line has been indicated by making the area behind it dark.

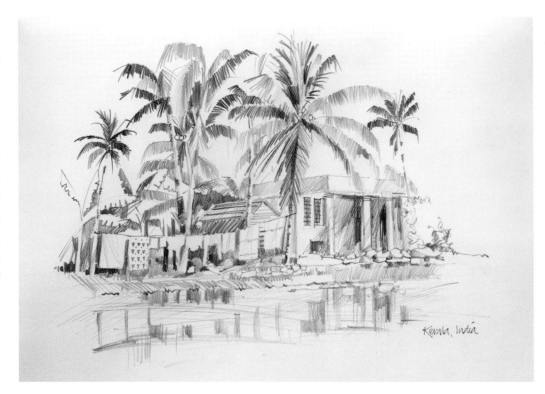

intricate detail with an ultra-fine technical pen, a wise choice would be a sketchbook whose paper has a surface that is fairly smooth. If your drawings employ a more vigorous approach, buy a sketchbook with a slightly rougher finish and of a reasonably heavy weight.

If you are someone who uses a lot of watercolour, then you will need a proper watercolour sketchbook. Most of these will be described as either 'Not' or 'Rough', the former having a less textured surface than the latter. Although in theory there is a right and wrong side to the paper, you can normally use either side as there is little difference in the finish. These papers usually come in a fairly heavyweight 200 or 300gsm, which is robust enough to prevent them from buckling when wet. These can be expensive, but are well worth the outlay.

There are also some beautiful hard-backed sketchbooks that contain handmade Indian papers made from natural fibres. The subtle colour of these pages may vary throughout the book and can add an exciting new dimension to your work.

Like most artists you will be tempted by all these wonderful books, just waiting to be filled with fantastic sketches, and no doubt you will soon have quite a collection. Some of them are beautifully made and costly, and sometimes almost too good to use!

TAKING THE PLUNGE

You have just bought an expensive, beautiful new sketchbook, and are terrified at the thought of messing up the first pristine page. It can sometimes be a struggle to take the plunge when committing pencil or paint to paper on that first virginal page. But remember, it's only a sketchbook and is just a vehicle for your personal thoughts and experiences at a particular time and in a particular place.

But if you intend to fill your sketchbooks with highly finished works for others to see and admire, and are worried about getting off to a bad start, here is a suggestion. Instead of starting work on the first page, use this page as an introduction to the sketchbook by writing a few words about the location, including the date. You could even start by pasting something on to the first page: a pressed flower, a train ticket, or something else relevant to your first piece of work. This will ease you slowly into your sketchbook without having to be confronted with the first empty page.

An alternative approach is not to start on the first page at all, but begin by working in the middle of the book, and a few other pages throughout it, so that you gently slide yourself into it. Failing that, just take the bull by the horns and go for it: after all, it's only a sketchbook!

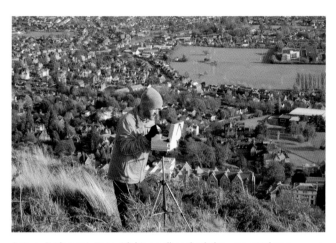

Antony Bridge painting with his small pochade box mounted on a tripod. To combat the cool and windy weather he is wearing adequate warm clothing, together with a pair of fingerless gloves, which will help to prevent his hands from becoming too cold.

Paper

If you want to draw on paper that's larger in size than the standard sketchbooks, you will need to fix it to a drawing board. Special drawing-board clips or 'bulldog' clips are excellent for this. As you will probably be carrying it around, choose a board that is light in weight and one that won't warp in extremes of weather. It should also have a smooth surface, as any texture will affect the marks you make on the paper.

The type and weight of your paper will depend on the kind of materials you use. If you are drawing, use good quality cartridge paper. If you are working in watercolour, you will need to stretch the lighter papers using gumstrip, but if you are using heavier papers, masking tape or clips will be adequate in securing them to your board.

For oils or acrylics there are special papers available that are ready primed for painting so they are non-absorbent.

Painting Boards

With oils or acrylic, you can work on purpose-made canvas boards. These are usually made from compressed cardboard or thin MDF that has been covered in a canvas material and primed. Choose one with a fine grain, particularly if you are using small sizes, as the boards with a coarser grain may give your painting an unwanted, dominant texture. This is especially true if you like to use the paint rather thinly. An alternative to this is to make your own painting boards from 3mm MDF: these can be painted with two or three coats of acrylic gesso, each lightly rubbed down with sandpaper. The reason for this is to stop your boards from being too absorbent. If you like to have a certain amount of texture to your paintings, the brushstrokes can be left to create a slightly rough surface. It's a good idea to give the back of your MDF board a coat of gesso too, as this will help in preventing it from warping.

There are many other lightweight boards on the market now and these are too numerous to list, so it really comes down to preference of surface. As with all art materials, you will need to experiment with different products until you find those that suit your way of working.

Canvas

There is no reason why you can't use ready-stretched canvases for painting outdoors. Their main drawback is that although they are certainly light in weight, they are more bulky and fragile than painting boards, and so care must be taken when transporting them back home. They are also prone to taking off even in a light wind, so must be firmly secured to your easel.

General Equipment

You will need a bag of some kind in which to carry your equipment. If you're not going too far and you don't intend carrying much equipment, a simple holdall bag will suffice. If you intend walking any distance, particularly over rough ground, a backpack is the best choice as it will leave your hands free and make progress a lot easier. Some backpacks have a seat incorporated into their design, and this is an excellent addition.

If you're quite happy sitting on a bench, wall or rock you won't need a seat, but if you are attempting work on a larger scale or on a drawing or painting that is going to be take some time to complete, you will need to make yourself comfortable. There are many lightweight fold-up seats available, from a simple camping or fishing stool to a sturdier picnic chair. I find that a folding chair with no armrests is the ideal seat from which to paint, as armrests can be an irritation when trying to reach for materials on one side or the other.

Whether you like to sit or stand when painting, you will perhaps have to consider using an easel of some kind. Again, there are many available to choose from. Tripod easels are often lightweight and will fold up to a fairly compact size, but they can also be rather flimsy and awkward to erect. You'll see many a painter scratching their head whilst trying to figure out which way round they're supposed to go. If you have one, or are thinking of using one outside, one way of making sure it doesn't take off in the first gust of wind is to suspend a heavy weight, such as a rock or brick, from its centre.

French easels are a much sturdier affair altogether, and incorporate a box for storing your paints, brushes and palette and other essential paraphernalia. They can accommodate fairly large boards or canvases, and fold up into a box shape with a carrying handle for transportation. Their drawback is that they are fairly heavy to carry and can be quite tricky to set up.

Many painters working outside now favour pochade boxes or panel holders. Panel holders can be attached to a sturdy camera tripod with a ball head that connects to a plate on the underside of the box. Setting them up is a quick and easy task, and there are many accessories available for storing paints, mediums, brushes and finished paintings. Some hold painting panels by means of a series of magnetic clips, and some use a system of springs. They can hold panels and canvases of a reasonable width and an even greater height. They are not cheap, but depending on the make they are well constructed from quality materials, and will last a lifetime.

Modern pochade boxes are based on a traditional design, the most basic being a simple box that will hold paints and brushes, with a slide-out palette and a lid with slots for storing two or three canvas boards. They are small and light enough to be used on a lap if necessary. These boxes can also be modified so they can be attached to a camera tripod. In their simplest form the size of the panels is limited to the size of the box, which isn't the case of the panel holders, as the panel or canvas sits on top of the holder's surface and can be larger than the size of the panel holder itself. Much more elaborate (and expensive) pochade boxes are also available in larger sizes.

If you are painting in a water-based medium you will obviously need a container of water, and also one for holding clean water whilst painting, and some kitchen towel for cleaning up. If working in oils, you'll need a screw-top container of white spirit for cleaning your brushes, and dippers for your painting medium. Kitchen towel or rags are essential, and a plastic bag for storing dirty or used items.

Preparing for the Unexpected

If you're working in a climate that can be changeable, you'll need to be forearmed with a 'Plan B'. An umbrella is a useful addition to your equipment, not only for keeping the rain off but also for keeping the sun off your work. If possible choose a white, purpose-made one that can be clamped to your easel and tilted at an angle to keep your working surface dry or in shade, whatever the position of the sun or direction of the rain. A coloured umbrella will cast a tint of its colour over your work and make it difficult for you to judge and match colours.

Include some extra clothing in your bag in case it should become cold or wet, and a hat and suntan lotion if you are working outside on a hot and sunny day. Insects can be a problem, so if they particularly like you, an insecticide spray will keep them at bay.

Take a camera with you, because although your photographs may not capture the true colours and spirit of your chosen subject matter, they may be useful for filling in any detail that you haven't had time to include. I have often had to abandon a half-completed drawing or painting because a lorry or bus has parked immediately in front of me, so it's a good idea to take a few photographs even before you start work.

When painting outside on a bright sunny day, the shadows cast by the sun will alter considerably during the space of a few hours, and this is even more the case when painting early in the morning or late in the afternoon. This means you will have to work quickly, and be prepared to stick with your original placement of shadows and highlights. If you keep changing them as the day wears on, you will be making alterations forever. The alternative is to paint in all the areas in their basic local colours, and then when you feel the painting is nearing completion, add them right at the end.

If you're going to be working in a busy place, a street market or in an urban environment, you'll have to be prepared for a bit of compromise when choosing your spot. Shopkeepers or stallholders won't appreciate you getting in the way of their customers, and a large easel erected on the pavement of a busy narrow street will most certainly be an irritation to some pedestrians, particularly if you leave your equipment spread all over the place.

You must use your common sense in these matters, so if the ideal vantage point happens to be from a traffic island in the middle of the road, then choose a spot elsewhere, even though it may be less than perfect. When possible, position yourself out of the way in an unobtrusive place where you won't be in anyone's way.

Getting Started

Before you set off to draw or paint it may be wise to check the weather forecast; there's no point dressing in shorts and a T shirt if rain or cold weather is predicted. If you are only going to be drawing, you won't really need to worry about what time of day you'll be out and about. But if you're inexperienced and are going to be painting in sunshine, it may be wise to choose the middle part of the day, providing it's not too hot, as the shadows won't change as dramatically then as they would in the morning or late afternoon.

If you have never painted outside before, an overcast day might be a better choice as a starting point, and although the scene might not be as interesting as one where the sunlight casts dramatic shadows, you won't have to worry about them changing during your painting session. The light and the fairly flat tonal contrast will remain constant over a longer time period and will give you a chance to depict them more accurately.

If you are really keen to paint the early morning light or the lengthening shadows of dusk, you will have to practise working at speed because the colours will change all too quickly. Depending on your location and climate, you may be lucky enough to find the same weather conditions at the same spot at the same time over a period of two or three days, which will allow you to capture the essence of the scene. If you choose to do this you'll have to set yourself a time limit for painting, so that you won't be tempted into constantly adjusting your painting as the lighting conditions inevitably change.

If you are painting for the pure enjoyment of it, there is no necessity to set yourself a time limit, unless you are trying to capture fleeting lighting conditions in a landscape or a brief gesture in a portrait. Everyone is comfortable working at his or her own pace, and art shouldn't be a race. Just because someone has captured the essence of a scene at breakneck speed, it can still be a less than successful painting. Consider what you want to achieve. If your painting has suffered from some too hasty or careless brushstrokes whilst painting on location, there is nothing wrong with tidying them up back at the studio. Many painters in the past who extolled the virtues of painting in the open air were not averse to finishing them up back at HQ. When questioned on this subject, Monet was very noncommittal as to whether or not his paintings had been completed entirely 'en plein air'. In fact there is evidence that some of them were fiddled with a long time after they were originally painted. So if Monet and some of his contemporaries were not averse to touching up their work a little when back at home after a day's painting in the field, then neither should you be.

Gwalior Fort, India, Felicity House (pastel, underpainted in watercolour).

Evening Harbour, Kevin Scully (oil on board). This was painted rapidly to capture the very last rays of light as the sun was disappearing, with the hill and houses already in darkness. Speed is of the essence when painting at this time of day, and hopefully what this picture lacks in detail is compensated for by the sense of atmosphere captured in its execution.

Preparing Your Paper, Board or Canvas

If you intend to paint in watercolour and choose a lightweight paper, you will need to have stretched it on to your drawing board the night before and let it dry naturally. If you are going to be using oils or acrylics, again prepare your painting surface the night before, whether it's board, canvas or paper. If you're not entirely sure what your subject matter is going to be, it's probably best to tone your board or canvas in a fairly neutral colour, thus eliminating the stark white.

If your preferred medium is pastel, choose a similarly understated colour paper as a base. It's a good idea to have a few of these in reserve so that when you're inspired to set out on a painting session on the spur of the moment, you'll be ready for action. The same goes for your other painting materials, so have them all ready well in advance.

Working at Different Times of the Day and in Different Seasons

Painting in different seasons will mean that different challenges will present themselves, and you'll probably need to alter your colour palette accordingly. Snow in winter will require an entirely different set of colours to those you will need on a bright autumn day in October. Even painting snow on a grey and dark January evening will involve the use of certain colours that will be absent from an early morning snowy and sunlit landscape. Although it may be more agreeable painting outside on a mild summer's day, there is much to be gained by braving the elements, even if it means a few raindrops on your work or cold fingers and toes.

An interesting exercise is to paint the same scene at different times of the day and at different times of the year. You may also consider painting the same scene in different mediums. As well as familiarizing yourself with a particular location, you will be able to note how changing light and weather conditions alter the appearance and colour of objects. You may not want to do this too often as it could become rather tedious and repetitive, so changing your viewpoint at some stage will keep your interest alive. At some stage it will be time to move on and seek out new inspiration.

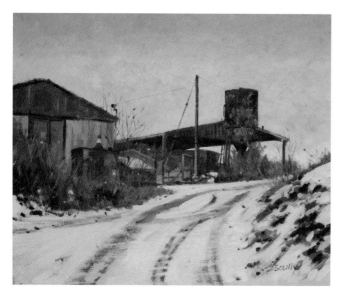

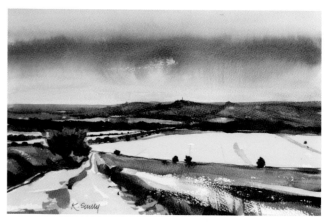

The Ridgeway 1, Kevin Scully (watercolour).

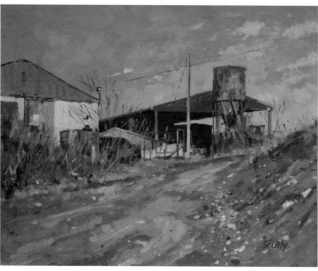

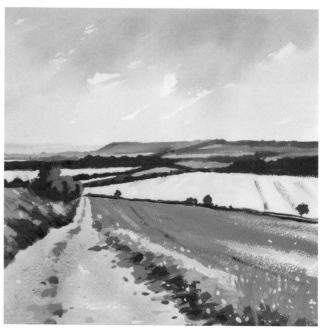

The Grain Silo, Kevin Scully (oil on board). Two images painted from the same spot at different seasons. The winter scene depicts that strange colour sometimes present when it is just about to snow again on a dark and dull afternoon. The board was toned with a wash of thin Raw Umber, which replicated the dirty, muddy farm track beneath the snow. The painting produced in summer was first toned with a wash of Burnt Sienna to establish a harmony within the warmer colour range.

The Ridgeway 2, Kevin Scully (gouache on watercolour paper).

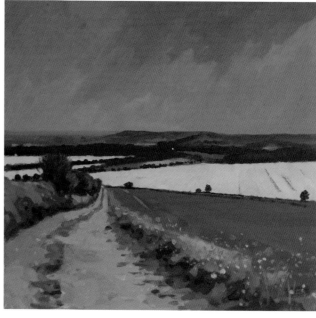

The Ridgeway 3, Kevin Scully (oil on board). Three paintings of the same scene in different mediums; the final one in oil was painted in the studio. The attraction was the brilliant yellow of the rape fields, which contrasts beautifully with the predominant greens and blues. When working away from a scene that you know well and have drawn and painted a few times, it gives you the opportunity to experiment with different colours for a less realistic look to a painting. In the oil painting, the winding track and the mauve in the distant hills creates a sense of distance, and the green and blue-mauve colour that has been taken up into the sky hints at a change in the weather.

Pastel over Watercolour

After the long, often grey days of winter, the welcome arrival of spring is an excellent time to head out into the open looking for suitable inspiration for painting. The light is vibrant and the air is clear, and the sun rises higher in the sky. The new greens are fresh, and the yellow and white flowers herald a new, optimistic season.

Although soft pastels may not be the first choice of medium for artists when painting outside, they do have a degree of immediacy when speed may be an issue in fast-changing lighting conditions. Within a few hours the shifting light can alter a scene quite dramatically, and this is even more evident when attempting to capture the drama of an early morning sunrise or the lengthening shadows of dusk.

Even with a limited number of colours, the essence of an image can be captured fairly swiftly in pastel, if detail isn't

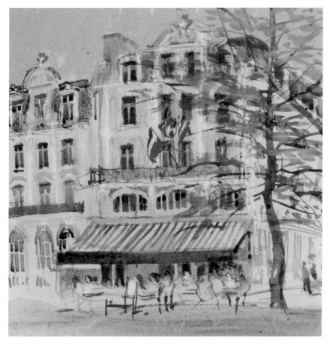

St Malo, Felicity House (watercolour and pastel on Colourfix card). Arriving in St Malo on the early morning ferry from Portsmouth, the artist ate a wake-up breakfast and was then ready to paint something close by. On this relaxed morning she set herself up in the central square opposite some early morning French coffee-goers outside this café. The colourful French flags and the complex building always hold an appeal. The support used was a square off-cut of pale yellow Colourfix card, and the majority of the painting was in watercolour, with only the minimal amount of pastel added. The flat blue sky and other touches of pastel provide impact, with some strong, bold colour. The figures are only just indicated, and the awning and tree establish a good structural foil and dimension to the whole scene.

going to be the prime objective of your painting. With a little planning, the process can be speeded up even further by initially blocking in areas of your pastel paper or card with thin washes of watercolour or acrylic paint. If you like to use pastel paper, you will need to stretch it first, as you would watercolour paper. However, as pastel paper is rather thin and lightweight and not really intended for use with water-based paints, you will only need to dampen it slightly before sticking it to your drawing board with Gumstrip. If you wet it too much there is a risk that it will tear as it becomes taut in the drying process. Pastel card can simply be held in place on your drawing board with masking tape.

As with most mediums other than watercolour, it is preferable to start with a tinted colour as a ground, rather than white. If this colour is a mid-tone it will help you determine more easily the different tonal values in your painting as you apply them. Starting with a fairly warm colour as your ground, and then applying pastels of a primarily cooler hue, you can create some scintillating effects. This is also true when you begin with a cool ground and paint your picture in a warmer range of colours.

For this painting in the following demonstration, a colour was chosen from a selection of pastel papers, ready stretched on to MDF boards and so ready to use. With pastel, working at a size smaller than half a sheet can be rather restricting, although this is often cut down on one side to create a format that is marginally squarer than the standard proportions. It may also get cropped slightly back at the studio.

Having decided on the composition, the image was first drawn in using Conte. If the subject is a landscape this is completed in a few minutes, but if something more complex has been chosen, such as buildings or boats, more care should be taken, as these shapes are more difficult to adjust if not drawn accurately. It's a lot easier to move a field or a hill than it is to correct a Gothic cathedral if you find you've drawn it too large or in the wrong place.

For the next stage, simple washes of watercolour were applied over the main shapes. This provided an immediate alternative hue to the ground colour without actually obliterating it. The underlying ground colour will still show through and help to unify the whole painting. No attempt has been made to match the colours of the subject exactly in watercolour; in fact it's far better not to, the theory being that once you start to apply pastel there is an immediate juxtaposition of colour which adds a lively appearance to an area, and subsequent small touches of colour add further to this sensation.

Providing you don't saturate the paper or card with paint, it will dry fairly quickly, except of course if the weather is cold and damp. In these conditions acrylic will dry more quickly than watercolour. If the weather is sunny, you can lay your board horizontally so that the heat of the sun will speed up the drying process.

Once dry, the pastel was applied in light, broad strokes over the main areas, suggesting the local colours without worrying too much about accuracy. It's important at this stage not to fill in too much of the surface of your paper or card with pastel, as this can make further applications of colour rather difficult. When painting outside, the sky is usually the area that's approached first: setting the tonal value here helps you to assess how light or dark to make the other larger areas of colour. Even when choosing not to use realistic colours, getting the actual tone right is important. For instance, if mauve is used in the sky and turquoise for distant hills, then it's important to make the mauve lighter in tone than the turquoise. Determining tonal values can be simplified by squinting at the scene in front of you, which reduces the tonal range to a minimum. If some areas appear the same tonally, they can be separated by using different colours, whilst still retaining the same tonal value.

A very basic palette of watercolours was used for the underpainting, including Ultramarine, Cerulean, Cobalt Blue, Cadmium Red, Cadmium Yellow Light and Burnt Sienna. Deciding which pastel colours to take out depends on the time of year and sometimes the weather. Here they were chosen from a selection from different manufacturers including Unison, Jackson's, Sennelier and Schmincke. In spring a selection of blues and greens, violets, mauves and various subtle 'in between' colours will be chosen, as well as a variety of paler yellows, creams and pinks.

The palette in winter will be different and will certainly include some greys and browns. In summer and autumn colours that are warmer and richer in hue will be chosen. Even if you have a thousand pastels with you, you may never find the right one, but by overlaying colours and placing them side by side you can achieve an effect that is just as good as, if not better than having exactly the right colour.

DECIDING ON A FORMAT

If your sketchbook is large enough, use some low-tack masking tape to divide the page into boxes of various shapes. Create a landscape rectangle, a portrait rectangle, a square and an extended landscape format rectangle. If necessary use another page of your sketchbook and create some more, this time changing the width-to-height ratio of your boxes.

When using pastel paper, the smooth side of Canson Mi-teintes paper is used, in preference to the rather mechanical texture of the reverse side. A stock of this is stored in a variety of colours, as well as a supply of Clairefontaine Pastelmat Card.

As the painting progresses, the colour is applied using a variety of strokes; some are light and hatched diagonally or horizontally, whilst others are heavy and applied with more vigour. Occasionally parts of the picture will be rubbed with a finger if it is felt that the painting is becoming too fiddly, or if it calls for a hazy effect to be introduced, although I try not to overdo this as it can make the picture look rather weak. Generally, a combination of varying pastel strokes works well and produces a lively and interesting picture. Interest is added by keeping some areas of the painting fairly obscure, whilst other areas have a little more detail. The intention is to allow the eye of the viewer to travel around the picture and complete it for himself.

If the light begins to change dramatically, it's best to stop painting, as you will be forever altering the colours that you have already put down. You can either return to the location on another day when the light is similar to complete the picture, or sometimes by looking at what you have painted a day or two later, a few marks here and there will be sufficient to satisfy yourself that you have created what you set out to achieve when you first put pastel to paper (or card).

Dunworth Farm, Spring, Kevin Scully (pastel over watercolour on cream pastel paper).

STAGE 1

The pastel paper had been stretched in the usual way and left to dry. The main areas of the grass verges have been indicated very loosely in black conte, whilst the farm buildings have been drawn with a little more care. A mixture of burnt sienna and Winsor violet has been washed over the sky and path, which were fairly similar in tone. The mass of green has been painted with a mixture of cobalt blue and raw sienna. Having resisted the temptation to get carried away and produce a watercolour painting as such, the washes were kept as loose and as simple as possible.

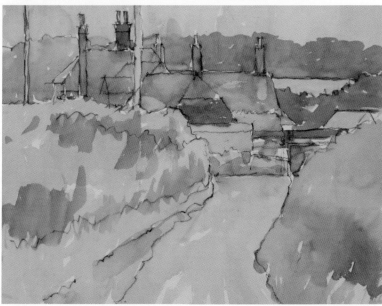

STAGE 2

For the darker foliage in the distance, a little Hooker's green has been added to the cobalt blue and raw sienna mix. The buildings and wall were painted with burnt sienna and ultramarine, and a few areas of grass were indicated with a darker version of the original colour. The whole process so far was completed in about fifteen minutes. The time it took for the paper to dry was spent organizing the pastels that were going to be used for the painting. It was estimated that the painting would take about two hours to complete from this point, and as it was the middle of the day, the light wasn't going to alter too much. There was some sun but not enough to create too many shadows, so the painting could be done at a fairly leisurely pace.

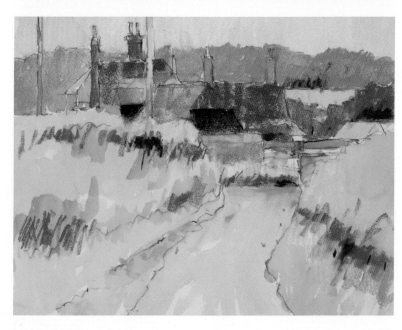

STAGE 3

Most of the initial marks are made with the pastel dragged lightly and sideways on. After some pale blue was dragged over the sky, other colours were distributed in their various positions all over the page without trying to finish any part of the picture until the very last stage. On the distant trees, tentative hatching marks have been added to assess the effect that these colours will have on top of the watercolour wash. By keeping the whole painting moving at an even pace everything remains unified and adaptable.

STAGE 4
At this stage more detail has been added, whilst still conscious of keeping everything as loose as possible. Several colours were applied in small marks, side by side. Touches of mauve and pink were introduced into the sky and the path. Stepping back from the painting it was noticeable that the prevalent colour, green, was in danger of becoming a bit too overpowering, so this was counteracted by adding touches of blue and yellow. The buildings had also become rather too dominant and needed to be softened in some way.

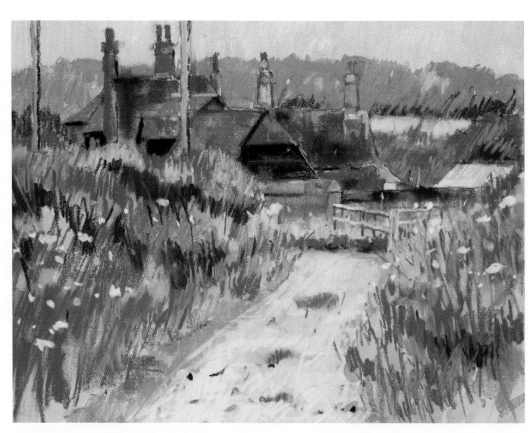

STAGE 5
There was a sense that the painting was becoming a touch too literal, so some of the edges where the different elements met were treated to a bit of 'roughening up' to give the picture a more painterly feel. This was achieved by blending some of the adjacent colours together with a finger, and also carefully dragging these colours over each other with the broad side of the pastel. Little flicks of colour were introduced here and there to instill some movement into the painting.

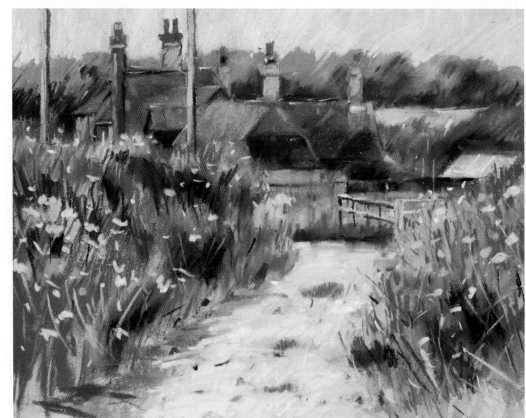

Marigot, Saint Martin

Different Mediums and Materials

The Sketchbook

The sketchbook is many things, and there are various ways in which you can use it. It is essentially a personal possession that isn't necessarily meant for anyone's eyes but your own, but this doesn't mean that it can't be shared. It can be a collection of intimate experiences, a graphic *aide de memoire*, a collection of ideas and experiments, some successful and some not, and it can also be a visual language of self-expression.

Your sketchbook may contain drawings, paintings, mementos, doodles and notes. It will include successes and failures both finished and incomplete, detailed drawings and quick sketches, but they will all be responses to how you perceive the world around you. You may only use your sketchbook for hurried scribbles, or you may be the kind of person who likes to keep an orderly record of neat drawings and paintings. How you use it is up to you, and there is no right or wrong way to fill it.

A large number of sketchbooks have been accumulated over the years, and some of them are showing their battle scars from trips around the world. A bulldog clip is useful for holding pages open, when sometimes even the lightest breeze can lift them up when drawing or painting.

Marigot, St Martin, Kevin Scully (fibre-tipped black fineliner, Pentel Sign Pen, HB and 6B pencils on Bristol board). A brief but substantial shower of rain had made the streets of this Caribbean town awash with water, before the sun came out and dried everything up in no time. Some areas in this sketch have been left untouched to emphasize the main features in the drawing. Being right-handed, drawing the curves in this street would have been difficult had the sketchbook not been turned about 30 degrees anti-clockwise to do so. The curved overhead cables were drawn with the paper upside down. All the curves were drawn with the aid of a flexible plastic ruler held on edge.

Pages from a Moroccan sketchbook; Kevin Scully. Sometimes even the simplest of subjects can be the source of interesting material to draw. A window, a tree or a piece of ornate detailing on a building can be a sheer pleasure to draw, with no thought given to producing a finished drawing or painting. Drawings such as these bring back more memories of this painting trip to Morocco than a hundred digital photos ever could.

Sketchbook from Portugal; Kevin Scully. Having produced the watercolour sketch on the right-hand page, a thought occurred that perhaps it might make an interesting finished painting in a slightly more abstract style. So on the left-hand page some strips of masking tape were applied to create a hard-edged border, and a slightly different composition was tried, again in watercolour. Some wax crayons were then rubbed over the watercolour in an attempt to simulate the kind of finish envisaged for a painting to be produced at a later date. That was fifteen years ago, and it still hasn't been painted. Sometimes experiments just remain as experiments!

Paints

Choose the best paints you can afford: these will normally be described as 'artist's quality'. There are many good brand names readily available, including Winsor & Newton, Maimeri, White Knights, Daniel Smith, Daler Rowney, M. Graham, Sennelier and Schmincke. Try and avoid 'student's quality' colours as these contain less pigment and are inferior in quality, and you will probably be disappointed with the results. Which particular colours to buy is a matter of personal choice, and over a period of time you will discover how they behave in different ways, which are more useful than others, and simply which ones you like best.

Watercolour Paints

Watercolours are normally the first medium that people think of when painting outside, but to the inexperienced painter they can be rather difficult to use successfully. A certain amount of careful thought and preparation when choosing your equipment will mean you have a better chance of success. Most artists will agree that watercolour is probably the most difficult medium to use well, but when mastered, the results can be wonderful. It is certainly the most portable of the traditional painting mediums, and you only need the minimum of equipment to take on a painting trip.

My basic watercolour kit consists of Lemon Yellow, Cadmium Yellow, Cadmium Red, Alizarin Crimson, Winsor Violet, Ultramarine, Cobalt Blue, Cerulean Blue, Hooker's

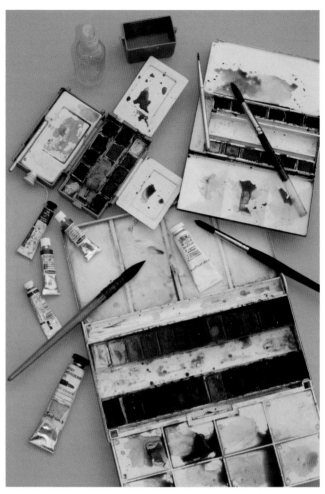

A selection of watercolour sets, including a tiny, compact, fold-up plastic set which can accommodate about twelve pans of watercolour as well as a water container that doubles as a palette, a miniature brush, and a lid that holds it all together, which can also hold water for mixing the paint. The small enamelled set at the top right has a ring underneath so that the box can be held by the thumb whilst painting. The large plastic set is one of a range made by White Knights which is available in a variety of sizes to accommodate a different number of pans. The image also shows a variety of colours in tubes, together with some very useful white gouache. At the top of the image is a small spray diffuser, used for re-wetting a painting when necessary.

Green, Perylene Green, Raw Sienna, Burnt Sienna, Raw Umber, Burnt Umber and Indigo. I don't use all of these all the time, but I find they cover almost every eventuality. There are other colours that I have accumulated over the years for specific commissions, but these are rarely used.

Most 'artist's quality' paints are sold in either tubes or pans of solid colour. As the best quality watercolours are rather expensive, the smaller tubes are adequate for most tasks. Although perhaps more convenient because they fit into watercolour boxes that normally include an area for mixing your colours, pans are less useful if you are working on a larger scale. However, they are perfectly suitable for smaller work.

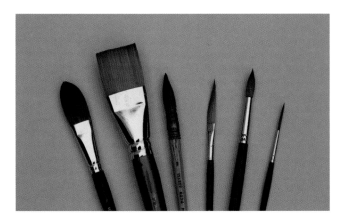

A useful range of watercolour brushes: from left to right – a squirrel-hair wash brush, a 1in flat wash brush, a Kazan squirrel mop brush, a swordliner, a Kolinsky sable and a Kolinsky sable rigger.

If you are just starting out with watercolour, it's a good idea to begin with a basic set of five or six 'artist's quality' colours from one of the previously mentioned manufacturers. There is no need to buy white watercolour, usually referred to as Chinese White, as it has no relevance in the use of watercolour painting. The real beauty of watercolour is its transparency, and this is put to good effect by painting on white paper, with any areas of white being created by simply leaving the white paper unpainted. A useful range of colours to begin with would be Lemon Yellow or Cadmium Yellow Light, Cadmium Red, Alizarin Crimson, Cobalt Blue, Raw Sienna and Burnt Umber. A fairly extensive number of greens, browns, greys and many neutral colours can be made from just a few colours. With more experience you will find you need other colours, and these will be a matter of personal preference and necessity.

Brushes for Watercolour

The finest watercolour brushes are made from sable hair. Usually described as Kolinsky sable, the hair is actually the winter fur from the tip of the tail of the Siberian weasel. These brushes hold a lot of colour, are springy, and readily form a fine point when required. They slide across watercolour paper unlike any other products and are a joy to use. They are also expensive, but the initial cost is undoubtedly outweighed by their effectiveness and life expectancy.

There are, however, alternatives that won't be too costly. You could perhaps use synthetic brushes, or brushes that are a mixture of both synthetic and natural hair. To begin with you will only need perhaps three or four brushes plus one large brush for creating washes. A useful set could include sizes 2, 5, 8 and 12, plus a 1in flat brush for covering large

areas quickly. These sizes are only a general guide, and sizes may vary between different manufacturers.

Over a period of time you may want to add to your brush collection, and there are a huge number of different types to choose from. An art supplier's catalogue will include pointed ones, square ones, round ones, mops, riggers, swordliners, stipplers, plus retractable and travel brushes. There are many more, but most of them are unnecessary to begin with, and the more you have, the more confused you will become. As you become more experienced there may be a call for the occasional specialist brush, but mastering the simple watercolour brush is the first challenge.

If you want to travel really light and only want to produce small pictures, a good quality retractable or travel brush will fit comfortably into a pocket or bag with your travelling paintbox.

Watercolour Paper

The range of watercolour paper is extensive and when choosing one that is suitable for your needs, there are some things you will need to take into consideration. Firstly, always buy the best quality papers available within your budget. Saunders Waterford, Arches, Fabriano and Bockingford all produce excellent papers as well as pads and blocks. Watercolour papers are generally graded in three or four different types of surface. If you like to produce small, intricate sketches and paintings, an HP (Hot pressed) paper will probably be the one to go for. This has a fairly smooth surface and is ideal for careful, detailed work. If you prefer to work a little larger and like texture to be visible in your paintings, then Rough is ideal. A good paper for general use is Not (Not HP), which has a surface somewhere between smooth and coarse. Some manufacturers also produce an Extra Rough paper, whose surface is self-explanatory.

Watercolour paper is available in a rather confusing assortment of weights, which basically equates to the thickness of the paper, and is specified in either grams per square metre (gsm) or pounds per ream, and occasionally both. All you need to remember is the higher the number, the thicker the paper: 300lb (600gsm) is generally the heaviest you will find, and 60lb (120gsm) the lightest. Any paper less than 140lb (280gsm) is likely to buckle when a liberal wash is applied, so it should really be stretched on to a drawing board before painting. You can paint on 300lb board-like paper without fear of it stretching, but it comes at a cost.

It is possible to buy tinted watercolour paper, which is available in a few subtle shades of cream, beige, grey and grey-blue. There are also some brands that now include a 'high

white' paper in their range, which will give an extra degree of luminosity to your paintings. There are many different papers available for many different applications, so experiment with some of them until you find one or two that suit your needs. It also makes economic sense to buy large sheets of watercolour paper and then cut them down to your preferred size.

Watercolour Pads and Blocks

The most convenient surfaces for painting on outdoors are watercolour pads or blocks. If you want to keep your paintings together or as a memento or travel journal, there are also some beautiful, bound watercolour books available in a range of different sizes and weights of paper. For a paper that doesn't buckle, it would be wise to go for one of at least 140lb in weight.

There are pads that have one gummed edge, which makes it easy for you to remove the sheet once your painting is finished, and there are spiral-bound pads which also allow you to tear off individual sheets. Watercolour blocks are glued on three edges, and partly on the fourth. This prevents buckling of the paper to a great extent, depending on the weight of the paper, as the gummed edges perform a similar task to that of stretching paper on a drawing board. There is a non-glued section at the bottom of the block that allows you to slide a craft knife or scalpel under the top sheet, and then all the way round the gummed edges to release your painting. However, because this part of the paper isn't glued, painting with a very wet wash may cause the sheet to buckle a little at the bottom.

Because these blocks contain several sheets of paper, they are raised, and there is a tendency for pools of colour to form along the edge of the sheet where a brush loaded with paint deposits it, as the hairs of the brush bend as they go over the rim of the block or pad. This isn't really an issue if you intend to produce just small paintings or sketches. This pooling of colour doesn't happen when using paper attached to a board, because the paint can be taken straight over the edge of the paper and on to the board, which is at the same level.

Boards for Watercolour

The size of your board will obviously be dependent on the size of paper you choose to work on. There are proprietary wooden boards and boards made from melamine that you can buy from art shops, but a simple drawing board can be cut to size from a sheet of 5mm MDF or plywood. An agreeable size would be roughly 14 × 18in. The disadvantage of melamine is that some tapes, and in particular Gumstrip, don't readily adhere to it. Neither can you stick drawing pins into it. On your homemade board, the edges can be sanded down and the sharp corners rounded off with sandpaper or an electric sander. The advantages of MDF or plywood are that they are both cheap, fairly light in weight, and all types of tape will stick to them.

When attaching watercolour paper to a board there are a few alternatives from which to choose. If the paper is lightweight, you will need to stretch it so that it doesn't buckle. If you use masking tape, this will probably become detached from the board when wet, especially if you are using a lot of water in your colour mixes. If you are painting on a heavier paper you can simply attach it with bulldog clips, drawing board clips or drawing pins. Some papers are so heavy that it's a bit like painting on board, so you don't have to worry at all about it buckling. Needless to say, these heavyweight papers are expensive, but a delight to paint on.

Masking tape can be used to create a white border for your paintings by sticking a strip round all the edges of your paper; however, if you use too much water, there is a tendency for the paint to creep under the tape. Also, unless you use good quality or low-tack masking tape, there is a risk that it will tear your paper when you remove it, particularly if it is left in place for any length of time.

Easels for Watercolour

Some people are quite happy to just sit and paint in a watercolour sketchbook, or on paper attached to a small board on their lap. But if you like to stand when painting, or are painting on a larger scale, you will need an easel. There are easels that are specially designed for the watercolour artist which are relatively light in weight and can be tilted from an upright to a horizontal position, and everywhere in between. They sometimes include a tray for holding brushes and odds and ends, and also incorporate the means of attaching a water container. In essence, any easel can be used, but these are the ideal. However, you might like to carry out a trial run in assembling one of these, as they come in a carrying case in separate pieces and have to be reassembled in situ.

If you want to be really extravagant, you can buy an all-inclusive system that is virtually an outside painting studio kitted out with easel, palette with cover, tray, brush holder, storage, water container and backpack.

There are many other water-based mediums apart from traditional watercolour, and these include gouache, watercolour pencils, ink, acrylic ink, water-soluble crayons and many others. The number of different products now on sale is bewildering, so try not to be tempted into buying things you may only use once, as their novelty value may be short-lived.

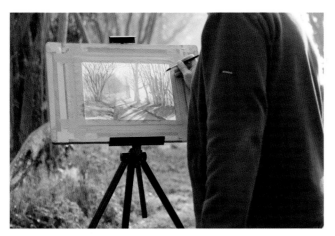

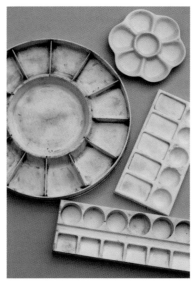

There are many watercolour palettes available in both plastic and ceramic. The plastic ones tend to be larger and come in a variety of shapes and sizes, and are of course cheaper. The ceramic palettes are heavy, and more suitable for studio painting. It can be seen from this image that the plastic palettes will become stained in time, but this is of no great importance.

The Bridle Path, Kevin Scully (watercolour on stretched Saunders Waterford 90lb paper). It can be seen from the colours in this image that by the time the painting was nearing completion, the light had already altered from an early morning blue haze to a mid-morning golden glow as the sun rose higher in the sky. The season was spring, and a wonderful time for venturing outside to paint.

The Bridle Path (2). Applying the finishing touches to the bare trees. Although the scene which had been the inspiration to begin this painting in the first place had changed, it had to be continued with the same combination of cool colours on the palette, rather than switch to a warmer range. Earlier in the morning the scene had been enveloped in a bluish haze, which disappeared whilst the painting was being worked on, to be replaced with a golden glow.

Other Equipment

Palettes

There will be occasions when you might need to hold your watercolour palette whilst painting, particularly if you are standing, or even sitting, in the middle of a field. There won't always be a convenient wall or table nearby, and constantly bending down to reach your colours on the ground will be very tiresome. A practical palette therefore is a folding one that has a hole in the base or a ring underneath, which you can hook your thumb into. This allows you to hold the palette at a convenient height when painting. These are available in either plastic or traditional, black enamelled metal. If you are to be working on a medium or large scale, choose one of a reasonable size that has several compartments into which you can squeeze your favourite colours, and a generous amount of space for mixing them. These colours will, of course, eventually dry out, but they can be revitalized by a little agitation with a brush in clean water.

A clever little palette that is marketed as a travelling kit or field palette incorporates several features into a convenient fold-up box. It contains up to twelve colours in half pans, a water container, space for a travel brush, and three colour-mixing areas. These boxes are ideal for working on a small scale.

Accessories

You will need a bottle of water with a screw lid, and a container of some kind for washing your brushes out in. I use two collapsible, plastic water pots, one for washing brushes, and the other containing clean water for diluting paint.

A useful addition to your kit is an atomizer for spraying a fine mist of water on to your painting when necessary, and also for keeping the colours in your palette moist on hot days. These can be bought cheaply from a chemist shop. Tissues and paper towels are a necessity for mopping up and dabbing drips, and some painters like to use a natural sponge during the painting process.

In some instances you may find that using masking fluid is essential, and this can be bought in a number of forms. Probably the most convenient is the applicator bottle with a fine nozzle, although even using these carefully can occasionally produce an unwelcome blob of the liquid in the wrong

place. Other methods of applying masking fluid include using a metal ruling pen, which can be adjusted to produce different line widths, and a metal dip pen. These instruments are easy to clean as the dried masking fluid can simply be peeled off. Do not use a brush, as you will never remove all the fluid from the hairs once it has dried. Masking fluid is available in a pale yellow colour, but this is difficult to see on white paper, so it's better to go for the blue variety, which is more visible.

Increasingly, opaque white gouache has become an acceptable medium to use for highlights in a watercolour painting, and is far superior to the Chinese White often supplied with sets of cheaper watercolours. It should be used sparingly, however, as its overuse detracts from the transparent quality of watercolour. Highlights can also be created by scratching back some of the paint with a safety razor blade or scalpel.

If you are working small, everything you need in a watercolour painting kit will fit into a carrying bag or rucksack, including a fold-up stool. For larger work you can carry a lightweight easel in its carrying bag over your shoulder, and a drawing board under your arm.

Oil Paints

I am a simple man, and I use simple materials: Ivory black, Vermilion (red), Prussian blue, Yellow ochre, Flake white and no medium. That's all I've ever used in my paintings.

L. S. LOWRY

If you can afford them, choose 'artist's quality' paints from established producers. Amongst the best are Sennelier, Old Holland, Winsor & Newton, Michael Harding, Schmincke and Vasari. The more affordable paints are in small tube sizes of 37ml or 40ml. You will need a larger tube of white, as it's surprising how much you will get through during the course of an oil painting.

A good basic palette for landscape painting could consist of Titanium White, Lemon Yellow, Cadmium Yellow, Cadmium Red, Alizarin Crimson, Cobalt Blue, Ultramarine, Cerulean Blue, Yellow Ochre or Raw Sienna, Phthalo Green, Chrome Oxide Green, Winsor Violet, Burnt Sienna and Raw Umber. The names of these will be slightly different depending on which brand you choose. You won't necessarily need all these colours to begin with, and your choice will depend on the kind of subject matter you will be tackling. If you're keen on painting only seascapes, some of these colours won't be relevant, so they can be substituted for others that are going to be more useful.

Oil painting requires more equipment than the other mediums, but when painting on location, it can be kept to a minimum. This image includes turpentine, alkyd medium for speeding up the drying time, liquin medium to improve the flow of paint as it becomes tacky, double dippers for holding turpentine and painting medium, white spirit for cleaning brushes, a brush washer for holding white spirit, a wooden palette, a palette knife and painting knives, a rag, and a selection of brushes.

Alkyd Oil Paints

Primarily made by Winsor & Newton, these paints are basically the same as their range of traditional oil paints but with the addition of an alkyd resin that speeds up the drying times. These paints will be touch-dry overnight. They can be mixed with and used in the same way as ordinary oil paint using the same painting mediums and solvents. Although there is a good selection of colours available, there might be a particular colour from the standard range that you want to use. By mixing this colour with the alkyd paints the drying time will be slowed down in relation to the amount of traditional oil paint you add. These paints are ideal if you want to use oil paint when working outside as they allow you just the right amount of workable painting time.

Water-Soluble Oil Paints

Several manufacturers now produce specially formulated oil paints that can be mixed with water rather than the usual solvents associated with traditional oils. So if you suffer from the effects of white spirit and turpentine fumes, these are probably the paints for you. Holbein produce a large number of colours in their Duo Aqua Oil Colour range, which can also be mixed with ordinary oil paint as well as acrylic paint. Drying times for these paints can be between one and three days, depending on how thickly the paint is applied.

If you mix more than about 25 per cent of ordinary oil paint with the water-soluble colour it becomes less water soluble, so it seems rather pointless and defeats the object

A selection of hog-hair brushes essential for oil painting, some new and some well worn, as well as a few cheap synthetic brushes for fine detail. Sometimes it makes economic sense to use some of these cheap brushes, and when they are no longer of any use, simply to throw them away and buy some more.

Canvas is fairly translucent, so if your canvas is on an easel facing into the light, there will be a dark shadow on your painting surface created by the framework of the easel itself. A simple solution to this is to attach a board the same size as your canvas underneath it, so blocking out the light. If you are painting in windy conditions, the canvas can act as a sail and a strong gust of wind could carry your canvas, together with your easel, crashing to the ground a few yards away! To counteract this, take a heavyweight, plastic carrier bag with you and put a brick or a rock in it, and hang it from your easel.

of the paint's purpose. You can also use traditional mediums and solvents with these paints, but why would you want to? You might as well use traditional oil paints in the first place.

In the early days of the introduction of these colours, they were seen as a product more suitable for the amateur painter and not considered of good enough quality for the professional artist. However, as these paints have developed and improved over the years, they are now taken a little more seriously and are certainly worth consideration.

Brushes for Oil Painting

You will need a different set of brushes for oil painting than those required for watercolours. The most common material for these brushes is Chinese hog bristle, a robust material that will stand up to the rigours of oil painting on canvas or boards. Cheaper alternatives are the brushes made of synthetic fibres such as nylon or polyester. There are also brushes that combine both natural hair and synthetic fibres.

They come in many shapes and sizes, but the three main categories are rounds, flats and filberts. Rounds are set in a round ferrule, and are rather similar to watercolour brushes in shape, and the ends have more of a point than the other shapes. They are ideal for smaller, detailed work and are generally used for more linear brush strokes.

Flats are as the name suggests: they are flatter and squarer in shape with a slightly rounded tip, and come in two lengths, short and long. The shorter version can be used to block in broad areas of colour and will give a rather square brush stroke when applying individual patches of colour. Another name for this brush is a bright.

Filberts can be described as a cross between rounds and

flats, and are probably the most popular brush for oil painters as their versatility can produce a variety of different brush-strokes. They are flat in shape, but their rounded end leaves a softer, smoother edge than the flats.

There are other specialist brushes, either synthetic or made from natural hair, which are also suitable for use with oil paints. A fan brush is designed for blending areas of colour together, and can be used for painting a variety of shapes, particularly the foliage of trees and other features in the landscape. A rigger can be used for long, fine lines and, of course, the rigging on sailing ships.

As with all art materials, buy the best you can afford, even if it limits you to just a few brushes, perhaps in sizes 3, 6 and 10. You will soon discover which ones you like best, and those that you can do without. Oil paint is going to be harder on your brushes than watercolour, so they should be thoroughly cleaned after each painting session in white spirit, and washed in a proprietary brand of brush cleaner when you get back home. If this isn't available, I find that washing-up liquid is as good as anything.

Painting Surfaces for Oil Paintings

Depending on how far back into history you go, the traditional support for oil paintings has been canvas, but artists have always used panels of various kinds. Before canvas was popularized due to its light weight and ease of transportation, wooden panels were the normal support, but these, of course, were heavy, particularly if a large painting had been undertaken. A picture painted on canvas could be removed from its stretcher when dry, rolled up and then dispatched to whoever had commissioned it. The stretcher could be

reassembled and the canvas tacked on to it, and the painting could then be framed.

Painting on a fine-textured canvas is certainly a pleasurable experience, as the paint slides over its surface, which has just enough 'tooth' to allow the paint to be deposited where required. However, painting on canvas on location can have its drawbacks, its relative fragility being the main disadvantage.

Because canvas is fairly flimsy it can be dented rather easily, which can be a problem when carrying a wet oil painting back home.

There are several alternatives to canvas now on the market. Lightweight, rigid painting boards are ideal, and there are a great many to choose from. You might like to try canvas panels, which consist of canvas mounted on to either thin plywood, hardboard or MDF. These boards are lightweight, rigid and durable and can be bought in many sizes, with surfaces graded from smooth to medium.

These degrees of surface finish will vary depending upon which brand you choose. The most expensive ones have a fine linen surface, which is ideal for painting on, especially if you like to paint in detail. Slightly cheaper are the panels that use cotton canvas of a heavier grain, usually referred to as medium. These are more suitable if you are painting larger pictures, as the rougher grain of the canvas will be more noticeable on smaller panels.

These panels come ready primed in either oil or acrylic gesso, which acts as a sealant to stop the oil paint from sinking into the support. Some are double primed, which makes them less absorbent than those that have simply been primed once. The primer is sprayed on, so the finish is smooth and there are no brush marks. It is also possible to buy MDF boards that have been given a couple of coats of acrylic gesso primer, sanded down between each coat.

Ampersand is a company that produces 'claybord panels': these consist of 3mm hardboard covered in a kaolin clay formula that imitates the clay gesso grounds used by Renaissance artists. The surface is sanded down to a smooth, absorbent surface. There are also aluminium painting panels on the market that have a specially treated surface that paint adheres to. These panels need no priming.

You can buy wooden panels of finely sanded plywood, attached to and braced by a slim wooden frame to prevent warping. These come as bare wood, ready for priming.

In the interests of economy you can make your own painting panels from sheets of 3mm MDF bought from a hardware shop. These can be cut to the required size and sanded down. Paint the panels with three coats of acrylic gesso, lightly

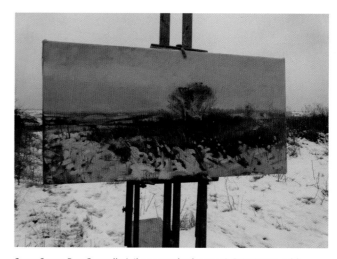

Snow Scene, Roy Connelly (oil on stretched canvas). Painting in cold weather is a good way to speed up your technique. This was painted in about forty-five minutes in an exposed location above the Stour Valley. The painting was started on a mid-toned canvas that had the beginnings of another painting on it. Starting on a white canvas would have made it hard to judge the tones correctly.

sanded between each coat. Also, paint the back with gesso, as this will help prevent the thin board from warping.

Pochade Boxes and Easels for Oil Paints

It is perfectly feasible to paint in oils on location without using an easel by investing in a pochade box. This is a self-contained portable studio in which it is possible to carry all the materials you will need to produce small paintings outdoors; it also allows you to carry your wet paintings back home in safety. Depending on its size, it can be held in your hand or rested on your lap or on any other convenient surface.

These clever little boxes have evolved into a more sophisticated version of the pochades that artists used in the nineteenth century. Essentially it's a box with a lid that folds back on hinges. Inside the lid there are two or three compartments for storing painting boards. A board can be attached to the inside of the lid by a variety of ingenious methods including spring-loaded clips and magnetic sliders. There is a palette that slides out, and in some boxes this can either slide to the left or the right, and underneath this is a compartment for paints and brushes and so on. Some of these boxes are tiny, no more than 5 × 7in, so the handles of brushes will have to be cut down to size. These boxes are perfect if you want to remain inconspicuous when out painting. Even the larger boxes – up to 10 × 12in – will rest comfortably on your lap. There is one box widely available where the lid holding your painting and the palette are joined together, and can be removed from the box and held in one hand by means of a thumb-hole, leaving your other hand free to paint with.

Janet Poole's much utilized and cherished Alla Prima pochade box, attached to a sturdy yet lightweight telescopic tripod. Although paints can be mixed directly on to the palette areas, the artist has added some clear perspex palettes, which makes for easier cleaning at the end of the painting session. The lid holds up to four small painted boards, for safe transportation. She has added a hook from which she has suspended her brush washer, and a strap for some kitchen towel. There are holes drilled into one of the side attachments for holding brushes. The whole set-up folds up neatly into a lightweight box with a carrying handle.

A new version of the Alla Prima pochade box. The box can accommodate a reasonably large board or canvas, held in place by a system of strong, sliding magnets. The two side panels are removed and attach to the lid with magnets, and into this lid several brushes can be stored diagonally. The beauty of this system is the absence of screws and wing nuts, and its ability to store wet panels.

If you like to stand back from your work to paint at arm's length, you can still use a pochade box by attaching it to a camera tripod. Most of the boxes on sale come fitted with a female-threaded screw on the underside, so that it can be connected to a quick-release head on the tripod. Some have extra trays that attach to the side of the box for holding painting mediums, rags and other bits and pieces, and some have pre-drilled holes for slotting your brushes into.

French Easels

French easels are essentially an easel and paintbox combined, where all the constituent parts fold neatly into the box itself. There are two sizes: the half-easel and the full easel, the main difference being the size of the box. If weight is to be a consideration, the half-easel is the best one to buy. Both sizes will hold fairly large boards or canvases up to about 34in in height, and can accommodate a palette, brushes, paints and all your other painting materials. There is a metal-lined drawer that folds out to hold paints, which can be used to rest your easel on, and your other equipment can be stored in the box underneath.

The easel can be tricky to erect, but once you have mastered the procedure, it can be up and ready for action in just a few minutes. The tripod legs and easel are fully adjustable and can be tilted to any position for painting. The 'Jullian' easel comes with provision for attaching a wet board or canvas to the box once it has been folded up, and includes a wooden palette and carrying case.

The Cherry Orchard, Roy Connelly (oil on stretched canvas). This shows the painting in its second year. It has only been worked on for an hour or two at a time, but after the first couple of sessions the grass was cut in the orchard, so it was put aside for a year. The following spring the artist returned to the same spot to complete the painting. In this image he has supported the large canvas on a tripod easel, and has used his panel holder as a palette. A clamp has been used to suspend his brush washer containing white spirit.

A full size Mabef French easel, kitted out with an array of pastels that fit neatly into the steel-lined compartments.

Of course any easel can be used for painting outside, but the beauty of pochade boxes and French easels is their ability to contain nearly all your equipment in one single unit.

Other Easels

For painting outdoors you will need an easel that folds up into a manageable, portable size, and there is a vast selection from which to choose. They are made in a variety of materials: the cheapest easels are made of plastic, and although they are certainly lightweight, they are rather flimsy, and because their adjustable components are often also plastic, they will soon wear out or break. Wooden 'field easels' and metal easels are sturdier, but with all these easels you will then have to bring along a box or bag for your paints, board or canvas, palette, brushes and other equipment.

This won't be a problem if you are just painting in your back garden, but it will be if you venture further afield, because unless you also bring along a fold-up table, most of your equipment will be on the ground, apart from your palette, which you can hold in your non-painting hand. This won't be too tiresome if you are sitting, but if you are standing at the easel, it will soon become very irritating having to bend down all the time to pick up the things you need.

Panel Holders

An alternative to easels and pochade boxes is the panel holder. This product combines a palette and panel holder into one unit, which attaches to the ball head of a camera tripod. They are made in the USA by Open Box M and come in a range of sizes, the largest of which will accommodate painting boards up to 24in horizontally with no limitation on the height. The panel holder comes with a side palette extension that can be fitted to either the left or right side. The company offers a range of accessories including extra extensions and a panel storage unit, as the panel holder itself doesn't have a built-in compartment for carrying boards.

This product isn't a box, so there is no storage capacity for paints or brushes; it is merely a very lightweight, neat piece of equipment combining a palette with the means of supporting your painting.

Palettes for Oil Painting

There are three basic choices for palettes. The traditional, large, kidney-shaped wooden palette with a hole for your thumb so that you can rest it on your forearm is more suitable for the studio than out in a field, but there are other versions available in a variety of shapes and sizes. Alternatively you

Pin Mill, Roy Connelly (oil on board). Painted at low tide on the River Orwell in Suffolk. It was the intense colour of the backlit red ensign that caught the artist's eye. Where possible, he will paint with the canvas in shadow as it helps him to judge the tones correctly. Painting with the sun on the painting can result in a picture that is darker than expected. The board has been turned to the sun in order for it to be photographed.

can use a tear-off paper palette, where each individual sheet can be removed and disposed of at the end of the day. These palettes are traditionally white, but they are now available in a neutral grey, which makes the task of colour matching a lot easier. The other option is perspex, which, like polished wood, is fairly easy to clean.

Other Equipment

You will definitely need more paraphernalia for oil painting than you do for watercolours, but as an artist, purchasing the delights for sale in an art shop will be more of a pleasure than a chore.

If you opt for a basic easel on which to paint, you will need a box or bag in which to keep your other equipment. A box is probably the best option for storing paints and brushes as it will prevent them from being damaged, and providing it's not too big, it can be carried in a bag or backpack along with your other materials. A good choice is a cantilevered box. These are usually made from lightweight plastic and can be left open to give access to individual trays divided into

compartments, in which you can keep your bits and pieces. Tubes of paint, brushes and larger items can be stored in the bottom of the box. You can buy these boxes in most art shops, and a similar item can be found in shops selling fishing equipment. Fishermen use this kind of box for storing hooks, fishing flies and so on.

If you are planning on painting larger pictures than those that fit into a pochade box, you will need to be able to transport them safely, especially once they are wet. There are various cunning devices on the market including canvases that carry clips, allowing you to carry two paintings face to face without damage. A product from the Guerilla Painter Company is the 'Handy Porter', a cardboard box with foam inserts which allows you to carry two canvases or four panels.

A much cheaper way of doing this is to insert double-ended pushpins into each corner of the painted side of your canvas or board, and then gently push your other painting face to face on to the pins. You can then tuck them under your arm and carry them home.

You will need a small plastic bottle of white spirit, which can be poured into a container so that you can wash out your brushes. This can be a screw-top glass jar, or a purpose-made, metal brush washer with a screw-top lid held firmly in place with spring clips. It has a removable, perforated insert through which the sediment filters into the bottom of the vessel, thus keeping the white spirit cleaner for longer. The sediment can be cleaned out and disposed of back at home by pouring off the relatively clean white spirit and removing the insert. This container can be suspended from your easel or tripod to save you bending down to reach it. If you are allergic to white spirit, or find it suffocating, you can substitute this with a non-toxic solvent such as 'Zest-It'. A palette knife is useful for scraping paint from your palette, and if you like to use painting knives you can add a couple of these to your equipment.

There are dozens of painting mediums to choose from, but to simplify matters your paint can simply be thinned with turpentine when necessary. You'll need very little of this, so it, too, can be kept in a small screw-top jar or bottle. As your paint becomes a bit tacky, as it will do on hot days, you can add a little liquin medium to it, which helps to improve the flow of the paint and reduces the brushstroke retention.

Double metal dippers can be attached to the side of your palette to hold turpentine or any other painting medium as you work. These can be purchased with screw tops to prevent any liquid from spilling out when they are being carried or are not in use.

A supply of rags is essential for cleaning paint from your palette and brushes.

One item that I find most useful is a small pair of pliers that I carry for unscrewing the lids from tubes of paint where the paint has dried, and which are otherwise impossible to remove. This is especially true of alkyd oil paint.

Take a plastic bag for discarded rags, empty paint tubes or any other unwanted items, which can then be disposed of in a convenient litter bin or back at home.

You will need to wear some old clothes for painting in oils, because it can be a messy business! You may also want to take a seat with you, and a fold-up fisherman's stool will take up the least room in your bag.

Acrylic Paints

Acrylic paints are water soluble but become permanent and water resistant when dry. One of the drawbacks with acrylic paint is the speed with which it dries, and this can be a problem, particularly in hot weather. Some manufacturers have produced acrylic paint with an extended drying time of up to an hour. M. Graham's acrylic range is one such product, and Chroma's Atelier Interactive Acrylics allow you to reactivate touch-dry paint using a fine spray of water. Golden Open Acrylics claim that their paint is workable up to ten times longer than most other acrylic products, and that the drying time is comparable to that of traditional oil paint. This paint can also be reactivated with a fine mist of water. With other acrylic paints unable to make such claims, the drying time can be delayed by the addition of a little gel extender.

As with other paints, the range available is vast and a good starting point would be a set of colours similar to those previously listed under the oil paints section. As with oils, you will need a larger tube of white.

Brushes for Acrylics

The brushes used primarily for oil painting are made from hog hair, which is tough enough to cope with the thick paint being pushed around and sometimes scrubbed into the canvas or board. Standard acrylic paint isn't quite as heavyweight as oil paint so pure hog hair isn't really a necessity. Most companies that sell brushes describe the different types as 'acrylic painting brushes' or 'oil-painting brushes', so this is a good starting point. As with oil-painting brushes, when choosing brushes for acrylic, go for a selection of rounds, flats and filberts in either a hog hair/synthetic mix or that are purely synthetic. Start with some brushes in sizes 3, 6 and 10, and a round in size 2 or 3.

Tear-off palettes are one of the most convenient products for mixing acrylic paints. Once only produced in white, they are now available in a neutral grey, which makes it easier for colour matching. The image shows a palette knife for mixing paints, together with a painting knife for applying it. The brushes used for oils can also be used for acrylics, although there are special synthetic brushes produced specifically for this medium. As it is water based, watercolour brushes can also be used, but it is advisable to use the cheaper, synthetic ones, as sable brushes won't generally last too long when used with acrylics. The image shows a bottle of liquid retarder, which when added to the paint, slows down the drying process.

You can use sable watercolour brushes for fine detail if you wish, but unless you wash them out often and thoroughly, the acrylic paint that will accumulate at the base of the hairs will eventually destroy them. It would be better to use round brushes in a synthetic or a synthetic/natural hair mix, as they will be much cheaper. You should wash all your brushes that have been used in acrylic paint very carefully, and all paint must be removed before it sets hard. This can be tricky when working on location, as you probably won't have access to any running water. What you can do, though, until you get home, is wash them as well as you can in clean water, separating the hairs at the base of the brush trying to remove as much paint as possible. Then rub some brush-conditioning soap or washing-up liquid into the hairs and reshape them. Repeat the process again thoroughly when you get home.

Palettes

Much of the equipment needed for painting in oils is also relevant for painting in acrylics, but with certain exceptions. One of these is the palette, and because acrylic does generally dry a lot more quickly than oil paint, you will need to keep the paint moist.

The 'Stay Wet Palette' by Daler Rowney is a plastic tray containing sheets of reservoir paper and semi-permeable membrane paper, and the paint stays wet by the process of osmosis. The semi-permeable membrane paper that forms

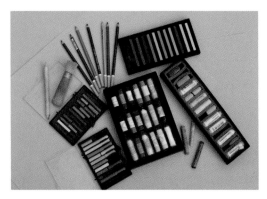

A selection of soft and hard pastels, both round and square, which can be bought in sets or singly. Pastel pencils are a useful addition to the pastel painter's equipment and can be sharpened with a scalpel, craft knife, or special pastel pencil sharpener. A stiff brush is useful for removing unwanted pigment, and a torchon can be used for blending colours.

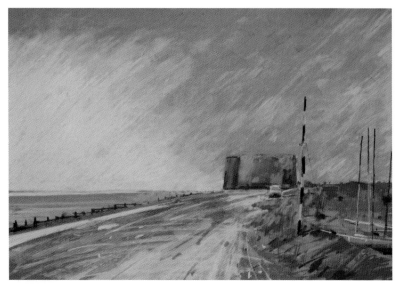

Martello Tower, Aldeburgh, Kevin Scully (pastel over watercolour on Clairefontaine light grey Pastelmat). The drawing and watercolour underpainting for this picture initially included some more vehicles and people, but it was decided that this rather detracted from the dramatic composition and this austere building next to the sea, so they were removed by covering them with pastel. It was painted on a rather bright but grey day, and there was very little colour to be detected anywhere, so some was introduced. A fairly limited range of mainly pastel shades was chosen, which seemed to reflect the spring season, and they were applied in a loose and lively way to suggest the windswept location. The strong diagonal of the composition leads the eye to the tower at the end of the road.

the working surface of the palette is kept moist by the dampened paper beneath. When not in use, the tray is covered in a transparent plastic lid so that the paint remains in a workable condition. Using one of these would be beneficial if you intend spending a reasonable amount of time working outside in any one session. Adding a little gel retarder to acrylic paint can extend its workable life even further.

An inexpensive version of this can be made by using a shallow tray with a tight-fitting lid, into which is placed some dampened paper towels or thin sponge. This acts as a reservoir. On top of this, place a sheet of greaseproof paper or parchment to act as a membrane: this will also be your mixing surface. As the water in the paint evaporates, it is replenished by that from the damp paper towels. Alternatively, if you are only going to be working on a painting for a couple of hours, you can use a tear-off paper palette and just squeeze out the amount of paint that you will need.

The problem with the osmosis process is that you are mixing paint on a non-rigid surface, and even the paper on the tear-off palette can wrinkle a bit and make mixing difficult. So if all of this is too tedious, you can use Golden Open Acrylics on a conventional palette or off-cuts of plywood, or in fact any other disposable material, and just scrape off any paint that you don't use at the end of your painting session.

Other Equipment

There are many mediums, pastes, gels, glazes and other additives that can be used in conjunction with acrylics, but experimenting with these is best done in the studio until you find one that suits your method of working. Acrylic paint can be used straight from the tube or thinned with water. You will need plenty of water and a container of some kind for washing out your brushes. You will also need paper towels or rags for cleaning up.

Pochade boxes, panel holders, easels, palette knife, painting knives and other sundry items have already been covered in the section on oil paints, and can be used for both mediums. With the pochade boxes and panel holders, where the paint mixing surface is integrated into the item itself, it would be best to use one of the palettes mentioned in the previous section. Otherwise, once dry, it would be impossible to remove the acrylic paint from the paint mixing areas.

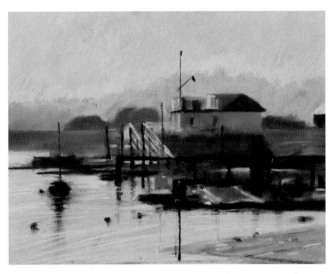

Deben Yacht Club, Kevin Scully (pastel over watercolour on watercolour paper). Painted in bright early morning spring sunshine, when much of the scene was in silhouette. The blurred elements in the painting were created with a very limited pastel palette of blues, greens, pink and cream, with the subdued highlights picked out in off-white. To achieve the atmospheric sensation of backlit sunlight, a lot of the colours were gently blended with a finger.

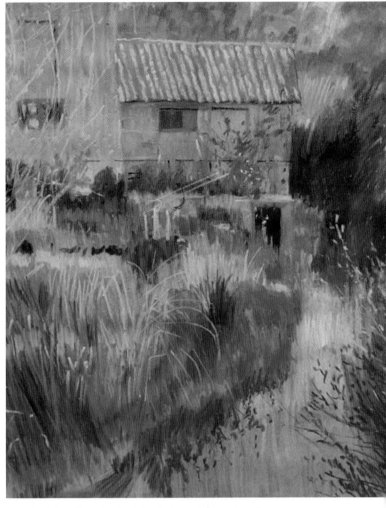

Damvix, Poitou-Charentes, Kevin Scully (pastel over watercolour on Canson Mi-Teintes Flannel Grey pastel paper). The two dilapidated buildings by the river in this French village added just enough contrast in colour to offset the predominantly green scene. To play down the green even further, the underpainting was laid-in using a nondescript mixture of colours left on my palette from a previous watercolour sketch. This monochromatic starting point contained just three or four areas of the same colour in different tones. Touches of blue, together with some of the colour used on the buildings also help to overcome what could easily have become too 'nice' a painting. A suggestion of sky at the top of the painting adds relevance to its reflection in the water.

Pastels

Soft Pastels

The available colour range of soft pastels is vast, and far greater than any of the ranges produced by paint manufacturers, so choosing a selection of colours can be difficult. You could begin by buying a starter set of half-pastels made by one of the leading manufacturers: consider brands such as Unison, Sennelier, Jackson's or Schmincke. All these companies sell sets of pastels suitable for the kind of subjects you may want to paint outdoors, and these sets can be added to as you discover the colours that you need. They will come in a cardboard box lined with foam that can be used over and over again as colours are used up and new ones added.

The brands previously mentioned are indeed soft, but there are other brands that produce pastels described as soft that are a degree or two harder, and don't have the creamy texture of true soft pastels. One of these is Talens Rembrandt Pastels, and those made by Daler Rowney and Winsor & Newton fall some way between the two. There are many other makes to choose from, and although some of the cheaper brands are surprisingly good, there are others that are awful. So choose the best you can afford, even if it just means buying a few to begin with.

Because you can't mix the colours you want as you can with paint, and because the colours you may want are rarely the colours you have, you must resolve this by overlaying or blending different colours on the paper. Only experience will determine which are the most useful colours for the subjects you like to paint.

STEP-BY-STEP DEMONSTRATION

It is possible to create an atmospheric painting by choosing a viewpoint facing directly into the light source. Viewed from the other side of this building, the scene appeared flat and virtually without shadows, and consequently without drama or interest. In this painting, a fiercely bright early morning sun produced a fascinating combination of hazy shadows and sharp silhouettes. Distant shapes are blurred, and much of the detail that you would normally see becomes vague and imprecise, and the scene takes on an almost abstract appearance. The water was suggested by adding a few horizontal marks over some vertical bands of colour that had been smudged with a finger. Although there is a fair amount of smudging of the pastel in this painting, this is counter balanced with other passages of directional, linear marks.

STAGE 1
The image was drawn fairly carefully on to the ready stretched paper, with the drawing board in an upright position, which makes it easier to establish the correct proportions.

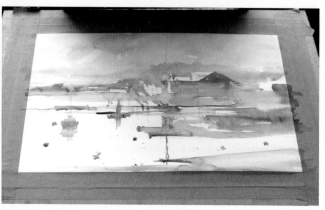

STAGE 2
The board was then laid down in a slightly tilted position so that the watercolour washes could be applied. This image shows the pencil drawing still visible through the watercolour wash. The main areas of the painting have been blocked in using a combination of blues that included Ultramarine, Cobalt and Cerulean, together with a touch of Winsor Violet. This photograph was taken whilst the wash was still wet, and the slight buckling of the paper is evident. Once it had dried, the paper became flat again, ready for the application of pastel. Even in this very loose wash, the mood of the painting has already been established.

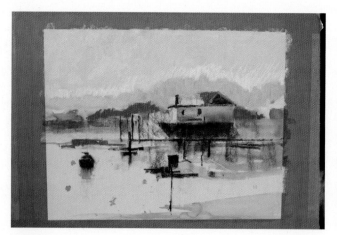

STAGE 3
The initial colours were applied with broad marks, mainly with the pastels held fairly flat. The tonal watercolour wash has been overlaid with pastel of a similar value, and so retains the tonal balance.

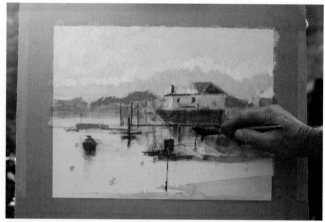

STAGE 4
A brush containing clear water was used to blend some of the pastel, which has the effect of laying a film of some of the pastel pigment over the underlying wash as well as some of the other pastel colours.

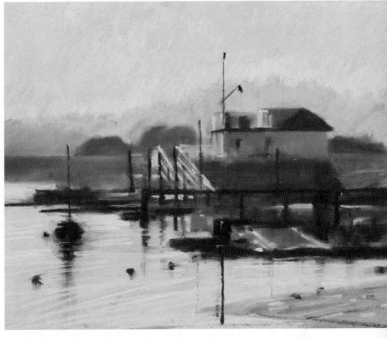

STAGE 5

More colours have been introduced into the sky, which was actually white, but cried out for a bit of colour. Often in very bright sunlight the sky does appear to be white, but this doesn't always look right in a painting. More solid blues were added and lightly blended with a finger, and some of the creamy colour seen in the sky was used for the light reflected on the surface of the water. The dark vertical accents were drawn in with a pastel sharpened to a point with a scalpel, and the off-white highlights were the final touches to the painting.

The finished painting, removed from the drawing board.

Hard Pastels

Hard pastels are not available in as many colours as the soft ones, but they do have their uses. They can be used to draw out your composition, and they can also be sharpened for drawing fine detail. They are available in both round and square form. As a general rule they are more suited for use beneath soft pastels rather than on top of them – it's a lot easier to cover marks produced by a hard pastel with a soft pastel than it is the other way around. Because of their hard nature they tend to scratch into the surface of marks made by the softer pastels. However, providing that soft pastels have been used fairly sparingly, and the surface of the board or paper hasn't been filled entirely with pigment, they can also be used to add some fine detail. And there is no reason, of course, why you can't produce a picture using entirely hard pastels.

Pastel Pencils

Pastel pencils are a convenient way of using pastel on location, but they are really more suitable for smaller, detailed work, and because they are encased in wood like an ordinary pencil, they tend to be on the hard side. They can be sharpened to a fine point with a craft knife, scalpel or pencil sharpener specially designed for the purpose. As there will only ever be a relatively short amount of pastel showing at the end of the pencil, they will have to be sharpened quite regularly during

Almuna Terrace, Andalucia, Felicity House (pastel, underpainted in watercolour on Colourfix card). The image was first painted with a neutral mix of Alizarin Crimson and Winsor Blue. The heat of the day has been suggested by the bright blue graduated sky that meets the distant hills, which have been painted with hatched pastel marks, rubbed and blended to suggest the soft, distant haze. Pastel pencil has been used for the chairs and for defining the overall structure of the image. Freer mark making on the plant pots, and the suggestion of dappled shade and strong sunlight, completes the atmosphere.

use, as they will wear down very quickly. You must be careful not to drop them, as there is a risk that they will become broken all the way through, and so be impossible to sharpen.

There is good range of colours available from Caran D'Ache, Faber-Castell and Carb-Othello. Unlike most soft pastels, pastel pencils have memorable names as well as being numbered, so are simple to replace. So when trying to replace a stick of pastel that once had a label which is now lost, describing it as Light LT10, there will still be a name on the case of a pastel pencil identifying it as Silver Grey.

Pastel pencils can also be used to add fine detail to a soft pastel drawing.

Oil Pastels

Oil pastels use an oil binder instead of the gum binder used in soft pastels. They can be used on both smooth and textured paper, as well as on canvas or painting boards. In the past only a limited number of colours was available, but that has now changed, and Sennelier in particular has a range of 120 colours. They can be sharpened to a certain degree for a finer line, and the colours can be overlaid in the same way as soft pastels. Used on canvas or painting boards, they can be diluted with a brush dipped in turpentine to create washes, which can then be drawn into or overlaid with more colour. They are perhaps more suited to expressive forms of painting rather than being used for fine, detailed pictures.

Pastel Paper

Unless you have a specific reason for doing so, choose one of the tinted pastel papers rather than plain white, as they will be of more use when working on location. Even if you are painting a snow scene, you will find it easier to begin with a blue tinted paper and add white, rather than the other way round. There is very little in nature and the big outside world that is white, so a better choice for a landscape, for instance, would be a fairly neutral mid-toned earth-coloured paper.

However, there is nothing to stop you experimenting with brighter coloured papers as a ground, because some interesting effects can be achieved by overlaying contrasting colours. Canson Mi-Teintes produce a range of excellent papers that have a less mechanical texture than some other brands. These papers have a smooth side and a slightly textured side, and you can work on either.

More popular of late and more robust is pastel card, or pastel board, now produced by several suppliers, which has a surface like very fine sandpaper and is therefore slightly abrasive. The surface of these products holds the pastel more readily than pastel paper, though care must be taken not to fill in the surface with too much pigment too early on. Pastels slide over the paper more, and it's not as easy to build up layers of colour as it is with pastel card.

Some great effects can be achieved with all these surfaces, so it's worth experimenting with them to discover which ones you like.

Other Equipment

Because it is essentially a dry medium, you only need the minimum amount of equipment with which to operate when working in pastels. You will, of course, need a drawing board, and preferably one that is rigid yet lightweight. Choose one that is as smooth as possible if you are going to be working on paper, as any imperfections or lumps and bumps will create an impression on your work. If you choose to work on a board that has been used for watercolour and which may have the remnants of Gumstrip attached, you can still use it by placing a thick piece of card over it to create a smooth surface to place your paper on. Paper or pastel card can be attached to your board using drawing pins, drawing clips or low-tack masking tape.

If you are using a French easel, you'll be able rest your boxes of pastels in the slide-out drawer, and if you're using a pochade box or a panel holder they will fit into the area used for mixing paint. If you are using a field easel, you may need a small fold-up table on which to rest your boxes of pastels. Some other useful additions include tissues, paper towels, a spray can of fixative, a paper stump or torchon for blending, and a putty rubber for erasing colour. Another way of erasing colour, and possibly more effective than a putty rubber, is to use a mixture of UHU Blue Tack and White Tack. The blue is rather hard and the white is rather soft, but the two kneaded together are good for lifting pigment off, and make an excellent eraser. You will also need a knife for sharpening pastels and a special pencil sharpener if you are using pastel pencils.

To carry your pastels safely you could use one of the purpose-made empty pastel cases produced by Jackson's, and fill it with your own pastel selection. This is a handy wooden box with a carrying handle, which opens flat. It can hold up to 112 pastels that are kept secure in foam-filled trays, held in place with melamine boards when the box is folded up.

One extra piece of equipment that is worth considering for painting on location in any medium is an umbrella, which will keep both rain and sun off your painting and equipment. Choose a white one so that no colour is cast on to your painting, which would otherwise make colour mixing confusing. The umbrella could be clamped to your easel or tripod. There are companies that produce an umbrella specifically for this purpose; one such is 'Best Brella', which sells a semi-translucent white umbrella that clamps to any surface and rotates to any angle. It is also vented, which means it won't take off and take your easel and painting with it!

Other Dry Mediums

As well as the ubiquitous pencil, there is a whole warehouse full of materials just waiting out there that you could use for simply drawing, and they are all lightweight and portable. When you have had enough of the ordinary graphite pencil, you could experiment with an oil-based pencil. This produces a very black line indeed, but because it is relatively soft, it will wear down very quickly, so needs constant sharpening. It is more suited to big, bold drawings that don't require too much detail.

Coloured pencils, on the other hand, are relatively hard, and will stand up to a lot of punishment before they need sharpening, and can be used for both detailed work and looser, more expressive drawings. They are particularly good for building up areas of colour by overlaying the pencil marks in a variety of different hues. They are made by any number of manufacturers, and vary slightly in the way in which they behave. Some of them are very hard and are suitable for very detailed work, whilst others are softer and better for filling in larger areas of reasonably flat colour. Some are a little waxy, which makes it difficult to overlay other colours, as they tend to slide across the surface of those already laid down. Some are soft, and as with soft, graphite pencils, some of the colour will transfer on to the opposite page of your sketchbook when you close it. You can spray this with fixative, but the constant opening and closing of the pages will eventually render the fixative inadequate.

Watercolour pencils can be used in the same way as ordinary pencils and can then be diluted by painting over them with clean water so that the colour forms a wash similar to watercolour. This can be drawn into whilst still wet, and again when dry. It is now possible to get watercolour markers that have two tips, one fine and one broad. Having drawn with these on to your watercolour paper, you can then dilute them in the same way as you would the pencils. Having a broad tip means that you can cover larger areas fairly quickly, but the colours don't blend with each other quite as well as the pencils.

Spirit-based markers have the advantage of your being able to lay down colour very quickly, and it dries even more quickly, in fact instantly. However, once applied they are permanent, so while they are ideal for use in a drawing to fill in an area of flat colour, they are less suitable for a finely detailed drawing where any mistake could be critical. Nor are they really suitable for colouring areas on a pencil drawing, as the spirit picks up the graphite and the result can be a drawing with unwelcome grey smudges. They can be used in conjunction with fibre-tipped pens, but care must be taken in using the right pens.

Experience has taught me that when used with some pens, both spirit-based and water-based, the spirit in the colour dissolves the drawing underneath to give a less than satisfactory result. Originally produced for graphic applications, they are perhaps used most effectively in producing more immediate and slick drawings. Ideally they should be used on special, non-absorbent marker paper, otherwise the colour will bleed through to the other side of the page in your sketchbook. There are many other coloured pens you can use, and all have their uses.

If you make a drawing with a water-soluble pen, you can then add clear water to it with a brush or water brush to create tonal variations. As the soluble ink on the paper dissolves it bleeds into the water, which can then be pushed around and manipulated with the brush to produce an image with light and shade almost instantly.

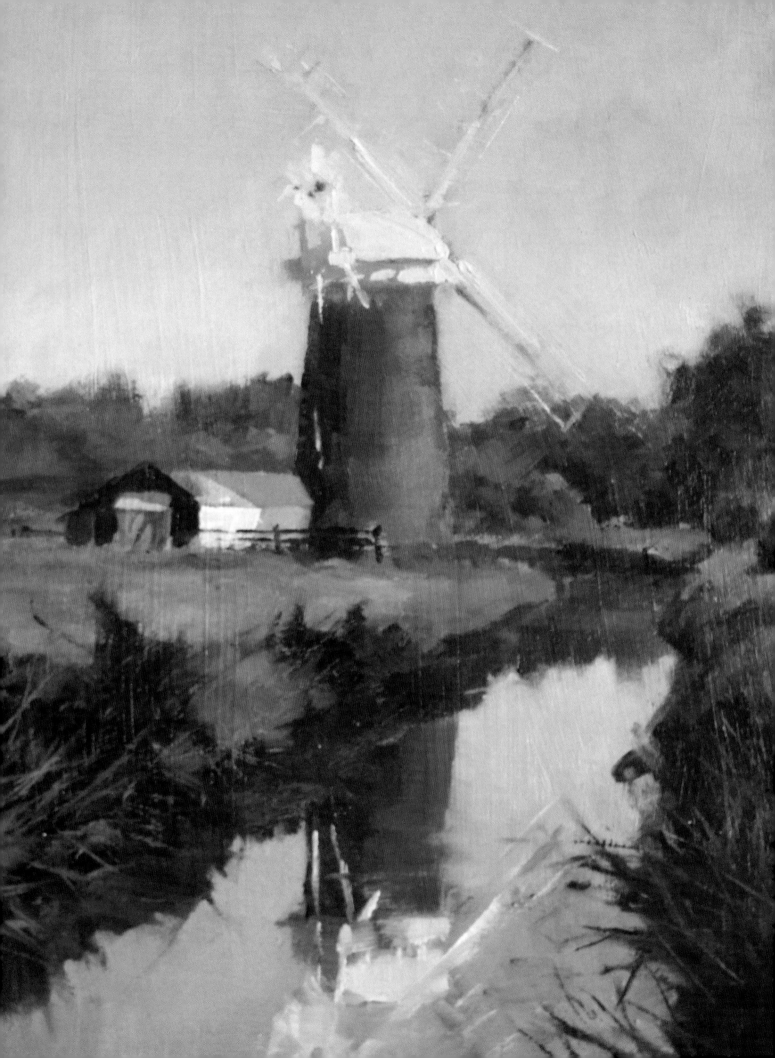

Locations

The first thing that comes to mind when considering working on location is drawing or painting the landscape. If you have never drawn or painted outside before this can initially seem quite daunting, but providing you don't get too ambitious too early on, a planned approach can produce some satisfactory results. Of course, landscape isn't the only area to be considered, but it's probably a good place to start. Generally speaking, you don't have to contend with complicated architectural detail or anything moving about too much, or struggle with perspective. It is also a very pleasant place to start.

There is nothing in the landscape that countless artists before haven't painted, but that doesn't mean that you can't paint your own version of it. Providing you can get out and about there will be something out there to inspire you, whether it is rolling green hills, barren jagged rocks, lush grassland or a wildflower meadow.

Windmill in the Morning, Deborah Tilby (oil on panel). This Norfolk windmill, in its peaceful, idyllic setting, was painted very early one summer's morning with only the cows for company. The reflection of the windmill in the water has been beautifully painted in a colour that is in a slightly lower key than the building itself. A sense of distance between the windmill and the trees behind has been achieved by creating a soft blend where they meet the sky. We can tell just how distant they are by their colour. Had they been further in the distance, they would have contained more than just the hint of blue that the artist has added.

Using a Viewfinder and Camera

But first things first, and where do you start? A way to ease your way into the unknown is to take yourself off into the countryside with a camera, a sketchbook and a viewfinder. When you come across a view that appeals to you, think about whether or not it would make a good drawing or painting. This may not always be obvious, especially if you are inexperienced. By taking some pictures with a camera, it will allow you to consider your options in the comfort of your home. You could also make a few simple compositional drawings in a sketchbook, or if you now feel really inspired, you could carry on and produce a finished drawing.

You could also use a viewfinder, which is a sophisticated version of two L-shaped pieces of card held in front of you to form a rectangle or square. It is a simple device that allows you to consider the different possibilities in composing a picture, and can help you decide whether a portrait format looks better than a landscape one, or if a square looks better still. If you have a fairly sophisticated camera, you will be able to carry out this cropping on the viewfinder on the back of your camera, or on your computer at home. Failing that, the adjustable viewfinder will do the same job on the spot: you simply crop the scene in front of you by moving the inner

This viewfinder is a useful addition to your equipment. It has a slider that changes your viewing format from a square to any proportion of landscape or portrait. Held at arm's length, it can be used to compose a picture by moving it up or down, from side to side, or backwards and forwards, until a satisfactory image has been established. The homemade piece of card with a transparent acetate window divided into thirds is also an excellent item to assist you in arriving at a good composition. It would be useful to have one in landscape/portrait format too.

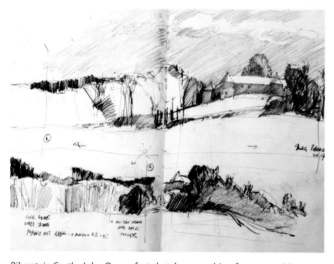

Piberstein Castle, John Owen; fast sketches searching for composition ideas. Tonal contrast has been emphasized around the focal point and its geometrical form, by surrounding it with free shapes and clear but varied lines. Enough notes were added to enable later paintings in the studio.

piece back and forth, and the viewfinder from side to side, and up and down until you find a composition that engages your interest.

Look for a focal point: this could be a large tree on top of a hill, or a winding path leading into a wood. More often than not, there will be a certain imbalance in what you have homed in on, but this is where your artistic interpretation comes into play. Don't worry if a tree is leaning over too much or if a rock or cloud looks rather like a horse's head: things can be adjusted and moved around when you finally compose the picture. Working from photographs can sometimes lead you

into copying exactly what's there, and the same can be true of working directly from nature.

Simplification

Once you have decided on your subject matter you may want to produce a drawing, so you should now consider what kind of drawing you're going to make. Are you doing it as an exercise or as a preliminary sketch for a future painting? Will it be linear or tonal, accurate or loose, in colour or in black and white? It's all too easy to try and include everything that's in front of you, so be selective and only include what interests you. Think about your viewpoint by stalking the subject first: perhaps positioning yourself lower down or higher up will give you a more interesting composition.

Consider the masses of shapes, large and small, and how they relate to one another. Look for small shapes against larger shapes, and light against dark and vice versa. Remember also that what you are drawing, unlike the landscape, has boundaries, so you must relate your shapes to those boundaries and not just assemble them in isolation. If you are working in tone, that is, in degrees of light and dark – and this is particularly relevant when tackling landscapes – identifying the underlying shapes is essential before adding the surface detail. If you are working in a linear way this is not an issue, and you should concentrate more on emphasizing the most important elements of the scene.

Depending on what kind of drawing you are going to make, you will need to decide on the instrument you are going to use. A pencil is the obvious choice if you are inexperienced, and it will also be very forgiving. If you are making a linear drawing, try not to make your lines too rigid, and instead think about the rhythm of nature and the landscape. There are very few straight lines in nature, so as you are drawing, keep your wrist turning gently, and occasionally apply a little more pressure on the pencil so that you produce a slightly erratic line that will be in tune with the landscape.

If you are making a tonal drawing, firstly assess the light and dark masses and simplify them into just three or four different tonal values. Adding too much detail on to these shapes will nullify the strong, abstract element in the composition; by keeping things simple you can produce a satisfactory drawing simply by breaking down a complicated scene into tonal shapes. Squinting at your subject is an excellent way of eliminating distracting detail. Just because it's there, it doesn't mean you have to include it. Remember, what you are doing is translating something in front of you that is in three dimensions into a two-dimensional representation. When we

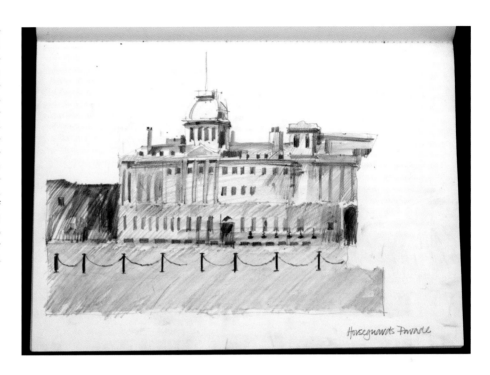

Horseguards, London; Kevin Scully (sketchbook drawing in HB, 8B and chisel-edged 4B wash pencils). The structure of the building was drawn using an HB pencil, keeping the marks loose but taking note of the proportions of its various sections. No attempt was made to keep any of the upright lines vertical, as sometimes a building can look more interesting leaning over a little! Some of the drawing was then shaded with the wash pencil, exerting more pressure in some areas that were darker in tone, whilst occasionally altering the angle of the pencil marks. This was then washed over with a waterbrush in clear water to add a little variation. Finally, the stronger darks were added with an 8B pencil.

look at a landscape we don't immediately see every leaf on a tree and every blade of grass: these are only detected when we focus on something in particular, and then these other elements are only in our peripheral vision.

It takes some practice to decide on what to leave in and what to leave out in a drawing, and making the right decisions comes with experience. Adding too much detail in the foreground can detract from your focal point, which may be some way in the distance, but adding some simple shapes in the foreground of the correct scale in relation to everything else, can give your eye a clue regarding the distance your focal point is away from you. It may be a few blades of grass, a fence, or a couple of rocks.

When drawing tonally the lightest tone will usually be the sky, so if you are drawing on white paper the sky will need very little shading, unless you are working under the threat of prowling storm clouds. The darkest part of a cloud is usually underneath it, so a little shading here will help to describe its mass and volume. In normal weather conditions, and especially on a sunny day with drifting clumps of clouds, those nearer to the horizon will appear to be of a smaller scale than those higher in the sky: this, of course, is because although they may all be of the same size, some are further away from you than others. So by drawing them in this way you will be creating a sense of distance.

This is one method of establishing aerial perspective. Another way is to shade the elements in the distance in a much lighter tone than those in the foreground and middle ground, as atmospheric conditions make objects in the far distance much more indistinct. As the distance between you and the elements in the distance increases, the contrast between them and the sky decreases. A sense of distance is further established by various elements overlapping each other, which you can convey by depicting them in different depths of tone.

There are occasions when some things are actually of the same tone, even though they may be of a different colour. If this is the case, when you are drawing tonally in black and white, you can make one of these elements slightly lighter or darker than the other, which will help to describe their difference. Also seek out diagonals, as these will suggest a sense of space, leading your eye into the distance or towards a focal point.

Inclusion and Omission

So you have decided on what you are going to draw, but there are some things that you are still not entirely happy about. Occasionally you may come across a scene that contains all the ingredients for a satisfactory composition, but this isn't always the case. Perhaps a hill appears a little too pointed, or a winding path has an unhappy kink in it. This is just the way things are in nature, but you have to remember that you alone are in charge of your depiction of what you see before you. So if it doesn't look quite right, you have the power to change things: you can move things around, enlarge them, remove them, or add to them.

This isn't as simple as it sounds when you are working out on location, but with a little experience it is possible. It quite often comes down to a simple thought process based on observation. We are often taught that we should draw or paint what we see, rather than render something in the way we think it should look. In other words when painting an apple, we should look at the true shape that it has and the space in which it sits, rather than just painting an apple shape. This to a great extent is true, and when tackling a landscape, we should be looking at the shape that a copse of trees makes instead of trying to draw or paint what we think it looks like. In other words, we should be looking at its shape in relation to other surrounding features – the sky, the foreground and the shrubs in front of it – and not just in isolation.

Drawing or painting the landscape on location is very different from painting a still life or a portrait in the studio, in that you are unable to physically rearrange things or move them around. If the fruits in your still-life set-up are all too similar in colour or shape you can replace some of them, and if your model's head is tilted too far forward, you can ask her to lift it up a little. But all the natural elements out there – fields, trees, grass and sky – are fixed, so if you don't like the way they look you will have to reorganize them on your paper or canvas. It's not always that easy to do this on the spot when there is so much going on in front of you, so sometimes it's easier to alter things back at the studio. It's probably easier to do this when you are sketching, rather than when you're painting.

Sketches and Paintings as Reference for Studio Work

It isn't always possible to complete a painting outdoors, for a number of reasons. The climatic conditions may change so dramatically that the scene you began painting has turned into something else entirely, the shadows have disappeared along with the sunshine, and the vibrant colours are now muted. If you are using watercolour and it has started raining, your initial washes will refuse to dry, so you might have to abandon painting for the day. Conversely, you may find that the river scene in pastel that you started painting in early morning, swirling mists is impossible to finish because now you find yourself in blazing sunshine.

You may have set up your easel in a field, gazing upon an idyllic, pastoral landscape, when suddenly the herd of cows grazing lazily and unconcerned, which up until now had been the perfect models, suddenly take exception to your presence.

The only course of action is to pick up your equipment and run for it. It is sometimes possible to return to the location at another time, but if you want to finish the painting whilst still fired up with inspiration, you can always continue working on it back at home. An alternative to this is to use this part-finished painting as reference for another painting. You can, of course, paint something purely as reference in the first place, particularly if you are happier using watercolour on location, but want to produce a large oil painting as a finished piece back at home.

Some artists like to produce the initial stages on location, and then complete the painting away from the subject, when it affords more time for consideration, especially if they want to create a painting that is more abstract than literal. I think many artists would agree that painting in an abstract, or even semi-abstract way, is rather difficult when you are confronted with stark reality.

Painting a picture entirely from pen or pencil sketches is perhaps more difficult, and a task that may be beyond those with limited experience in painting. Unless you have a photographic memory, trying to remember specific colours in a scene is tricky, unless of course you don't intend to produce a realistic painting. It's possible to make colour notes, and some painters find this useful, but writing about colours isn't the same as seeing them. For instance, if on your sketch you were to make a written note telling yourself that the roof on a house was 'terracotta' or 'pinkish terracotta', a quick look at a set of paint colour sample cards will show you that there is an infinite number of different colours that fall into that category. And colours perceived naturally are also affected by other colours around them, so any shadows cast on an object may contain a certain amount of colour from that object, or reflected light from elsewhere. By the time you have made a note of all the subtle variations in colour and tone, you might as well have painted them in the first place. It is possible to paint from notes on sketches in this manner, but you will need a great deal of experience to produce a painting that is entirely convincing.

You can, of course, combine both methods, and make colour sketches in whatever medium you are comfortable with – watercolour, ink, markers and so on – and then make written notes as well. There is no right or wrong way of going about this, and it's all a matter of what works best for you.

What you are able to do in a colour sketch is focus on a particular aspect of the scene that particularly strikes you, and one that is going to be the whole point of your painting. Mood and atmosphere can be captured in a colour sketch, something that isn't always possible in a photograph. The

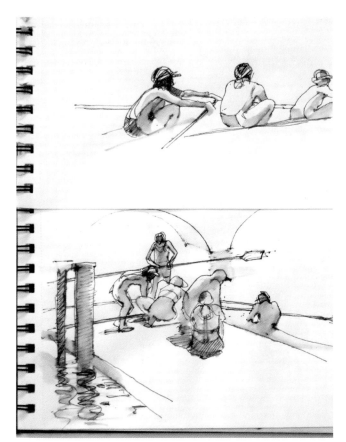

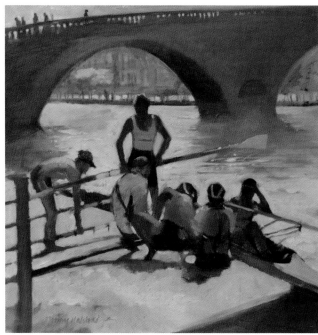

Spring Teams, Jenny Halstead. Pen and wash was the technique used in this sketch of a rowing team as they were out on the river practising early one Sunday morning in spring. Firstly moving out on to the river and then returning, their actions made lovely shapes with the oars and created interesting shadows as they glided across the water. As the artist sketched, she was aware of the rhythm they created with their careful and repetitive movement. The scene was later painted in oil, and the figures were reorganized in such a way as to create a satisfactory composition.

sketch should be painted in such a way that you will be able to rekindle the sensation that first inspired you, when you refer to it back in the studio. This sketch will be an 'aide memoire' and a complement to any photographs you may have taken. You will often find that you have created an atmosphere in your sketch, perhaps even on a subconscious level, that is entirely absent from your photos.

There is no reason why you can't execute an atmospheric colour sketch that captures the essence of a scene with as much or as little detail as necessary, and also make a detailed drawing of the same scene to be used as more extensive reference material. With this as back-up, you can decide how much detail you need to include, or how much you can do without. Drawing and painting are inexorably linked, and it's difficult to paint well if you haven't mastered a degree of drawing. It is possible to get away with it if you go down the purely abstract route, but even then there are abstract painters who

have already mastered the art and skill of drawing, whose work is superior to those who use abstraction as a means of expressing themselves without the use of any drawing skills.

Sketching is a natural stage of the painting process and is a way of connecting your eye, your brain and your hand in a continuous cycle. Even if you don't sketch for either the sheer joy of it, or for producing reference material, when it comes to producing a painting, you will be sketching on your canvas or board. You may be carefully drawing out every detail prior to painting, or you may be loosely indicating elements with a brush. Whichever way you do it, you will be going through the same thought process. It's impossible not to think when you are painting, as you will be constantly considering what colours to use, how dark to make the shadows, what kind of brushstrokes describe different parts of the picture best, and a thousand other thoughts will be filtering through your mind as the painting progresses.

A certain amount of preparatory work will pay dividends, as basic potential problems can be addressed at this stage. Settling on a satisfactory composition means that you are off to a good start even before you begin to paint. Thumbnail or compositional sketches allow you to see in an instant what works and what doesn't, especially if these are produced as tonal sketches. There has to be a balance between dark, light and the intermediate tonal values. You may be attracted to a scene because of the fantastic colours in it, but if there is no tonal variation, it will be a fairly dull picture. Darks won't appear dark if there isn't enough contrast between them and the other tones, and highlights will look sad if the whole painting is too light.

Some more experienced painters don't produce sketches for paintings any more, simply because they have repeated the exercise so many times that they immediately know exactly how they want the painting to look, and where the focus of attention is going to be, and just get started straightaway. Their brain has already gone through the initial thought process at top speed.

Depending on which medium you have chosen, you will have prepared your paper, canvas or board. If you are working in pastel, a tinted paper or pastel card will be attached to your board on an easel. If you are using watercolour, you will have some heavyweight paper attached to a board, or some lighter paper ready stretched, or you may simply have a watercolour pad, block or sketchbook. You may require an easel, but you may be happy working with just a pad resting on you lap.

If you have chosen oils or acrylic, you will almost certainly have an easel of some kind, unless you are working with one of the smaller pochade boxes. You will also have prepared a board or canvas by tinting it with some kind of thin colour to compromise the glaring white surface. This colour should be a mid tone, so that you can quickly judge the darker and lighter tones in relation to it. If you are working in acrylic this colour will be permanent, but if you are using oils, and providing the paint you have used was diluted enough, a rag dipped in white spirit will remove some of it if necessary. By doing this, you can also establish your lighter areas fairly speedily, and your darker areas can be created by adding a stronger version of the same colour used in the toning stage.

You can in fact produce an entire painting in this monotone fashion: it is a process that is long established and was once used as the underpainting for more detailed work in full colour. If you are uncertain about colour, an excellent way to begin painting is to use just one colour plus white, as you only have tone to worry about. Beginning with the thinly painted mid tone, you could slowly build up the painting with thicker paint until you have a finished, monotone painting. You could choose a dark colour such as Prussian Blue or Indigo, with the darkest darks being made by using the colour at full strength, and the other tones in the painting by adding varying amounts of white. This will also allow you to practise mixing paint to the right consistency and to experiment with brushwork, without the added difficulty of choosing and mixing different colours together.

There are alternatives when it comes to choosing a colour for an underpainting. If you want to play safe, choose a mid-toned, neutral colour: this might consist of a blue-brown mixture with a little white added to tone it down a little. It will get rid of the white and be an impartial colour against which to judge your other colours. Or, if you were painting an autumn scene which is going to have a bias towards golds, reds and browns, then you could mix up a mid-tone colour that hints at a little of each of these colours, with a mixture of Raw Sienna and Burnt Sienna. If its consistency is thin enough, the white of the canvas or board will show through and prevent it from being too strong and overpowering.

Some artists begin their painting when the underpainting is still wet, and do indeed achieve some success, but there is a danger that the painting can become too muddy if the thicker paint applied on top mixes too much with the paint underneath. Another option is to choose a colour that is in direct contrast to the overall dominant colour in the scene you are painting, providing it is not too intense. So if your painting contains a lot of green, then your underpainting can be biased towards red.

So, you are now ready to paint. If possible keep your painting surface in a position where there is plenty of natural light, but not in direct sunlight. Nor will you want to be in shade, because when you emerge, you will find that your colours are all too dark.

If you are using watercolour you will probably first draw out your composition lightly in pencil. If you make a mistake you may want to rub out some of your pencil lines, but take care when doing this, as too much erasing can ruin the surface of the paper. If you really need to correct mistakes, use a putty rubber rather than a plastic one, as it will be kinder to the paper. Providing you haven't pressed too hard with the pencil, it is possible to erase pencil lines even through the watercolour paint when it's dry, using a putty rubber. However, the occasional pencil line visible in a watercolour painting will not detract from it, and providing it has been drawn well, it could even add to its overall appearance.

Some compositional studies made in a sketchbook of this rather complex collection of buildings. They were drawn from different viewpoints, and show the different formats that were being considered for a final painting. Some changes had already been decided upon, in the belief that the composition of a picture is more important than accuracy. Apologies to the owners of the building on the hill that has been left out, but being so large, it created an imbalance in the composition. The shape of the hill in the distance to the right has also been altered.

This photograph was taken for reference after the compositional sketch had been completed.

Initial sketch on watercolour paper.

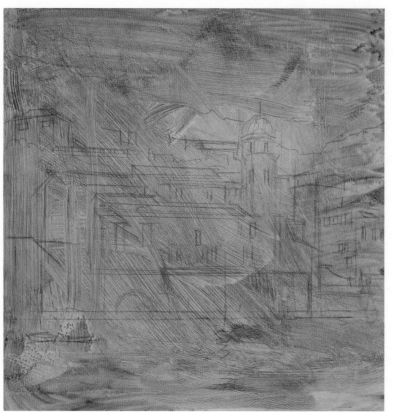

STAGE 1

Having decided on the composition and format, an MDF board of the right proportions was selected; it had already been tinted with a thin wash of Raw Umber. Rather than produce a painting in the actual colours seen, it was decided to use a limited palette of colours for a subdued painting of this otherwise colourful scene. The composition was then drawn in with a reasonable degree of accuracy but with little detail, using a dark blue coloured pencil.

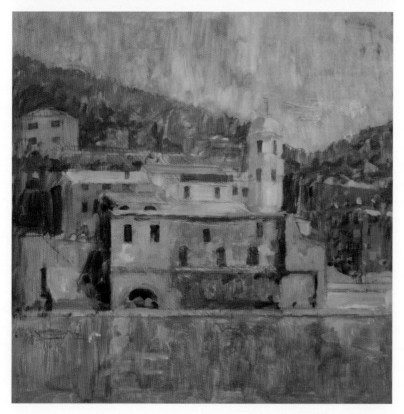

STAGE 2

A general colour was mixed as the basis for the range of colours that were going to be used. As this was to be a fairly monotone painting, the different areas were blocked in with varying mixtures of Titanium White, Burnt Sienna and Dioxazine Purple. On a couple of the buildings a little Cadmium Yellow Light and Raw Sienna were added just to introduce a variation in colour. Even at this stage, the distinct changes of tone have been loosely established. The paint has been applied fairly thinly so that the pencil lines still remain visible. With the addition of a little alkyd medium, the paint dries to a degree that allows subsequent layers to be added.

STAGE 3

A couple of different colours have been tested in the sky, made up of varying proportions of Titanium White, Raw Sienna and Cadmium Yellow Light. These have been left for future consideration whilst adding more opaque colour to the other elements in the picture. It was decided to keep the sky light in tone, so the white tower will eventually be painted in a tone slightly darker than the sky, but lighter than the background hills, so that it doesn't get lost.

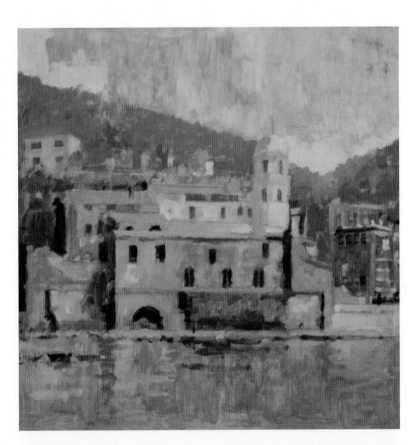

STAGE 4

At this stage, all the brushstrokes are considered as underpainting. Similar touches of colour have been added over the whole image to retain a kind of unity, whilst still keeping all the elements separate. The sky has been blended into the distant hills to establish a degree of perspective, and some of the reflections have begun to be suggested in the water. You can see at the bottom of the painting that some of the underpainting has been removed, whilst some colour used in the water has been wiped away, as it didn't look quite right. This has revealed the brushstrokes of the gesso primer beneath.

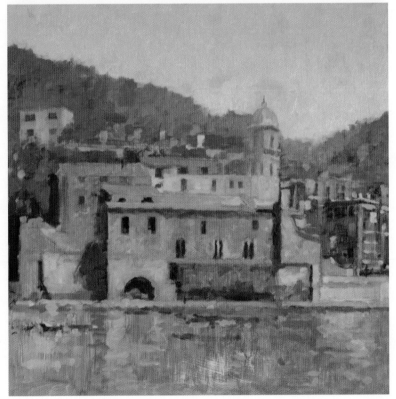

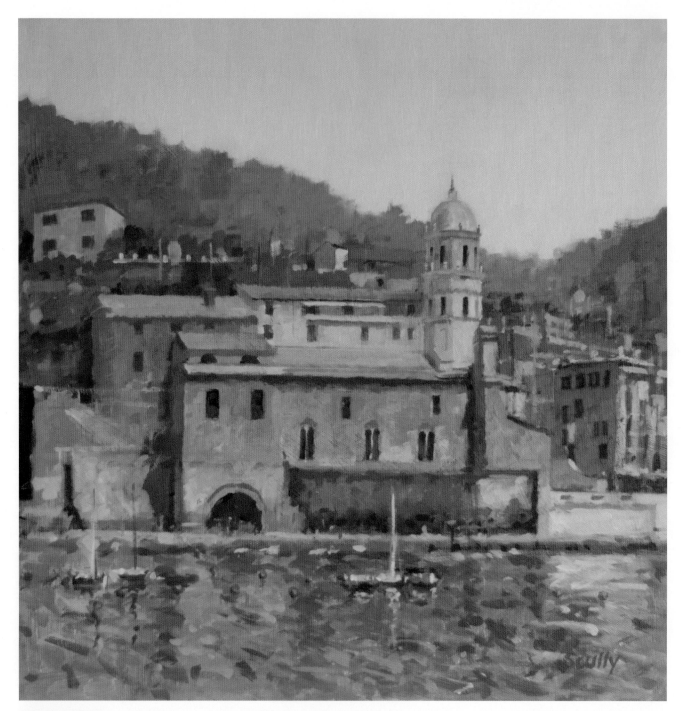

FINISHED PAINTING
The Harbour at Vernazza, Kevin Scully (oil on MDF board). The sky has been lightened, as it appeared just a little too subdued in tone. The water and boats in the foreground have been treated in a loose way so that the viewer's eye is drawn to the middle ground, which is the main focal point of the painting. Further small patches of colour were added throughout the painting with a square, synthetic watercolour brush, and a few looser edges were tidied up where necessary. The final touches were a few swift brushstrokes in the foreground to suggest some movement in the water.

STEP-BY-STEP DEMONSTRATION

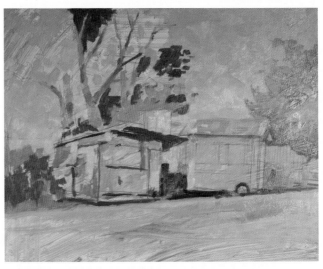

Castries, St Lucia, Kevin Scully (Caribbean sketchbook). The attraction of this particular scene was the sentiment painted on the side of the trailer. Before this sketch was finished, someone decided to park his large pick-up truck right in front of the shack. He wandered over to see was going on, and wanted to know why anyone would want to draw 'that pile of rubbish'. He suggested that a far better scene was to be found on a beach a couple of miles away, and with that helpful advice strolled off down the hill. He clearly wasn't going to move his truck, so the rest of the sketch was completed from memory and imagination.

STAGE 2

By establishing the tone of the sky first, and also referring to the sketch, it was then possible to determine how light or dark to make the other elements in the picture. Patches of colour were added here and there throughout the painting, which even at this stage determines how well they relate to each other. By moving all over the painting in this way, nothing is set in stone, and colours can be adjusted at any time. A little of the purple has been added into the blues of the shack and trailer, as well as the trunks of the trees, which unifies this as the main focus of the composition. Up until this stage the paint has been used in a fairly diluted way, by thinning it with turpentine.

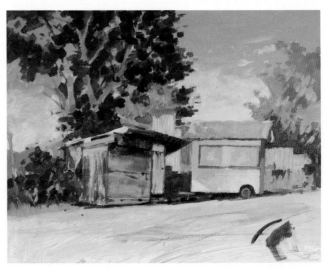

STAGE 1

A sheet of MDF board had previously been primed with three coats of acrylic gesso, each rubbed down slightly between each application. This produces a semi-absorbent surface with a slight texture that gives just enough tooth to stop the paint sliding over the surface. The board had been tinted with a thin mixture of blue-black oil paint, left on the palette from a previous painting.

The main elements of the image were copied very loosely from the sketch in dark blue pencil, knowing that as the painting progressed, a few changes would be made. The subject matter didn't call for the kind of initial detailed drawing that might have been necessary for a more complicated composition. The sketch was a stand-alone drawing with lots of white space around it, so the painting had to be extended to the edges of the board. The whole image was enlarged so that the trees on the left were less dominant and bled off at the top of the board. Some foliage and corrugated iron have been added at the right-hand side of the painting. Beginning with the sky, which is usually the area in the lightest tone, the various sections were then blocked in.

STAGE 3

Some thicker paint has now been used, and some clouds have been introduced into the sky. Looking at the sketch, it appears that the sun must have been almost directly above and a little over to the left, so some stronger shadows and highlights have been painted to suggest this. To add variety, the tree on the right-hand side has been painted in a way to indicate a different variety to those on the left. A dark shape to the right in the road gives the sense of a change in its direction, which is travelling downhill towards the viewer.

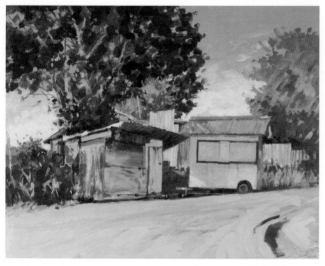

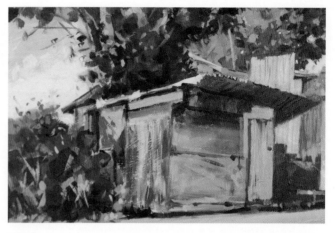

DETAIL

This detail shows how some of the semi-dry paint has been wiped with a rag, revealing the brushstrokes of the gesso beneath. This wasn't entirely intentional, as this was the result of removing some colour that didn't look right. But it was a happy accident that has added to the dilapidated look of the shack, so it has been left. As the paint was beginning to dry, some highlights were added by dragging paint over the slightly textured surface.

STAGE 4

This is further emphasized by brushstrokes going in that direction and the suggestion of a kerb. The dark tree formed a good backdrop to the shack, and the white clouds created some sense of distance behind the trailer. The intention throughout the painting was to keep it loose but not out of control, so a few details were sharpened up, such as the corrugated iron and the structure of the trees and grass. Some of the foliage has been painted over the clouds to create a degree of perspective. All the dark shadows are a mixture of Phthalo Green and Dioxazine Purple, which produces a beautifully rich and intense shadow colour.

FINISHED PAINTING

The bottom of the painting was looking a little short on detail, so some shadows that would have been cast by the overhead cables have been added across the road. The lettering and the strange circles were added, together with the washing line with the jeans hanging out to dry. The strip of metal across the top of the trailer was repainted as it didn't look quite right, and a little more detail was added to the wheel. The painting was completed with a few extra details, such as the dappled sunlight on the trailer, and further highlights and shadows were painted with flicks of colour, in keeping with the feel of the whole image.

Turning Location Sketches into Studio Paintings

The colours used in this painting were Winsor & Newton alkyd oil paints: Titanium White, Cobalt Blue, Cerulean Blue, Dioxazine Purple, Cadmium Yellow Light, Phthalo Green and Cadmium Red.

One of the advantages of working from sketches is that you can be less literal when it comes to producing a painting from them, particularly if there has been a long time lapse between making the sketch and tackling the painting. Sometimes sketches are made simply for the enjoyment of it and experiencing the atmosphere of a time and place. On other occasions sketches can be made specifically with the intention of producing a painting, and this usually happens within a day or two. But this fairly detailed sketch, amongst several others, was made in a sketchbook some time ago on a trip to the Caribbean. I hadn't intended to create a painting from the drawing at the time, but I unearthed it a couple of times since whilst looking for something else.

The objective behind the painting was to give it a particularly Caribbean feel with some bright colours applied in a loose painterly way, which would suggest the atmosphere of the location and the sentiment of the words crudely painted on the trailer. The paint chosen for this picture was Winsor & Newton alkyd oil paint, which is very useful when painting outside mainly because of the speed it dries at; this is quicker than ordinary oils but slower than acrylic, which allows just enough time to put down what is required. Alkyd is thinned with turpentine in the usual way, and the brushes washed out in white spirit. The slightly unrealistic colour scheme of primarily blue and green evokes the memory of that hot, sunny day when the sketch was produced.

Landscapes

I devour nature ceaselessly. I exaggerate, sometimes I make changes in the subject; but still I don't invent the whole picture. On the contrary, I find it already there. It's a question of picking out what one wants from nature.

VINCENT VAN GOGH

If you are planning on painting purely from observation, there are a few things to consider first. If you have unlimited time and the weather is favourable, you can simply pack up your equipment and venture forth. You will perhaps have a general location in mind, if not a specific spot. You may stumble upon

Castlemorton Common, Antony Bridge (oil on canvas). An example of complementary colours being used to good effect, where the predominantly warm colours in the foreground are balanced against the cool hills in the distance, which have turned blue as the light begins to fade towards the end of the day.

a scene immediately, which is just perfect for what you have in mind; but more than likely you will have to do some scouting around first. If your intention is to paint a simple landscape, devoid of any buildings or man-made structures, it will have to possess some strong element of design, or a focal point that will direct the viewer's attention. It's no good just painting a field in the foreground and a wood in the distance with sky above, and hoping for a successful picture. Spend some time walking around and looking at the view from different directions, and if possible from different levels.

As a general rule, placing the horizon halfway up the painting is not a good idea, although there are always exceptions to the rule. Unless you have some strong, vertical lines to counteract the strong horizontal focus, or several other elements to partly obscure its presence, it often just doesn't look right. This is especially true if the landscape is flat and featureless. It would be better to place the horizon at a point about one third of the way from either the top or the bottom of the picture. The horizon is always at your eye level, which is the point immediately in front of you when you look straight ahead. But this doesn't mean that you can't place it anywhere you like in your painting.

If you are particularly struck by a dramatic sky or the colour of the clouds, this is where the focus of attention should be, so this should take up the larger proportion of the composition. The painting would undoubtedly fail if you were to give this less elbow room, and instead paint a large area in the

One of the mistakes that many beginners make when painting a clear blue sky in landscape format is to paint it with slow horizontal brushstrokes as if they were painting a wall. This results in leaving horizontal lines, particularly in watercolour. Unless you are able to produce a perfectly even wash from dark at the top to light at the bottom, which is possible with a little practice, it would be better to apply the paint in a more random fashion. A clear blue sky with stripes will always look wrong, so it's better to apply the paint in a more arbitrary way, alternating the angle of the brushstrokes. One way to reduce this stripy look in watercolour is to dampen the paper first so that the colour bleeds, which diminishes the risk of hard edges.

foreground where nothing is happening. Of course this also works the other way around, and if you want to emphasize a strong feature in the foreground, this should be given some extra space. In the natural order of things, when we look at a scene briefly, our eyes focus on the middle distance, which is that area neither immediately close to us, nor that in the far distance. Unless we look down we don't see every blade of grass, and unless we look up we can't see detail in the structure of the clouds. This is simply the way in which our eyes work. If you wanted to paint a purely naturalistic scene, this would be a strategy to consider.

By using a viewfinder you can weigh up the pros and cons of placing the horizon in different positions and evaluating where you want the emphasis to be in your painting. If you have a viewfinder that is divided into thirds, you can try placing a particularly strong element on one of the points where the lines cross. This could be a tree, a rock or a path that winds its way to the horizon.

The natural format for painting a landscape is just that, but there is no reason why you can't choose a portrait shape or even a square. If you are painting a wide open landscape with a big sky, a portrait format would have the opposite effect to what you were trying to achieve. A portrait format is perhaps suited to a landscape containing a vertical feature, such as a tree in the foreground or middle distance.

You will be observing your subject from a different viewpoint depending on whether or not you are seated. An interesting viewpoint can be taken from high up, which will mean you are looking down on a landscape and will generally see much further into the distance. The emphasis here could be on the features immediately below you, or by means of aerial perspective, the effect that distance has on colours,

which become fainter in tone as they disappear into the distance until landscape meets sky.

A clear, empty sky can have as dramatic an effect in a painting as one that is action packed, providing that there is sufficient interest in the rest of the composition to hold the viewer's attention. Here too, the illusion of distance can be created by gradually lightening the colour of the sky as it reaches the horizon. This replicates the way that we perceive the sky. On a clear, bright sunny day the sky is blue, and without going into a detailed scientific explanation, this is due to the light from the sun passing through the nitrogen and oxygen in the earth's atmosphere, and scattering short, blue light waves throughout the sky. As you look towards the horizon, less of the blue light reaches you because it has to pass through more air, so the colour there appears paler and sometimes even white.

Water

Water in all its forms provides a fantastic range of material for painting subjects, and whether you are drawn to tranquil river estuaries at sunset, or wild and ferocious seas, the possibilities are infinite.

Still water in a river or canal will have reflections, and these will alter depending on your position. Working out why some things are reflected in water whilst others aren't is a fairly puzzling business, as reflections depend on many things.

The shallow water in streams is more often than not warmer in tone than deep water, and its appearance is affected by the kind of material on the bed of the stream, which may be sand, rocks and plants. Its movement produces ripples as it travels over rocks, stones and natural debris. These ripples contain complex reflections of colours from the surrounding area. The colour tends towards green, and the small particles of sediment and debris reflect light, which creates a pale tonal value in the water. Distinct reflections aren't visible when the water is moving, but instead are broken up into indistinct patterns. In places where the water is deeper, the colour becomes darker in tone.

When the sky is reflected on the surface of water, it is usually a tone darker in reflection than it is itself. One of the general observations of reflections is that the colour of objects appears in a slightly lower tonal key than they are in reality, and that sometimes the lighter coloured areas that are reflected in the water appear darker, and the darker areas can seem lighter.

The closer you get to water, the less the sky and surrounding

Otranto, Puglia, Italy, Kevin Scully (watercolour sketch). The day this scene was painted from the harbour wall at Otranto was fiercely hot, and because of this and the glare of the white paper, it was painted in stages after several retreats into the shade. There was a variety of boats in the water, including speedboats and catamarans, but these looked rather out of place, so were left out.

features are reflected. You will notice that the water closest to you will have rather indistinct reflections, whilst that further away will reflect much sharper images. Also, the water closest to you will appear darker than that in the distance, which will be brighter and lighter. A peculiarity of reflections, and something that people often don't notice, is that occasionally you will see the reflection of something that isn't visible when looking at the object itself. For example, when looking at a boat sitting in still water, you may notice the reflection of the underside of the buoys hanging from the side of the boat, whilst this cannot be seen when looking at the buoys themselves. This occurs because you are looking at the reflected object from an angle of view as far below the water's surface as your eyes are above the water.

You may also have noticed when walking along the sand at the water's edge that the seagulls standing in an inch or so of water not only create a strong reflection of themselves, but depending on the angle of the light source, often cast a shadow as well.

It isn't really necessary to be able to understand fully why all these things occur, but it is advisable to take note, and to look out for these peculiarities if you are striving for realism in your paintings.

Painting fast-flowing rivers demands a completely different approach in execution to that needed when attempting to capture the myriad of reflections of boats in a calm estuary. The effect of moving, deep water, whether it is the result of

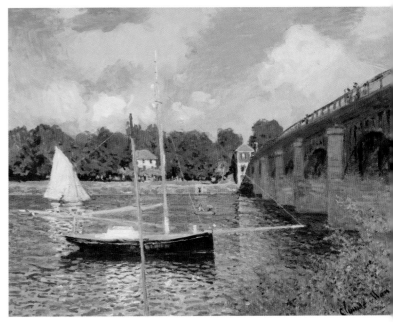

The Bridge at Argenteuil, Claude Monet (oil on canvas). Monet offered this advice to the American artist Lilla Cabot Perry: 'When you go out to paint, try to forget what objects you have before you, a tree, a house, a field or whatever. Merely think here is a little square of blue, here an oblong of pink, here a streak of yellow, and paint it just as it looks to you, the exact colour and shape, until it gives your own naïve impression of the scene before you.' This describes exactly the way in which Monet executed this painting. (Courtesy National Gallery of Art, Washington)

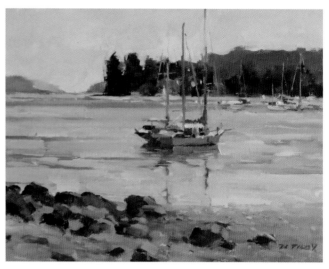

Against the Light, Deborah Tilby (oil on panel). This subject was a challenge for the artist, as it was tackled on a windy day when the boats refused to sit still in the water. Consequently, it was painted at speed using a wet-in-wet technique that suited the subject matter perfectly. Had the boat been placed in the centre of the composition, the painting would not have worked visually. As it is, the eye is led towards the boat, and is then directed around the strip of land behind it, and out into more open water beyond. The verticals of the boat's masts contrast well with the horizontal landscape.

Rodl 3, John Owen (watercolour). This was painted on a wonderful early spring morning using a limited number of saturated, clean and luscious colours. Black focuses your eye on the area of greatest contrast, producing the maximum illusion of light. Spattering with gouache created the blossom on the overhanging branches. Gouache is useful as it lends an additional dimension of opacity, which provides a contrast with, and emphasizes, watercolour's transparency. The painting conveys a simple message, and anything that could distract from it has been eliminated.

Honfleur, Roger Dellar (oil on canvas). The predominantly cool colours used to paint the buildings and road in shade on the left-hand side of this picture, contrast beautifully with the warm range of colours seen in the buildings and water on the right-hand side. The strong diagonal line of the road dividing the two sections of the painting further strengthens this effect.

Montrichard, France, Felicity House (pastel, underpainted in watercolour). This was painted on a boiling hot day overlooking the River Loire, when the artist had to stand under a tree for shade. Everyone but mad dogs, Englishmen and artists was hiding indoors. She enjoyed the opportunities that this scene offered, particularly the building in profile, the simple reflections, the soft, pale browns and creams, and the subtle geometric shapes.

Barges at Pin Mill, Roy Connelly (oil on board). In this atmospheric painting, the artist has used a fairly limited colour range to convey a sense of calmness in this scene. The colour that has been used to tone the board can be seen throughout the painting, and has the effect of bringing together all the separate elements. The still water adds tranquillity to the quiet and peaceful composition.

a fast-flowing current, waves created by a moving boat, or merely a strong wind blowing across its surface, creates an absence of reflections. There will be few, if any reflections visible in a river that is in full flow, unless the water is clear and shallow. Movement can be suggested by the direction of brushmarks, and the positioning of highlights reflected by the light from the sky. In some instances there will be a mixture of both moving and calm water, which means there will be some reflections as well as white water.

Because water is fluid and often moving, it is often difficult to focus on what is really happening, and it is therefore a challenge to draw and paint. Painting waves in a seascape is a real test of your observational skills. As the water is constantly moving, it is impossible to paint waves exactly as they are at a particular moment, but by studying their repetitive pattern and observing how they roll over, it is possible to paint them from memory. Photographs of waves will hold a clue to their shape, and the way they form and then break up, how they arrive in staggered lines, and how the water deposited on the beach retreats back into the sea.

When painting waves 'en plein air', and when standing fairly close to the sea, there is a temptation to keep altering them as each one rolls in in a different position. A good strategy is to spend a reasonable amount of time just observing, and then to paint them in just four different tones: the shadow, the mid-tone, the highlight, which is usually white, and the tone beneath this highlight. These tones can vary slightly in

hue, depending upon what you see. The darker tone may be greener in colour, the mid tone greyer, and the shadow under the foaming highlight a pale turquoise. Once these colours have been pinned down and the structure of the waves established, a few subtle variations can be added as details. If you are painting the sea from any distance, it is likely that you will see much less variation in tone, so using three colours will probably be sufficient.

The sea, of course, needn't be painted in isolation, and by including other elements such as shoreline, cliffs, rocks and beaches, there will be added interest. Waves crashing on to rocks or over a seawall will make a far more interesting painting than waves crashing over each other. Consider also painting the sea or a lake from an elevated viewpoint, or perhaps just as a distant backdrop to a landscape.

The sky is vitally important and not to be neglected when painting water, as it is often the sky that determines its colour, especially when painting large expanses of water, such as lakes and estuaries. A painting that demonstrates no connection between the two is lacking in unity, as the two elements are interwoven and inseparable.

Boats, naturally enough, are an important element associated with water. Colourful fishing boats and canal boats will provide you with fantastic reflections, and sometimes just the reflections themselves make wonderful paintings. Sailing boats with their glistening white hulls, and rigging flashing in the sunlight, provide an often needed vertical contrast to the

Basalt Cliffs, Lennox Head, Kasey Sealy (oil on hardboard). The inspiration for this painting was all about the drama of the dark rock headland contrasting with the soft, subtle distance. It was painted in the studio after a plein-air trip in the area. The artist likes to paint these almost immediately on his return, so they are still fresh in his mind's eye.

Connemara after the Rain, John Owen (watercolour). Painted near Clifton on Ireland's west coast late one cold afternoon, with the sky clearing after being washed clean. The tide is on the turn, exposing those black strips of rock. As is so often the case, the quality of light at a particular moment is the artist's subject. It has been painted in a high-key sky with a large squirrel mop, first applying a few fast dabs of clean water at random, and then infusing gentle drifts of dilute Cerulean Blue, Yellow Ochre and Burnt Sienna. The important thing is to keep each colour pristine so that it mingles on the paper and tints the light reflecting off it, giving an illusion of airiness. The feel of bright light is maximized by contrasting the free shapes in the sky with the complementary purple-coloured water and sharp-contoured forms of the black landmasses. Finally the foreground was relieved with some warmer pigment, and the swirling, sparkling light on the water created by scratching with a sharp blade.

horizontal nature of water. And don't dismiss the more utilitarian vessels even though they may not afford much colour, as their rugged forms and bulk can provide an excellent foil to a softer, watery background. Boatyards contain a treasure trove of nautical paraphernalia, and provide outstanding material for paintings.

Boats are notoriously difficult for the beginner to paint, particularly if they are bobbing about and turning in the water. It can be very tricky to draw their complex shapes and to make them look as though they are actually sitting in the water. You will have a better chance of drawing a convincingly accurate boat if you choose one that has been hauled up for winter maintenance in the boatyard, where you could also include some people busily working.

As well as painting water from the shore, a different kind of view can be obtained by painting from the water itself, looking back towards the land. If you have the opportunity to take a sea or river cruise, or even a trip in a small boat, this will give you a chance to see the land and buildings from a different viewpoint, and you will also be able to experience the sensation of water very closely indeed.

These are only general guidelines, and of course the best way to paint water is to get out there and paint what you see, and not what you think should be there.

Buildings

Buildings included in a landscape or seascape can greatly enhance a painting, as well as adding an extra dimension. This man-made element will give you the opportunity to add variation in colour to a scene that might otherwise have a limited colour range. This might be a broken-down corrugated-iron shed in a field, or a beautiful white beach house by the sea. But buildings themselves can be a great subject for a drawing or painting. If you paint realistically, there is less of a margin for error than there is in painting a landscape, as accurately drawn perspective will play a great part in producing a successful painting.

Perspective plays an important part in drawing, whether it's in depicting a herd of cows in a field or a row of beach huts on a promenade. Perspective is merely a way of formalizing, and making sense of the way our eyes work, and the way in which we see things. We can only draw or paint in two dimensions, but armed with a certain amount of knowledge regarding perspective, we can render an image in a way that suggests a third dimension. Drawing or painting buildings face on won't cause us too many problems, but as soon as we

Château de Chenonçeau, Felicity House (pastel, underpainted in watercolour on Colourfix card). This pale but beautiful architectural scene with lovely soft reflections was painted from the river bank, where the artist could include the full reflection of the château. She always carries a selection of supports in different colours, so that an appropriate one can be chosen for a particular painting. This soft yellow support was chosen because it represented the predominant colour of the subject. When working outside and when time is limited, choosing a suitable colour means that part of the work is already done. Unusually for the artist, she sat down to paint this scene, which allowed her to peep through the arches and paint the shadows within, adding to the three-dimensional quality of the building.

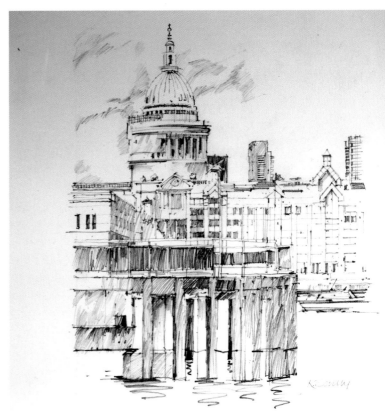

St Paul's from the South Bank, Kevin Scully (HB pencil sketch). The attraction of this composition was the contrast between the fine architecture of St Paul's and the crude, no-frills landing stage in the middle of the Thames. There was a tarpaulin draped around part of the building whilst restoration work was being carried out.

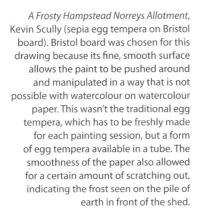

A Frosty Hampstead Norreys Allotment, Kevin Scully (sepia egg tempera on Bristol board). Bristol board was chosen for this drawing because its fine, smooth surface allows the paint to be pushed around and manipulated in a way that is not possible with watercolour on watercolour paper. This wasn't the traditional egg tempera, which has to be freshly made for each painting session, but a form of egg tempera available in a tube. The smoothness of the paper also allowed for a certain amount of scratching out, indicating the frost seen on the pile of earth in front of the shed.

view them from an angle, things can get somewhat trickier. But providing you're not thinking of attempting an oil painting of the Winter Palace in St Petersburg which is going to include every single window and architectural detail, a simple understanding of two-point perspective will be invaluable. With this basic knowledge you will be able to work out how to draw a building from any angle. It's not necessary to draw or paint every detail of a building, but it is important to establish its structure, and the way it sits on the ground.

As with looking at any scene, the basic rule of perspective applies, and this is based on your eye level. Your eye level is that imaginary horizontal line level with your eyes when you are looking straight ahead, and it helps to draw in this line lightly before you start drawing. Imagine a building that is a simple rectangular shape being viewed at a slight angle. The lines that you see on this building which make up the windows and doors, and which are below your eye level, travel upwards towards it and meet at a point somewhere along it. Any lines that are above your eye level travel down to it and also meet at the same point. This is known as the vanishing point. This applies to the face of the building, but you must also locate another vanishing point for the side of the building along your eye line, and follow the same procedure.

So in essence, the lines below your eye level go up, and the ones above go down. Holding a pencil horizontally at arm's length level with your eyes will demonstrate this to be the case. You can also use the pencil to measure relative distances, heights and sizes, both horizontally and vertically, by sliding your thumb up and down its length to make comparative measurements. An even better way of doing this is to substitute the pencil for a non-transparent ruler, and take measurements in millimetres.

This puts into practice what you actually see, because of the way that our eyes focus on things up close, as well as further into the distance. If you look at a drawing involving even the most basic perspective and something looks amiss, it is usually because some of the lines are going in the wrong direction. A common mistake is to make part of a symmetrical shape that is furthest away from you, a window for instance, look larger than the part that is closest to you.

Proportion is vitally important when drawing buildings, so comparisons can be made and measurements taken, as you would when working out perspective. If you are inexperienced, it may take a while to construct your drawing and to appreciate fully the basic principles, but with experience it will become second nature, and the more often you draw buildings, the sooner you will be able to draw them freehand and with confidence.

Once you have become comfortable with perspective, everything else is relatively easy, and with experience comes self-assurance, which will allow you free rein to interpret buildings in any way you wish. You can even abandon perspective to a degree if it gets in the way of your creative energy, but an understanding of it is fundamental to drawing.

Exaggerated perspective can be used to emphasize the scale of a structure. A tall building can be made to look taller by tweaking the vanishing points to create the effect you want, and by changing the scale of objects on the ground. For instance, if you draw a car at half the size that it would normally be in relation to a building, it will make the building look twice as big – and of course this works the other way round: so if you want to make a building look small, then enlarge something standing next to it. You can also suggest and exaggerate distance by placing one large object, perhaps a road sign, in front of a road lined with buildings in a smaller than realistic scale. This immediately creates a large space between the foreground and the background without necessarily showing anything in it.

As well as just drawing buildings for the fun of it, think about composition. When you are sufficiently inspired to draw something, consider what it is that attracts you to it. If there happens to be a jumble of not very appealing modern street furniture in front of a beautiful Georgian townhouse, you can place the disparate elements in your composition in such a position as to emphasize the difference between them. You could even render them each in a different way, perhaps drawing the street furniture in a harsh and flat way that suggests little aesthetic appeal, and then drawing the house with carefully considered detail. Sometimes a sense of composition comes naturally, and you may not even be aware of it, so if what you have drawn looks good, you may have composed it without knowing it.

As well as just drawing in black and white, think about adding colour to your drawings. You don't have to colour the whole drawing – in fact just by introducing a little colour here and there, you can give it a greater impact where necessary. If you are knocked out by a house in a suburban street that has been painted in a lurid mauve, or a shop sign in fluorescent green, make this the dominant feature of your drawing by using these colours as you see them, and then perhaps just drawing the adjacent buildings in black and white or grey. Follow your instincts and use your imagination.

In towns you will encounter not only buildings, but also street signs, vehicles, building sites, roads, bridges, flyovers, gates, trees, hot-dog stands and a thousand other things, so there will always be plenty of inspiration out there, and

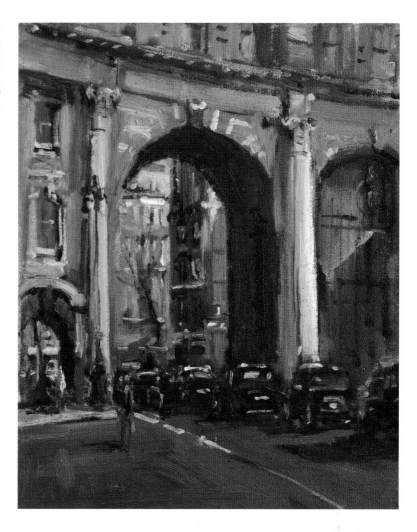

Admiralty Arch Study, Roger Dellar (oil on board). Painted 'en plein air', this image was later developed into a larger painting in oils. The portrait format chosen is particularly suited to the subject matter, and its proportions correspond to those of the arches. The line of black taxis and the figures define the scale of the structure.

something for you to draw. Don't discount the decrepit, abandoned, broken and ugly: they are all part of our towns and cities, and say something about the way we live. A battery of television aerials or a tangle of electricity cables may not be the most exciting things in themselves, but they can still make an interesting and poignant drawing. The way they are drawn is the most important thing, as it illustrates the way we have reacted to what we have seen, and the way we have applied our own personal signature to it.

Painting buildings on location is more of a challenge, and because they are generally a lot more complicated than landscapes, the time element is one factor to take into consideration. A garden shed will obviously not take as long to paint as a dozen houses in a town square, although you may be painting in a very loose style. Even producing a simple drawing on your paper or canvas will take some time to draw out prior to beginning the painting. If you are painting in an urban environment, especially in a city centre, you may have to contend with traffic, crowds, noise, vehicles, cyclists and many other unwanted interruptions. If you are using watercolour or some other fairly speedy medium, this isn't

as much of a problem as setting your easel to paint in oils, acrylic or pastel. A way of minimizing the amount of time actually painting on the spot in one go would be to draw out your composition on one day, and then return on another day to paint the picture. If it is an especially complicated composition, you could return on as many days as necessary in order to finish the painting.

A river will often run through the heart of a city or town, and will provide plenty of material for a painting. It you are an early riser, dawn is a great time to be out painting a city's river, with its backdrop of buildings from different decades. Also consider the scruffier, industrial part of the city, which may include a canal with moored canal boats, barges and other utilitarian river craft. Sunset, too, can cast a picturesque spell over a cityscape that is grey and uninspiring during the day. Reflections in the water, and smoke emanating pink and blue from factories, can turn the tragically dull into an exciting and colourful painting.

Towns and cities are not the only place to seek out buildings. Villages will contain a wealth of period houses built from brick, stone, slate, flint and thatch. There will be pubs, shops

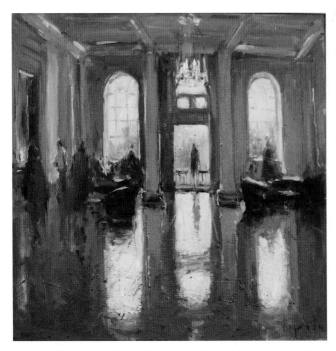

Somerset House, Roger Dellar (oil on board). An evocative interior looking into the light source, where the brilliant reflections are the primary subject of the painting, even though the eye is directed towards the figure at the far end of the room. The other figures have been added to include some activity and to create an architectural–human balance. Although they are in silhouette, the change of tonal value in which they have been painted justifies their presence in the whole scene, rather than simply being flat shapes against the light source. The reflections indicate bright daylight on a highly polished floor.

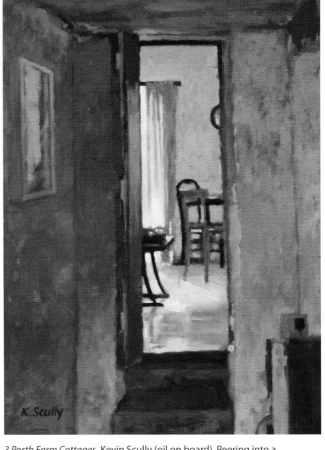

3 Porth Farm Cottages, Kevin Scully (oil on board). Peering into a seemingly empty room through a doorway always conveys a sense of intrigue and mystery, and the open French windows suggest that someone has just left the room and gone into the garden beyond and out of sight – which indeed they had.

and churches, and often a rural landscape as a backdrop. Old churches and churchyards are often very picturesque, and you may not need to spend too much time seeking out a favourable viewpoint. There is a risk, though, when painting picturesque village scenes, that you may produce something that is just too nice and too perfect, so it is always worth finding a viewpoint that isn't too obvious and hasn't been painted from the same spot a thousand times before, and is on every postcard in the village shop. Instead, try to include elements that are rather more mundane and involve real life and the less charming, such as a pick-up truck or a speed limit road sign. A far better picture would be one that combines the picturesque with the mundane – the thatched roof with the litterbin.

Churches, both inside and out, and churchyards make good subjects for a painting. Churchyards may not be the first place you think of when you go looking for inspiration, but they often supply all the ingredients for a winning painting.

There will be the church, often with stained-glass windows and perhaps some landscape as a background, and there will almost certainly be trees, one or more of which will be dark green yews; there will be tombstones in marble and stone, and you may even come across an alabaster angel with a broken wing, standing guard over one of them. And the chances are that you will be left alone to get on with your painting, without being disturbed by anyone.

Don't neglect the interior of buildings – and they don't necessarily have to be anything spectacular. An interior glimpsed through an open door, with light emanating from an unseen window, suggests that perhaps there is something secretive happening within. As well as looking into a building, you could paint a view looking out through a window or door. But if you wanted to go for the spectacular, there are countless country houses and cathedrals where you could set up your easel to paint, or could just find a quiet corner and get out your watercolour pad.

STEP-BY-STEP DEMONSTRATION

The colours used in this painting were Titanium White, Cobalt Blue, Ultramarine, Raw Sienna, Burnt Sienna, Raw Umber, Permanent Rose, Phthalo Green and Cadmium Yellow Light.

This board has been toned with a thin wash of Raw Sienna, and the composition has been drawn out in pencil, taking care to ensure that the perspective is correct before painting.

A French easel set up with a small board, ready for painting. Most of the equipment needed can be stored within the easel itself.

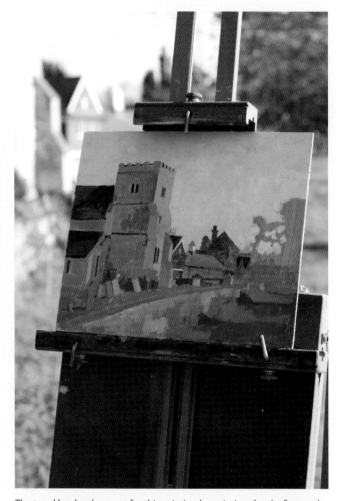

The tonal key has been set for this painting by painting the sky first, and then relating all the other tones to it. This stage shows the other main areas laid in with a mid-tone of their general local colours; these will be adjusted as the painting progresses, and further detail added on top of the basic colours.

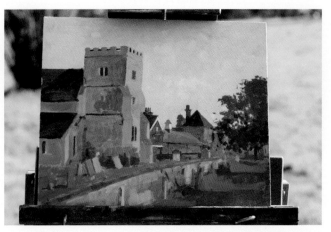

A wooden palette used for mixing the oil colours, with a selection of paints from different manufacturers. Note that only the colours used in the painting have been squeezed out on to the palette; they have been arranged in no particular order. The photograph shows some small synthetic brushes used for painting the smaller details. Also the palette is seen in a horizontal position in sunlight, but whilst painting, it was actually held in a more vertical position in shade, so that the colours could be mixed accurately and appeared the same on the palette as they did on the painting.

The underpainting almost complete, and ready for the final details. The sun was now shining on the board, so the easel was turned to a position in semi-shade.

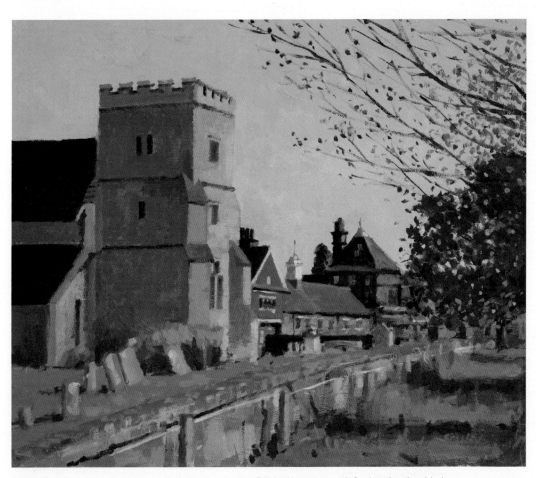

St Mary's Church, Streatley, Kevin Scully (oil on board). The finished painting, with further details added. The last parts painted were the branches and blossom on the flowering cherry tree. The painting was completed in about two hours, by which time the sun had moved, so the shadows and highlights were left unpainted until the picture was nearly finished.

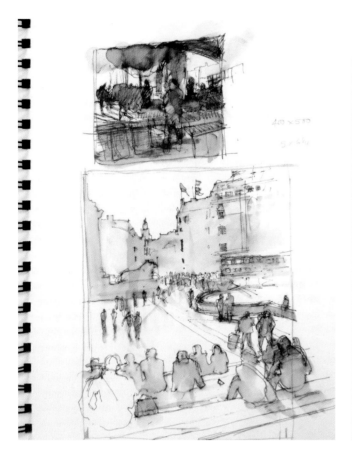

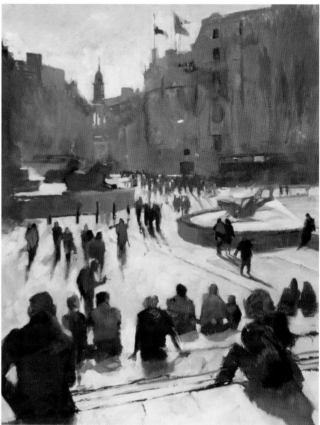

Don't Look Now, Jenny Halstead. Sitting on the steps in front of London's National Gallery in winter, the artist first sketched this scene in pen and wash, making use of the strong light and sharp shadows. It was later worked up into an oil painting, moving the figures around a little in order to create a pathway through them and into Trafalgar Square and beyond, to find the flash of scarlet on the roofs of the buses. Your eye is led into the distance by the way in which the majority of people are looking in that direction, where the buildings and figures have been suggested with as little detail and fuss as possible.

People

By introducing people into your compositions, particularly when working on urban scenes, you will add a sense of scale and energy. Unless you intend making a particular statement about an urban scene, figures will give it the necessary human element, even though they may not be its main focus.

Humans are endlessly varied in their appearance, gestures, features and clothes. They also come in all shapes, colours and sizes, and there are lots of them. You will find them in cafés, at markets, on buses and trains, at libraries and on beaches.

If you are merely drawing people, there is no great need to create an exact likeness, partly because that person will probably never see the drawing you've made of them, but also because what you should be attempting is not a deep and true likeness as in a portrait, but more of an overall suggestion of their essential character. Sometimes you might not even need

to draw any features at all. For instance, if someone is wearing a very large hat and their face is in shadow, by simply drawing the hat and a dark shape for their face you will have captured the overall first impression of that person.

People may come and go in speedy succession, so being able to draw at speed is an advantage, but this is not something that is easily done without practice. If you are not comfortable with the frantic pace of drawing people on the move, you can begin with drawing some that are going to be stationary for some time. A great place to start is in the library, where there are usually several people using computers. As well as young students, there will be a collection of people from several age groups who will remain fairly motionless for long periods of time. There may also be a reading session taking place, where an adult will be reading a story to a group of young children seated on the library floor.

Working the Flotation Tanks, Jenny Halstead. As 'artist in residence' at an archaeological project, one of the artist's tasks was to capture in drawings and paintings, the various tasks and processes involved when excavating a site, and this scene in summer shows students at work. The figures were drawn in pen as they moved around, eventually returning back to the same positions. Drawing the table and wheelbarrow early on established a scale the artist could then refer to when drawing the figures at the correct size, when they had moved position. She then sat with her watercolour box open and proceeded to add some colour.

Other places where people are trapped in reasonable relaxation are the nail bar, the hairdresser's and the barber's, although unless you are paying to have a manicure or are having your hair done, you may not be entirely welcome.

If you have decided to draw someone who is going to remain in roughly the same position for some time, take a few moments to study them. If they are doing something repetitive, such as cutting hair or typing on a computer, they are likely to return to, and repeat that movement or gesture from time to time. You can decide which one will make the most interesting image, and base your drawing on that, drawing it with a little more detail each time that pose is adopted.

Public transport is another place where you will find convenient models, although those travelling by underground and on buses may only be going a short distance. Long-distance trains provide an excellent cast of examples of humanity, and if you're lucky you may find yourself in close proximity to someone who has fallen asleep: this will give you ample time to study them in detail without worrying as to whether or not they are annoyed with your constant staring.

Waiting rooms of any description are a good hunting ground, with doctors' and dentists' surgeries, hospitals, train stations and airports full of people displaying a variation in body language. Some may be relaxed and others agitated, some may be excited and some bored, some may be sitting and some standing. People stand in any number of ways, and

An Andalucian sketchbook; Kevin Scully. A great time to draw people is when they are actually drawing something else. They will remain fairly stationary just long enough for you to capture the essence of the individual way in which they sit or position their body.

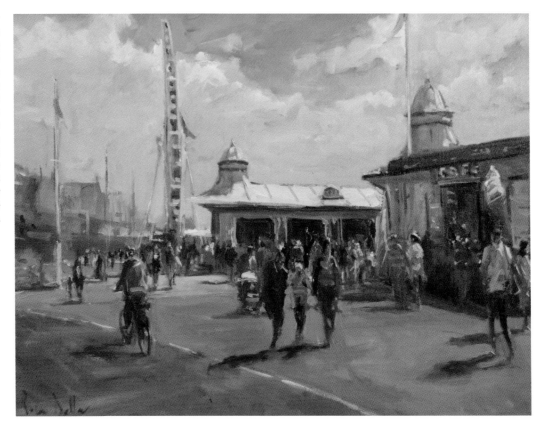

Brighton Promenade, Roger Dellar (oil on canvas). The artist created this painting from a smaller, half-size painting of 12 × 10in painted 'en plein air'. The painting was concerned with conveying a sense of the activity of warm light on a scene of seaside crowds, out for a good time. Note how the shadows cast by the figures decrease in intensity as they recede into the distance.

they may have their hands behind their back, or they may have them thrust in their pockets. Even from a distance you can often recognize a person if you know them reasonably well, either by their stance or the way they walk. This uniqueness is difficult to capture, but can be hinted at by means of exaggeration.

In cafés, restaurants and pubs people will be more animated, particularly if they are in groups. Finding a table in the corner of a café will provide you with some interesting subjects. If you don't want to be spotted drawing someone, choose a person who is sideways on or turned slightly away from you, as they are less likely to see you. It's impossible to hide completely, but the majority of people who know they are being drawn don't normally mind. Some may even come over to ask you what you're doing, and when you show them, their reaction may be of mild interest, or they may be flattered, or they may be horrified. In a café you may be able to work 'undercover' by secreting your sketchbook, if it's small enough, inside a book or a magazine.

You may be happy working solely in black and white, but a little colour added occasionally will give your drawings life. Just by introducing a patch of colour on a skirt or hat, or on a particularly striking part of the figure, will help define your impression of that person. A drawing of a market place will invariably include figures, and in an ethnic area there will be a great variety of people of different races for you to include. Nobody will be still for very long, however, although the stallholders will undoubtedly return to their position behind their wares from time to time.

When sketching in another country, particularly in one that doesn't have a tradition of artists going around drawing people, you will almost certainly attract the attention of a few onlookers, especially children. At first this can be quite entertaining, and quite often one or more of your audience will ask you to draw them. After a while, however, it can become rather tedious, especially if you just want to draw people unobtrusively, simply going about their business. On other occasions, and in certain countries, you may be asked for money if someone agrees to let you draw them.

Adebanji Alade. The artist's hunting ground for interesting people to sketch is London's transport system. In this double-page spread in his sketchbook he has added locations and dates beneath each person, to remind him of when and where he created the sketches.

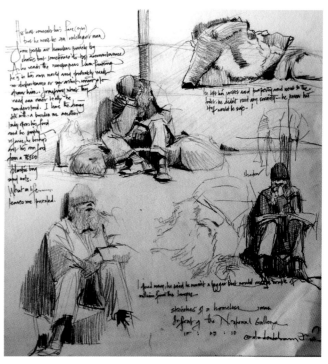

Sketch of a homeless man; Adebanji Alade. A sketchbook page with notations and pencil drawings of this man as he adopts a variety of different positions, seated in front of The National Gallery, London.

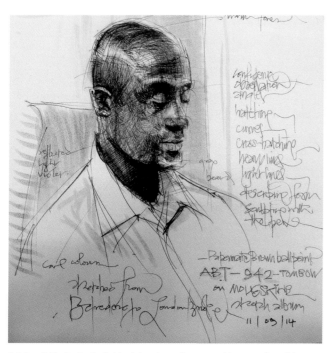

Adabanji Alade. An individual drawing of a man, with notes describing the colours and the drawing methods used, and the materials. The drawing is dated, and a note has been made of the two London Underground stations that the man was travelling between when it was produced. The drawing demonstrates the great variety of techniques employed in producing this wonderful sketch in pen and marker.

Adebanji Alade. The artist couldn't resist drawing this man who was travelling on the London Underground between London Bridge and Westminster, as his characterful face provided great subject matter. It has been drawn with a 'Bic' fibre-tipped pen and Tombow ABT dual brush pens in a Moleskin sketchpad.

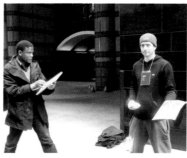

Sketching a big issue seller; Adebanji Alade. The artist has a passion for people and faces, and here he is in action sketching a big issue seller in Villiers Street, London. This man is going to be fairly stationary for just enough time for the artist to capture a reasonable likeness. He won't be posing, but simply standing in his usual way whilst selling the magazine.

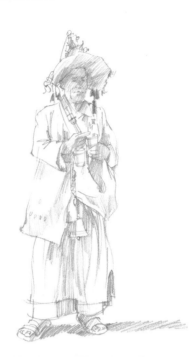

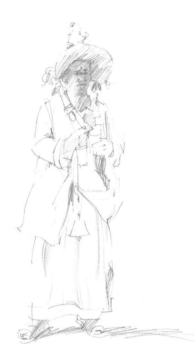

STAGE 1

In this exercise, the drawing of a Moroccan water-seller was simplified in stages by eliminating various areas of detail. The initial drawing shows several layers of clothing and other paraphernalia hanging from the man's hat and around his neck. To capture all of this in a quick sketch is almost impossible, so parts of it have to be left out. As this is a rather complex drawing, there is obviously a limit as to how much you can leave out whilst still retaining the essence of the image.

STAGE 2

In the second drawing, much of the detail in the water-seller's face has been left out, and the complicated folds of his garments have been removed. A much looser style of line has also begun to be established.

STAGE 3

The third stage shows detail further reduced, and certain parts of the original drawing have been left out altogether.

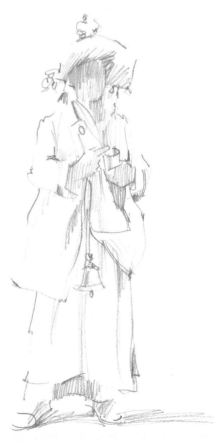

STAGE 4

In the last drawing, all detail in the face has vanished and, as with the other shaded areas, it has been drawn with rapid pencil marks. To give the sketch some life, other lines have been drawn swiftly with varying degrees of pressure applied to the paper. By practising this method of simplification, less complicated figures can be rendered quickly and simply whilst still indicating the spirit of the pose.

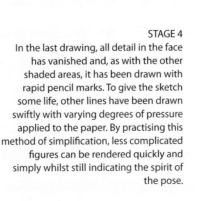

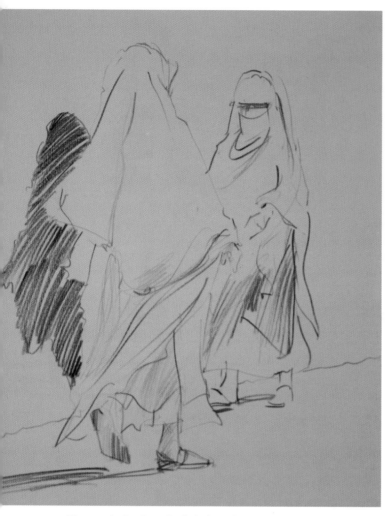

Moroccan Ladies, Kevin Scully (coloured pencils on Canson Mi-Teintes Cream pastel paper). An exercise in reducing figures to the minimum of lines, whilst still retaining the essence of the pose.

Developing a Shorthand

Exaggerate the essential; leave the obvious vague.
VINCENT VAN GOGH

Drawing figures is often something that people have difficulty with, but as with most things, it's a question of observation and practice. Life-drawing classes will give you a good grounding in this discipline, and the process of drawing the figure from life can be rewarding in its own right.

Sometimes you have to draw figures very quickly. If you're sitting in a café, or on a bus or train, there is always the risk that the person you're drawing will suddenly change their position, or even worse, get up and walk away, giving absolutely no thought to the fact that they have totally ruined your drawing!

Here is a way of teaching yourself to draw at speed. First make a detailed drawing, preferably from life, or if this isn't possible, from a photograph, and use this as a starting point. Choose an image that has a certain amount of movement or dramatic gesture. It doesn't really matter whether or not the person is clothed, but perhaps it's an easier exercise to begin with a clothed figure. Try to determine which are the most important elements of the figure: it might be the angle of their head, their stance, or maybe just a single striking feature. Then begin another drawing, eliminating a few of the less relevant details. Now do two or three more drawings of the same figure, each time reducing the number of lines needed to express what is significant about the figure. Try to keep your pencil lines loose and organic.

The object of this exercise is to develop a personal kind of shorthand, so that when you look at a figure you begin to instinctively leave out the immediately irrelevant detail. In this drawing from a Moroccan sketchbook, large passages on the figures have been left blank because there wasn't really much going on. By squinting at the image, I was able to determine which areas were darker than others, and these were shaded more heavily. Movement of the figures was suggested in the way the pencil marks depicted the direction of the flowing fabric of their clothes. This sense of movement was also accentuated by varying the amount of pressure applied to the pencil marks. The drawing was given the suggestion of three dimensions by exaggerating the shadow on the wall, cast by the figure on the right-hand side.

This is, of course, a lot easier when you are drawing figures as distinctive as these, and it's not quite as easy if you are trying to draw a figure that is rather mundane in appearance or lacking in movement or gesture.

The best piece of advice anyone can give concerning figure drawing is to attend a life drawing class, where you will learn about how the body is put together by studying it closely through lengthy, stationary poses from a model. You will also learn how the body moves by making rapid drawings when the model is in motion.

Remember that when you see a drawing that is not only convincing, but also looks as though it's been dashed off in seconds, the person who has drawn it has practised drawing figures in that way hundreds or perhaps thousands of times!

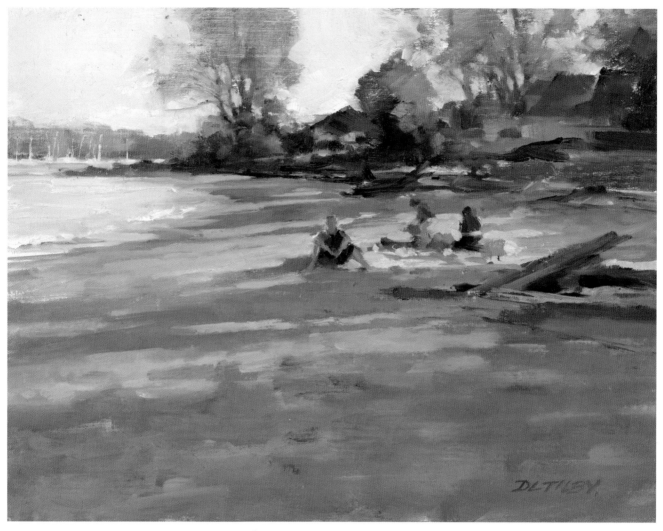

A Quiet Moment, Deborah Tilby (oil on panel). This was painted one summer evening at a beach near the artist's studio. The warm colour palette that she has used, and the lengthening shadows, tell us that this is evening, and the relaxed figures add a sense of calmness to the quiet scene. The gentle waves have been painted very simply and with an economy of brushwork. What could have been a rather bland expanse of beach in the foreground has been painted in such a way that the evening shadows are emphasized by the directional way in which the paint has been applied. There is a minimum of detail here, which doesn't detract from the main focus of the picture. The generally muted colours form an excellent backdrop to the brighter clothes worn by the figures.

People in Paintings

Oh! I must somehow manage to do a figure in a few strokes.

VINCENT VAN GOGH

You may want to include some figures in your paintings, and they will of course add a sense of scale to the landscape, and even more so to the urban environment, even if they are in the distance and rather indistinct. In fact the vaguer they are, usually the better. It's very easy to spoil a good painting by including some figures that don't look quite right. A common mistake is to make their heads too large and their limbs too rigid.

It's actually more difficult to draw people on a small scale than it is to draw them larger. Because of their size, even a line drawn in the wrong place by a millimetre or two can mean the difference between a convincing figure and one that is not. So great care must be taken to ensure that they have their heads and feet on the right way round. When it comes to painting figures, they should also be given a kind of shorthand treatment. A useful trick when painting figures in movement is to give them just one and a half legs, and occasionally one and three quarter legs, and instead of painting them all in an upright position, include one or two that are leaning over to one side a little, which suggests a shift in balance when moving quickly.

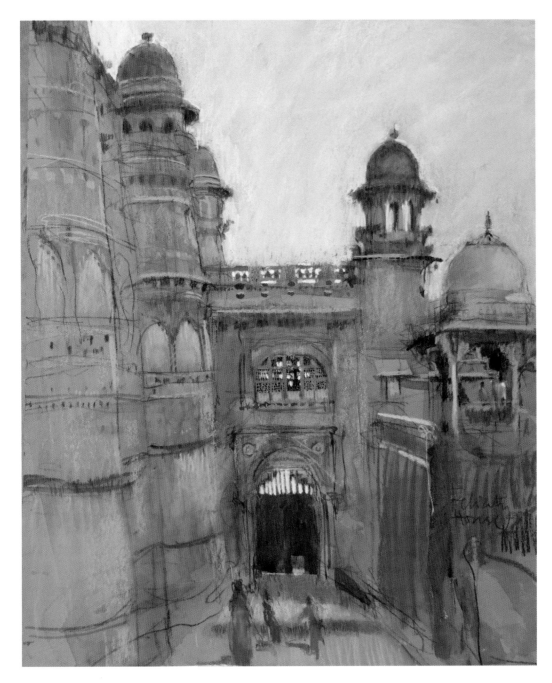

Gwalior Fort, India, Felicity House (pastel, underpainted in watercolour). Unusually for this part of the world it rained while this was being painted, but an enterprising lad appeared and asked the group of artists if they would like umbrellas whilst they worked: 25 rupees for the umbrella and 25 rupees 'for holding'. Naturally everybody paid up to have the umbrellas held. The ladies in the colourful saris added a nice splash of colour, but sadly there was not too much sunshine to 'lift' the beautiful features of this quite wonderful place, although the fabulous blue ceramic tiled decoration has helped.

In a bustling city scene with lots of figures scurrying around, you may not want to draw attention to the people at all, but instead to a building in the distance. If you include too much detail in the figures in the foreground this focus will be cancelled out, so although they may be closer to you, just treat them as shapes and paint them simply. Proportion is vitally important, so look at the length of limbs in relation to the torso, and avoid arms and legs that are too straight. A slight curve strategically placed will add a more natural look. Use as few colours as possible – perhaps one for the top half of the body, one for the legs, one for the face, and perhaps one for the hair. So a good strategy would be to draw the figures carefully and then paint them simply, without trying to include facial features or other unnecessary detail. You could keep a sketchbook of figures that you have drawn, to be inserted in your paintings when required.

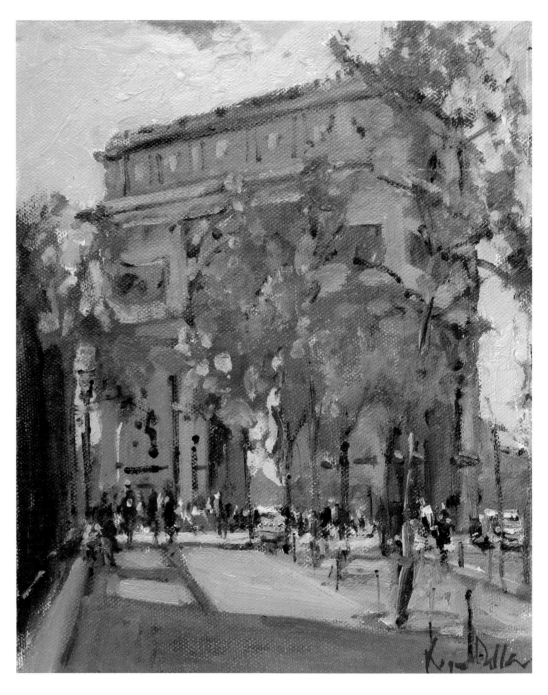

Admiralty Arch, Roger Dellar (oil on board). Painted 'en plein-air' on a bright, sunny day, the figures and trees lend a sense of scale to the imposing arch, while the strong diagonal lines in the composition lead your eye into the painting.

Whether or not to include figures in the landscape is another matter. There are some schools of thought that believe they should be left out altogether. If you do see people in the landscape, they are usually just out walking, or in a rural environment they may be at work on the land in some way. My inclination is to leave them out unless they are relevant. A figure or two loading up a trailer attached to a tractor wouldn't look out of place, and nor would a woman feeding some hens, but a solitary figure just walking through the landscape never looks right.

Figures look perfectly acceptable around boats and harbours, whether they are fishermen or tourists, as this is a more concentrated and bustling working environment, and it is where you would expect to see people. People on beaches are a popular subject for painters, as they can provide plenty of colour with their windbreaks, sun umbrellas and other trappings. As well as people relaxing, there may well be a certain amount of activity within the framework of sea, sky and beach.

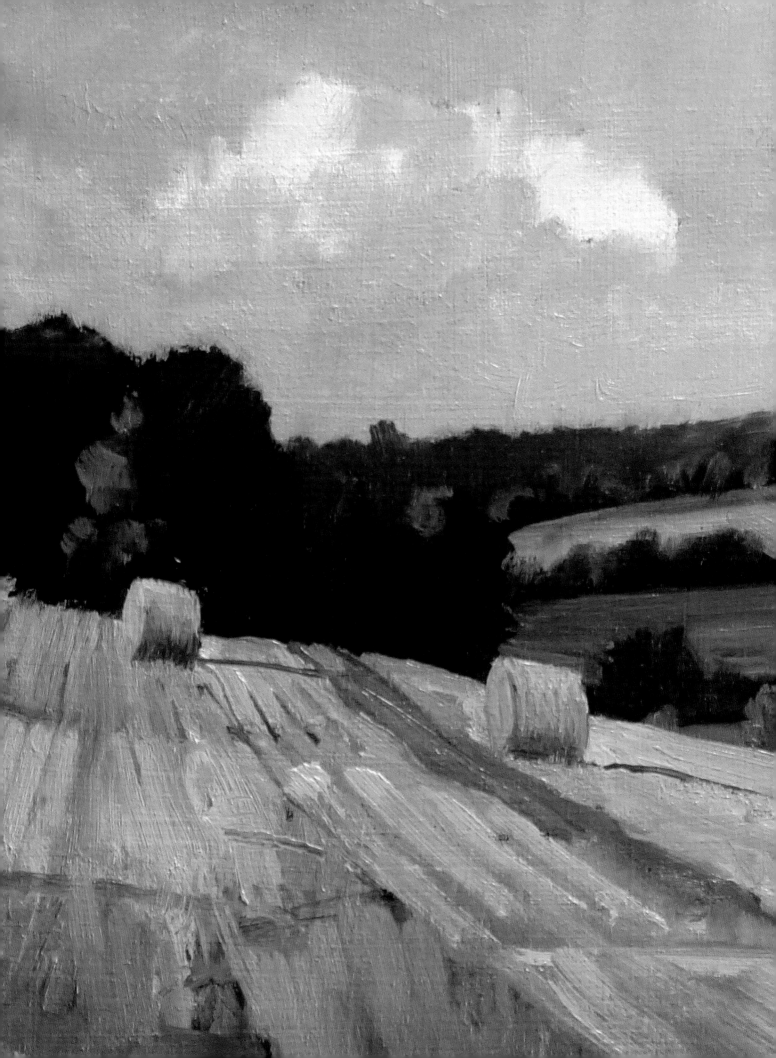

Drawing and Painting Techniques

Composition and Perspective

Composition

Whilst it may come fairly naturally to you to compose a picture to produce an interesting and visually pleasing arrangement, there are a few procedures that can help you achieve a stimulating composition.

One of these long-established aids is the 'Rule of Thirds', sometimes called the 'Golden Mean', where your picture is divided equally into thirds, both vertically and horizontally. Where these lines intersect produces four 'hotspots', and it is on, or very close to, one or more of these points that the viewer's attention should be focused. If you are making a compositional sketch with the intention of producing a finished drawing or painting, you can divide your page into thirds and begin by roughly drawing your main point of focus on one of the four 'hotspots'. This will immediately create an agreeable starting point for your drawing.

If there is another, lesser point of interest in your subject matter, try placing this on another point diagonally across the page from the primary point of interest. Providing this does not compete for centre stage with your main focus, this can produce a harmonious balance to your composition. With experience you may find that you are creating some wonderful compositions instinctively, only to discover that when analysed, they fall into the 'Rule of Thirds' concept.

You can make a simple viewfinder by drawing a grid of thirds on to a piece of transparent acetate, and then taping it on to the back of a piece of card with a hole cut into it. You could make one in a landscape format and the other in portrait format. Grey or black card is probably a better choice of colour than white, and a black fineliner pen is ideal for drawing the lines on to the acetate. This can be held in front of your chosen subject and moved from side to side and backwards and forwards until a satisfactory arrangement has been arrived at.

A useful addition to your drawing kit is a product called 'Viewcatcher', which incorporates a push-pull lever that allows you to choose a composition and alter the format by adjusting the proportions both vertically and horizontally.

Detail, *Straw Bales, Box Valley*, Roy Connelly (oil on board).

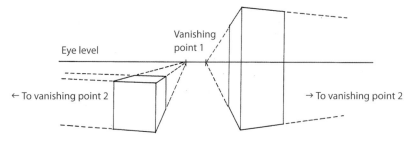

This illustration demonstrates two-point perspective. Although each box has its own two vanishing points, they will both be located somewhere along your eye level. Each box is turned at a slightly different angle to the other, so their vanishing points are in different places. If they had been placed in parallel, they would share a common vanishing point, no matter which angle they are viewed from. Vanishing point two has to be estimated, as it falls some way off the page. Note how the lines above your eye level are travelling down to it, whereas those below your eye level are travelling up.

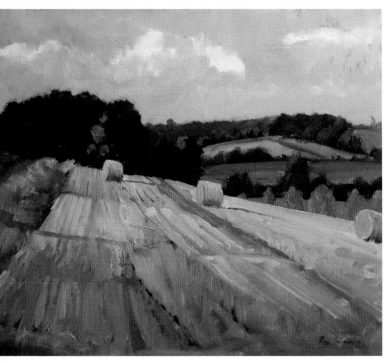

Straw Bales, Box Valley, Roy Connelly (oil on board). In this painting created in late summer, the artist has used a strong diagonal element, intended to take the viewer's eye in a particular direction – so although the straw bale on the left is the smallest of the three, it becomes the focus of attention. This strong, oblique dividing line also tells us that, because of the field's sharp contrast with the darker landscape behind, as well as sloping down to the right, it also slopes down in the direction away from us. The way in which the blue-green trees to the right of the painting diminish in size adds to this illusion.

To intensify this main focus of attention even further, you can place both your darkest dark and your lightest light on this spot, which will guarantee a very strong focal point in your picture. A focal point can also be created by including extra detail, more intense tonal value, or a dominant contrast in colour or size, in that area where you want your main point of interest to be.

Rules are there to be broken, and are useful as a guide, but a drawing or painting doesn't necessarily have to have a single focal point. If you want to emphasize the chaos or complexity of a scene, the viewer's eye can be kept moving around the picture by including many centres of interest. You may also simply trust your instincts, and if a composition that doesn't follow any rules looks good, then it is good.

Choosing an appropriate format for your composition is also an important factor to be taken into consideration. If you are drawing or painting a panoramic landscape with wide open spaces and skies, it would be counter-productive to choose a portrait or even a square format shape, when a landscape, or better still an extended landscape shape would be better suited to emphasize the dramatic composition. If you are using a sketchbook to draw or paint a horizontal image, you can open it up to extend your composition over both pages.

When drawing or painting a landscape that has very little detail, you may want to emphasize either the sky or the land area. By placing the horizon, or eye level, directly in the centre of the image you will confuse the viewer's eye, which won't know which area it's supposed to be looking at. But by either raising or lowering this line you can orchestrate your intended main point of focus. If there is a dramatic cloud formation, the sky should be given the greatest amount of attention, so the horizon line should be lowered; but if the main interest lies in the foreground, the horizon should be raised. However, if you want to lead the eye on a path through the foreground to a point of interest somewhere in the distance along the horizon, it would be possible to achieve a successful composition by making the land mass larger than the sky, even though your focus is not on the land at all.

A balanced composition can be arrived at by a combination of vertical and horizontal lines, connecting and intersecting at strategic points in the picture. This has the effect of making the eye travel across the picture, taking in subordinate, peripheral details as it moves up and down. These pathways can be cropped at the extremities of the picture's framework,

which has the effect of coaxing the eye into travelling once more back down the lines of visual communication.

Diagonals perform a similar task and can add a sense of dynamism to a composition, particularly if the subject matter is mainly on one plane, either horizontally or vertically. Diagonal lines entice the eye to travel in one direction or the other, and as with verticals and horizontals certain details can be added on the fringes of these lines for additional interest. If there are elements along these horizontals that are fairly regular in size – for instance trees, fences or railings – then a sense of space and distance can be created as they diminish in size as they stretch into the distance. Roads and paths also accentuate this element of distance, as they become narrower towards the horizon – and don't forget that clouds can perform a similar task by suggesting another dimension. Even though clouds are of an irregular size, they generally appear smaller further into the distance, merely because they are further away from you than the clouds immediately above you: so if small clouds are painted at the top of the picture, and large ones near the horizon, things just won't look right.

Perspective

A basic understanding of perspective is fundamental when attempting buildings, but it also comes into play with all forms of drawing. If the basic rules of perspective have been ignored due to a lack of understanding, no matter how well something has been drawn or painted, it will all have been in vain.

There are a few basic principles to grasp, which are the cornerstone of understanding and describing perspective as we see it. These rules make sense of the way our two eyes work, and how they focus on objects. There are two ways in which this three-dimensional visual phenomenon can be translated into two dimensions when drawing or painting, and they can be described as linear and atmospheric perspective.

Linear perspective is used to make sense of the way that the scale and location of objects can be determined as they recede into the distance. Aerial perspective does this by describing the way in which colours and tonal values change, and how atmospheric conditions create blurred edges to objects that are further away from us. By combining these two theories, we can create a certain feeling of three-dimensional realism in our drawings and paintings.

Basically, any object, whether it's a tree, a building, a car or a person, will appear smaller, the further away they are. If that object, for instance a building, is viewed at a slight angle, the part of that object which is further away from you will appear smaller in size than another part that is closer to you.

The best place to begin with is to sit at a table facing a wall and attach a large sheet of paper to the wall opposite you. Make a mark on the paper exactly level with your eyes. Using this as the starting point, draw a line horizontally across the whole sheet of paper. This is known as your eye level. Place a rectangular object on the table, a box for instance, and also place another rectangular object next to it, perhaps a taller box. The top of this object should be above the eye level that you have drawn on the wall. Close one eye, and holding a ruler at arm's length in front of you level with one edge of the small box, make a visual note of where the edge of the ruler crosses the eye-line. Now hold the ruler in front of you along the other edge of the box and you will see that both of these lines meet at the same point on your eye level. This point is known as the 'vanishing point'. No matter which way you turn the box, both sides of it will meet at a point somewhere along your eye level.

Repeat the same exercise with the taller object, and you will notice that the top and bottom lines also meet at the same point on your eye level, no matter at which angle the box is turned. It's useful to remember that any lines travelling away from you below your eye level will be going up to it, and any lines travelling away from you above your eye level, will be going down to it. This is perspective in its basic form and is known as one-point perspective.

You will notice, however, that as the book and the box have four sides, there are two other lines that travel in a different direction. These also meet at a point somewhere along your eye-level line. This point can also be located, but depending on the angle at which the object is turned, it may be at a point beyond the scope of your piece of paper and must be estimated – but if the wall and paper were long enough it could be pinpointed accurately.

Things get slightly more complicated with buildings, which is where three-point perspective comes into play. The same theory applies, though, whereby any part of an object that is further away from you will appear smaller than a part that is closer to you. So if you are looking at a tall building it will appear to diminish in size as its vertical lines travel upwards, and they will eventually converge at a vanishing point somewhere up in the sky.

Aerial, or atmospheric perspective can be introduced to suggest distance, even though there may be no linear perspective present. When we first view something briefly, we tend to focus on the middle distance, which is the area at and around the level of our eyes. This is usually along the centre of a picture. If we look down slightly, we will see more detail in the objects immediately in front of us, but this is not where our eyes normally look first. If we were to draw or paint this area in great detail, it would prevent us from focusing on that natural band of vision lying in the middle distance, so this is generally drawn or painted in a slightly looser way, as if in our peripheral vision. We can suggest distance beyond our focal point by drawing or painting this part of the picture in a less well defined way, where objects have diffused edges and their colours are more muted.

The two forms of perspective can, of course, be used simultaneously to great effect, and there is nothing to stop you using exaggerated perspective to create an added sense of drama in your pictures. Once you have grasped the basic principles, perspective can be manipulated to suit your own needs, and doesn't have to be an obstacle in the way of creativity.

Drawing Techniques

Drawing in Pencil

When drawing in pencil, the most comfortable and natural way to hold it is as you would hold a pen when writing. For most people this means holding the pencil between their thumb, forefinger and middle finger, whilst resting it in the crook of the hand. This will give you the maximum amount of control over it, and you will be able to create a vast range of marks, from fine outlines to vigorously shaded areas of tone.

By altering this natural grip and holding the pencil in the palm of your hand, but still between your thumb, forefinger and middle finger, the pencil will lie in a position almost horizontal to the paper. Marks created by holding the pencil in this way will be broader, as a greater part of the graphite in the pencil will be in contact with the paper. This grip is ideal for producing large sweeping gestures, and is often a more comfortable way to draw when your paper or sketchbook is vertical. Drawing on separate sheets of paper attached to an A4 or A3 clipboard will enable you to hold your drawing in a more vertical position more comfortably than you could when holding a sketchbook. There is a risk when drawing in a sketchbook on your lap or on a table top that perspective will become distorted, particularly when drawing buildings.

A pencil is the ultimate, user-friendly drawing instrument. You can use it to produce a simple, linear drawing, or you can build up areas of hatched lines to suggest different directional planes. You can vary the pressure exerted when shading in, which will produce different tonal areas, from almost black to light grey. You can also smudge it with your finger to soften passages, and erase it to create highlights. You can produce further variations in the marks you make by holding the pencil at different angles to the paper. Your pencil can be sharpened with a scalpel or craft knife to produce a chiselled point, which will let you create different line widths, depending on how you hold it. You can turn the pencil when drawing to produce a line that alternates between broad and narrow along its length. You can produce a lightning sketch in a few seconds, or you can spend hours in making a realistic and almost photographic image.

By combining different pencils together, both hard and soft in the same drawing, you can imply variations in dimension and form. A notion of perspective and space can be suggested by using a different weight of pencil for objects in the foreground to those in the background, and an even greater degree of contrast can be achieved by adding marks with a very black conté, or oil-based pencil.

Coloured Pencils

For those who like to draw in a linear way, coloured pencils can be used in a similar way to the techniques described for graphite pencils, and can also be used to introduce a little colour into a pencil drawing. They are especially effective used in a linear way when rapid and expressive lines are overlaid in successive, different colours, without blending them together. The appearance of one colour can be suggested by the juxtaposition of two or more other colours. They can also be used to create highly detailed coloured drawings by careful shading and overlaying.

Watercolour Pencils

A step on from ordinary coloured pencils, watercolour pencils can provide an alliance of several techniques. Some sections of a drawing can be filled in with solid colour, and others parts can be drawn in a linear way. Water can be brushed over one or both of these areas, dissolving the colour in a controlled way. Whilst still wet, this can then be drawn into with more colour, to add stronger accents and definition. A water brush can be used for this, or even an ordinary brush in clean water. You could also dampen parts of the paper with an atomizer containing water, and then draw into these areas. However, care must be taken not to overdo the process, as the surface of the paper will become damaged by constantly drawing into it when wet.

Drawing in Charcoal

If you don't mind getting messy, charcoal can be used to produce lively, tonal drawings, when large areas can be covered at speed. Because it tends to sit on the paper rather than becoming too engrained into it, one of its advantages is that it can be continually altered and adjusted during the drawing's progression. To a great degree, areas can be darkened, then lightened again by wiping, smudging and erasing. Highlights can be created with a kneaded putty rubber by removing the charcoal almost back to the original surface of the paper. It can be sprayed with fixative to seal it, and further darker marks can be applied on top.

One way in which a tonal drawing can be made is to wipe the whole surface of the paper with powdered charcoal to produce a mid-tone of grey, and then lighter areas can be created by removing some of the charcoal with a putty rubber. Further negative and positive areas can be consolidated by this reductive and additive process, until the correct tonal balance has been achieved. Chalk can also be added to define further, brighter highlights.

Charcoal is more suitable for producing larger drawings on paper, rather than in a small sketchbook, and drawings will have to be protected when completed because of charcoal's rather fragile state – ideally they should be sprayed with fixative. A more portable alternative to sticks of charcoal are charcoal pencils. These are slightly harder than the willow sticks, so the drawings will have a slightly different appearance.

Malvern Hills, Antony Bridge (pencil and charcoal). An initial compositional sketch, drawn from a viewpoint at the top of the Malvern Hills looking south. In this drawing the artist has quickly established the tonal values he intends to create before starting work on a large oil painting on canvas.

A stone detail from the pyramid at Palenque; Colin Moore (fountain pen and gouache in A5 Moleskin sketchbook). Sometimes a small detail, such as this sketch of a stone carving spotted at this Mayan ruined city in Mexico, can say as much about a location as a full blown panoramic view.

Drawing with Pens

The traditional way of applying ink to paper was by a dip pen. The beauty of using Indian ink with a flexible steel nib is that it produces a variety of line width according to the degree of pressure exerted. Its drawback is that it doesn't hold much ink, so you have to keep dipping into the bottle to replenish the supply. Nibs are available in a variety of sizes and shapes, and a drawing can be made using different line widths.

Pen and ink drawings have a particular look to them that is difficult to achieve with other drawing instruments. Areas of tone can be produced by a scribbling technique that slowly

Street scene, Berkeley, California, Colin Moore (dip pen and wash in an A4 Daler Rowney sketchbook). A lively sketch using a minimum of washes, in tones ranging from pure black through to two different greys on white paper. The clever use of horizontal and vertical lines with distorted perspective adds a certain tension to a scene, which otherwise could have been fairly mundane subject matter.

Central Valley, California, Colin Moore (dip pen and wash in an A4 Daler Rowney sketchbook). The juxtaposition of the man-made electricity pylons with the trees has made for a dynamic composition in this sketch. The skeletal pylons have been drawn in pen, whilst the trees have been painted very simply with a brush. The angle of the cables and the shadows cast by the trees tells us that the pylons are on a hill, and the road sign tells us their location.

Universal Studios, Los Angeles, California, Colin Moore (fountain pen and wash). A drawing demonstrating the effective use of line, together with more solid areas of varying degrees of tone.

builds up in density until the correct tonal value is achieved. Multi-directional cross-hatching is another way in which to produce a tonal range. Solid black can be created by painting these areas with a brush dipped in the ink, which can also be diluted with water to produce a range of greys. Pens and brushes that have been used with Indian ink should be washed regularly and thoroughly. Coloured inks can be used in the same way, but particularly when using acrylic ink, take great care with your brushes or pens.

Using a dip pen on location can be a little inconvenient, because you will need to balance your bottle of ink somewhere whilst you are drawing with one hand and holding your sketchbook with the other. There are plenty of pens available that operate by means of an ink cartridge, but these pens don't have a flexible nib so they produce a line of a regular width; this is ideal for drawing more intricate detail such as ornate architecture. There are also fountain pens, biros, and fibre-tipped, felt-tipped, water-based, spirit-based, calligraphic and brush-tipped pens and markers. The choice is almost limitless, and all have their uses.

A good choice for speedy sketches where a little tone is required would be a water-based pen, as the marks it makes will dissolve slightly when washed over. The degree of tonal value can be manipulated by painting over some areas with clear water, and pushing the dissolved colour around with the brush.

For a pen and watercolour wash drawing you will need to use a waterproof ink that won't run when you apply colour over it.

Drawing in Pastels

The advantage of pastels over water-based mediums, along with some pens and markers, is that pastel will allow you to add colour with immediate effect, without having to wait for it to dry. Oil pastel is probably less suited to the paper in a sketchbook, but there is no reason why is can't be used. Soft pastel will have to be sprayed with fixative.

You may also like to mix two or more mediums together when drawing, for instance watercolour over pencil, pastel over a marker drawing, or watercolour and pastel over an Indian ink drawing.

A selection of pens showing how a variety of marks and techniques are possible, by using them in different ways. Clockwise from the top left: steel, adjustable ruling pen; chisel-edged bamboo pen; broad, steel automatic pen; pointed bamboo pen; steel calligraphic pen; steel dip pen; narrow, steel automatic pen; steel mapping pen.

There are countless pens available for drawing, ranging from the simple biro to markers containing three different types of nib in one pen.

The twelve-section colour wheel showing the primary, secondary and tertiary hues.

Painting Techniques

Colour Mixing

When painting in any medium, there are a few basic rules regarding colour that you will need to know. Here is a brief description of the terminology used in colour mixing:

PRIMARY COLOURS: Red, yellow, blue.

SECONDARY COLOURS: The result of mixing two primary colours together: green, orange, purple.

COMPLEMENTARY COLOUR: The complementary of a primary colour is the combination of the other two primaries mixed together. For example: blue and yellow mixed together produces green, which is the complementary of red.

TERTIARY COLOURS: The colour formed by mixing a primary with a secondary: yellow-orange, red-orange, red-purple, blue-purple, blue-green and yellow-green.

In spite of the theory, there will be times when you will need colours that can't be made by mixing two other colours together. If you like to use really bright colours in your paintings you will find that it's impossible to achieve the richness in hue by mixing together colours from your basic range. A vivid turquoise, a lurid pink and a garish magenta are colours that you can buy, but can't mix yourself. This applies to watercolours, oils and acrylics.

As a general rule, the more colours you mix together, the muddier and less intense they become. Of course there are often times when these are exactly the colours you need to counter-balance brighter, richer passages in a picture, and combining the three primaries together in varying amounts will produce some very useful greys.

Pigments contained in paint will vary in intensity, and there are some colours that have a high tinting strength, which means that when you mix them with another colour in equal proportions they will overpower and dominate the other colour. Winsor Blue is such a colour. If you are using oils or acrylics, and wanted to mix a fairly pale blue with this colour by adding white, you would begin with white and gradually add small amounts of Winsor Blue into the mix until you had the desired colour. If you did it the other way around and were to start with blue, you would probably use a whole tube of white before you arrived at the colour you wanted. Similarly, if you are using a very strong watercolour, you would be wise to add the colour to water on your palette, rather than squeeze out the colour and then dilute it with water.

A whole book can be written about colour theory and it can all get rather confusing, but the best way of arriving at satisfactory colour mixing is by experimentation, and if something looks right, it is right, regardless of colour theory. It's sometimes a good idea to follow your own instincts when using colour, and if things aren't going satisfactorily, you can revisit the theory, and adopt a different approach. Sometimes for an artist, logic isn't always the best path to follow, so if the rules don't suit you, then break them.

Tonal Value in Painting

As in drawing, an understanding of tonal value, sometimes referred to simply as tone, is fundamental, and is the degree by which colour can be assessed in terms of lightness and darkness. Tone depends on the effects of light on an area or object, and how these degrees of lightness and darkness relate to each other and other things around them.

Thus a yellow building seen against a pale sky will appear darker in tone than the sky; but if a red brick building were situated alongside it, the yellow building would then appear lighter in tone than the red one. It is this comparison in strength of tone that it is important to understand, regardless of the actual colour of the object. To produce a dramatic painting, it's important to have a mixture of dark and light tones, not forgetting that a range of middle tones is required to hold the whole thing together. It's also important when composing a picture to have a balance of tonal contrast. If you have some very dark areas on one side of your composition,

you will need to counterbalance this with some on the other side.

By analysing the range of tones in your composition you will be able to replicate them in your painting to suggest three-dimensional volume. If you intend to paint in a fairly realistic way, an understanding of this is essential. The way in which these tones are graduated will suggest whether or not an object is flat, multi-layered, round, solid or transparent.

Sometimes when two objects are side by side, their tones can appear exactly the same: that is, neither one is darker than the other. The difference between one and the other will then be established by the difference in their colour.

In landscape painting the strongest contrast in tones is usually between the sky and the land, so a good starting point when evaluating the tonal differences in a scene is to establish a tone for the sky first; as this is the primary light source, it is usually going to be the lightest part of the painting. However, as with all general rules there are exceptions, and one of these can sometimes be found when the sky in a snow scene is actually darker in tone than the snow-covered land.

When starting a painting, or when producing a compositional, tonal sketch, it is a good idea to squint at the scene to establish the various tonal divisions. This will entail a certain amount of scrutiny and editing, where several tones may overlap in one area; however, for the purpose of this exercise they can be classed as just one area. As the painting progresses, the subtle differences within that area can be re-established. When adding colour, the contrasts in these primary tonal regions can be maintained by making occasional adjustments.

Sometimes it can be very difficult to assess relative tonal values as we tend to be more aware of colour than the lightness or darkness of things. For example, Ultramarine and Burnt Sienna are two distinctly different colours, but when both are diluted sufficiently in varying degrees they can be produced in exactly the same tone – and this applies to any colours. That is, if one were to take a black and white photocopy of them side by side, they would be indistinguishable, being the same in tonal value. Judging tone can be practised by placing two objects next to each other, perhaps a green pen on a red book, and by squinting at them with half-closed eyes you will soon be able to tell which one is darker than the other.

Each time you add a colour to a painting it affects the colours already there, so a certain amount of adjustment sometimes has to be made. A shadow that you initially thought of as being strong enough may have to be given a bit more punch, and similarly with a highlight.

By building up your picture with the addition of colour over the whole image, rather than trying to finish in detail certain elements of the picture, you will find it easier to assess the strength of dark, light and intermediate tones.

It's very easy to get engrossed in one section of a painting just because it's the nicest or easiest bit to paint. However, always treat the painting as a whole, and avoid concentrating on the separate entities within it.

Colour Temperature

As a general rule, colours become slightly cooler as they recede into the distance and reduce in intensity. Strong, bright, warm colours will appear closer to the viewer than subdued colours. This is perhaps more relevant to the painter of landscapes, but the principle still applies to all painting. By squinting at a composition it will become evident which are the cooler colours and which are the warmer ones.

Unless you wish to dissect colour in a scientific manner, it is really a subjective matter as to whether a colour is warm or cool. It is generally accepted that blues, greens and violets are cool, and that yellows, reds and oranges are warm, but there are a million intermediate colours that can appear either warm or cool depending on which colour they are placed next to. There are also degrees of warmth or coolness within individual colours. For instance, Cadmium Yellow comes in a range of colour temperatures, and depending on which brand you use, there is Cadmium Lemon, Cadmium Yellow and Cadmium Yellow Warm. When placing Cadmium Yellow next to Cerulean Blue, it will appear quite warm although it is generally perceived as a cool colour. The temperature of a colour will also be altered by light shining upon it.

If you want a bright colour to really stand out and to give it extra richness, this can be achieved by placing a fairly subdued neutral colour next to it. Very light colours will only appear light if they are placed next to darker ones, and vice versa. A successful painting will contain passages of both cool and warm colours.

Harmonious Colours

A painting that has been executed by including a common base colour will produce a harmonious effect. For example, if you choose blue as the base colour, by then using blue-grey, blue-green and blue-violet you will create a visually harmonious painting because you are using a cool set of colours.

This harmonious effect doesn't necessarily need to have a primary colour as its base. A similarly pleasing painting could be created by choosing a colour such as Raw Sienna as its base, and this could be added to red, yellow, brown and perhaps any of the earth colours to produce a warm tonal range.

The colours used in this painting were Titanium White, Raw Sienna, Burnt Sienna, Cadmium Red, Oxide of Chromium and Burnt Umber.

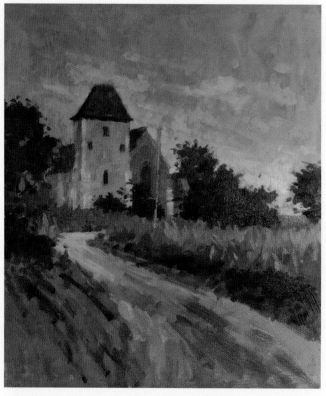

STAGE 1
One of the range of earth colours, such as Umber, Ochre or Sienna, is usually an appropriate base with which to tone your canvas or board prior to painting, if you wish to create a harmonious picture. For this painting, a thin wash of Burnt Umber alkyd oil paint was used, which dries very quickly. An alternative is to use acrylic, which dries even more quickly. The main areas of the composition were indicated in pencil as a simple outline drawing. The diagonal and curved sweep of the track leads the viewer's eye first to the church and then beyond. The scene provided a ready-made composition, so nothing needed to be added or altered.

STAGE 2
The sky was painted first, at this stage leaving much of the underlying colour showing through. It was lightened next to the horizon, and this set the tonal key for the rest of the painting. The other main parts of the image were painted with brushstrokes in a way that suggested their form: thus the low hedge on the right was painted with vertical marks, the bank in diagonal marks to indicate a slope, the track in sweeping, directional brushstrokes, the foliage of the trees with random marks, and the church with flat, static marks.

Techniques in Painting

As this is a book about the practicalities of drawing and painting outside, it would be impossible to describe the vast number of techniques associated with each of the primary painting mediums. However, there are some basic techniques that will apply to each medium, as well as some that are more specific.

Watercolour Painting

If you are fairly new to watercolour painting, there are a few techniques that you can try until you find a way of working that suits you. If you are a complete beginner, the best way to ease yourself into the medium when working outside is to begin by using just one colour, to produce a mono-chrome painting. This will allow you to concentrate on how to apply the paint, and the different effects you can achieve when doing so.

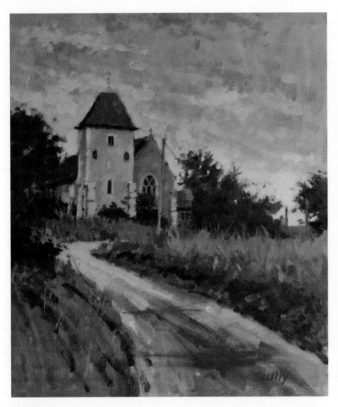

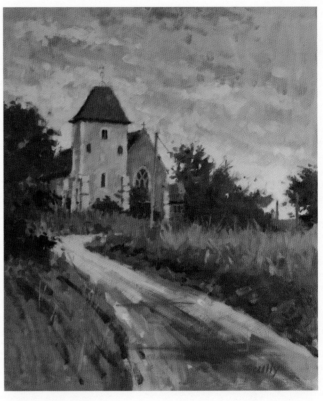

STAGE 3

As the church was the main focus of attention, this was painted in a little more detail, taking care not to make any of the brushstrokes too definite or sharp, as the building is some way in the distance. Some more clouds were painted higher in the sky, and some of this colour was added to the track to suggest a slight reflection and to tie the two areas together. A few horizontal brushstrokes in the foreground break up the rather linear appearance and indicate the level of the track, and to accentuate its curve in the middle distance, this area was lightened. The trees silhouetted against the sky were given a little more definition, and to the right of the church a couple of touches of sky colour were added, to break up the solid mass of foliage. The simple painting was completed in one and a half hours.

The finished painting.

Wet-in-Wet

The wet-in-wet technique is very useful for painting landscapes and seascapes to capture the illusion of receding space, taking advantage of how watercolours blend on paper.

Choose a colour such as Ultramarine or Indigo, and mix up a reasonable amount of paint on your palette to be used as a fairly pale wash. If you have separate mixing wells, take half of the paint and dilute it further. You can either dampen your paper first, or paint straight on to it. If the paper is damp, your watercolour will dry lighter than when applying it to dry paper, because the water already in the paper will dilute it further. Painting on damp paper will produce a very soft blend of tones, whereas on dry paper they will be more distinct.

The principle difference between watercolour and other paint mediums is that it is subtractive, which means you should take care to retain the light areas in a painting right through the painting process, whilst adding successive darks.

Have your board tilted at a slight angle towards you. If you are painting a landscape, begin at the top with the slightly darker wash, and with a large brush paint the top half of the

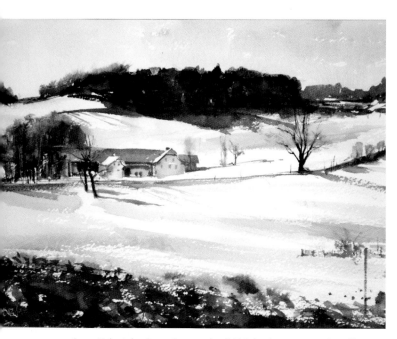

Snow Light, John Owen (watercolour). This landscape was painted in a biting wind in the early afternoon when the temperature was below zero. The buildings are sandwiched between the blue-black foreground shadow and the dark mass of trees on the hill. The artist has had the courage to use strong, clean colour, and has painted sharp contours in one go with no reworking. The cobalt-turquoise sky tells us it is cold, and the quality of light illusion is created by the correct strength of single stroke, warmer blue shadows, subdued warmth in the tree mass, and a very dilute neutralized warmth on the snow. The colour of the farmhouse roof is a mixture of the sky and foreground blues, and its rectangular shape stabilizes the composition.

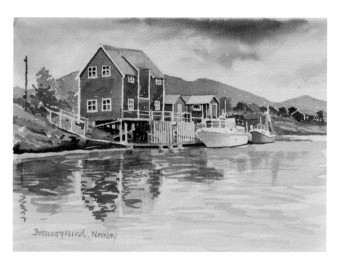

Bronnoysund, Norway, Kevin Scully (watercolour sketchbook). A scene typical of the Norwegian fjords, where many of the houses are painted in this traditional 'red barn' colour. The sky was painted wet-in-wet to show that it was about to rain (which it did). All the white areas in this painting are where the paper has been left unpainted, and there was no masking fluid or white gouache used. Sometimes when confronted with a scene like this, it isn't always easy to determine why the reflections appear as they do, and it is usually just enough to paint them as you see them. But here, the dark reflection in the centre of the sketch looks wrong, so if a finished painting were to be produced from this sketch, it would be either altered or omitted altogether.

sky, taking care not to produce stripes. Do this as quickly as possible, without going back and forth over the same area. Then using the same brush, take some of the lighter wash from your palette, and, picking up the colour along the bottom edge of the first wash, blend the two tones together and continue painting down to the bottom of the page. As the board is slightly tilted, the paint will bleed down paper, producing a soft blend of tones as it goes. The two different tones in the sky represent the way in which, on a bright, sunny day, the sky will become lighter as it reaches the horizon. Whilst the paper is still damp, you can mix up a slightly darker tone of colour to paint in some distant hills. Judging when the paper is at the correct stage of dampness is a matter of experience, and will depend on several factors, including the degree of absorbency of the paper and the air temperature when you are working outside. If there is a lot of moisture in the air the paper will dry slowly, but if it is a warm and windy day, it will dry fairly quickly. If the paper is too wet, the colour that you add will bleed upwards as well as downwards.

If you add paint to an area that is still damp, make sure that it is stronger in tone than the colour already there – in other words, that it contains less water. If you add colour that is too diluted you can create an effect known as 'cauliflowers' or 'mushroom clouds', where the pigment in the over-diluted colour floats away, and forms a dark ring when dry where it is deposited.

Providing all is well, you can now add other elements in the landscape in varying degrees of tone, gradually getting darker as you reach the foreground. This stronger colour can be added by dropping it in with just the tip of the brush so that you don't stir up the colour already in place. If you haven't managed to paint all that you intended before the paper is dry, you can re-wet certain areas with a brush loaded with clear water, or if you need to dampen large areas, or the whole sheet you can do so with an atomizer spray.

You will probably need to add a few extra details with stronger colour, to add definition once the painting is dry, or nearly dry. The secret is not to overwork anything, as the paint will lose its translucent quality, which can never be regained.

Providing this has been successful, you could then try a similar operation using two colours, this time Ultramarine and Burnt Sienna. You can begin to add more variation to the different elements in your composition by altering the ratio of one colour to the other. You could keep the sky in blue, but introduce a little more of the brown into the landscape areas. You will also notice with these two colours that they granulate – this is the effect created when the pigments in

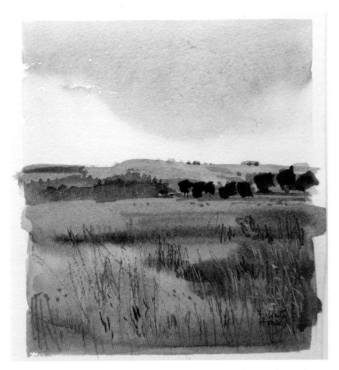

Purbeck Hills from Arne, Dorset, Felicity House (watercolour and pastel pencil on paper). Situated at the back end of Poole Harbour, Arne provides some great subject matter for painting. The artist always travels with a watercolour kit and a variety of papers. The background of this watercolour was painted wet-in-wet and then allowed to dry. The hard-edged horizon and bands of landscape were added in successive layers. The texture in the foreground was created by drawing into the wet watercolour with pastel pencil.

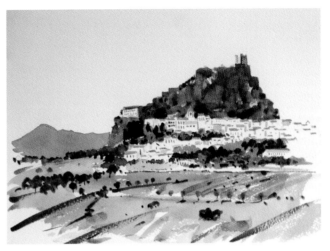

The Castle at Zahara from the Lake, Kevin Scully (watercolour sketchbook). In this sketch, the white buildings weren't drawn out at all before the painting was started, but were left as white paper. Because their arrangement was so complicated, it was easier to indicate them with a brush in just three colours: terracotta for the roofs, mauve for the shadows, and a dark, nondescript colour for the windows. The rock on which the castle sits was painted in a tone lighter than it actually appeared, so that it didn't look too top heavy in the painting. A lot of white paper has been left unpainted to help retain the sketch's bright and airy look.

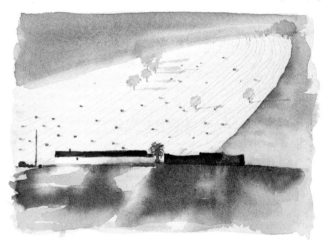

Dawn, Valle de Funchal, Portugal, Kevin Scully (watercolour sketchbook). This watercolour was painted from a terrace on a hill overlooking a valley below. The reason for the rather strange, flat perspective is that because these buildings were so far away, it was painted with the aid of binoculars. This is a good example of how certain colours granulate when mixed together, in this case Burnt Sienna and Ultramarine. The ridges in the bright yellow field were drawn with the wooden end of the paintbrush into the watercolour whilst it was still wet.

the two paints don't mix entirely, and tend to float away from each other, producing a rather attractive atmospheric texture.

Taking this a stage further, you can now try painting in full colour, although it is good practice to use as few colours as possible. Too many colours competing with each other will confuse the eye, which may be acceptable if you are painting in a decorative way, but not if you are aiming for a degree of realism.

If you need to keep some areas in your painting in pure white, you can either paint around them, or use masking fluid if the shapes are too fiddly for the paintbrush. This can be peeled off when the painting has dried, to reveal white paper. You can also scratch into the paper when it's dry to reveal the white paper beneath the paint, and this method is very successful for imitating the bright white highlights on water. White, opaque gouache can also be used with discretion, where highlights are needed.

Paint that has been applied over another colour can also be scratched into when wet with the wrong end of the paintbrush or a knife, to reveal fine lines of the original colour underneath; this is an excellent way to suggest light-coloured grass against a darker background. The edge of a fingernail is another useful tool, and can be used to pick out lighter parts of buildings or tree trunks whilst the paint is still wet.

It's advisable not to go in for too many tricks until you are fairly confident with watercolour, as these can place an emphasis on flashy technique to the detriment of a sound understanding of the medium.

Autumn Reflections, John Owen (watercolour). This picture was painted on a mild afternoon after rain, with the sun breaking through again. The artist was attracted by the reflection of the golden ferns at the water's edge, where the river runs more slowly and deeper on this stretch before a small waterfall. The sky has been painted using a base of Cobalt Turquoise Light and Cobalt Blue. This also formed the cool component of the greens mixed with the earth colours, Yellow Ochre and Burnt Sienna, together with Cadmium Yellow. The trees were painted with a swordliner brush, which was also used for the horizontal reflection lines. The foreground hazy weeds were created with Aquapasto, mixed with various pigment remains on the artist's palette, and applied loosely with a narrow painting knife. The dark Ultramarine seen in the water's depths acts as a foil to the warmer hues, and provides a realistic foundation for the autumn leaves floating by. The painting succeeds by describing the quality of light on the water, supported by the 'feel' of the air around it.

Passing Rain on Loch Eribol, John Owen (watercolour). After a wet night, it was still spotting with rain when this landscape was painted quickly before breakfast. The greatest degree of light was in the centre of the sky, and the artist surrounded this with warm greys to make the illusion stronger. A dragged dry brush of the same mix on the water connected it with the sky, and provides a linear foil to the loose sky washes. If the foreground had been painted in too strong a colour, it would have detracted from the light as the focal point of the painting, so it was painted in more subtle tones. It's better to stick to one message. The picture could have been painted again in stronger hues, but then the sensation of the light would have been totally different. The flat, similar landscape shapes and subtle colour temperature changes maintain harmony here. The empty field in the foreground has the same shape as the area of light in the sky, connecting the two and keeping the eye moving around the picture plane.

Oil and Acrylic

Unlike watercolour, there's no need to be so cautious when applying oil or acrylic paint, because leaving the lightest areas untouched for as long as possible is unnecessary. The most popular way of starting a painting in either medium is to begin with your painting surface tinted with a thin wash of colour in a medium tone. You may want to draw out your composition in pencil and coloured pencil, or you may find that drawing with a brush using thin paint suits you best. When Monet began painting 'en plein air', he stated that he never drew at all, but simply painted. Charcoal has often been used in the past, but I find that it can dirty the colour of the paint, and adds a grey tinge to it, which is particularly irritating if you are painting something in clean, fresh colours.

The number one rule when painting with oil or acrylic is to begin with thin paint and progress with thicker paint on top, and not the other way around. If you apply your oil paint too thickly to begin with, it is then difficult to add any more paint on top, as the two colours will mix together. This is especially relevant to painting outside when you have limited time available. Even if you wait for the thick paint to dry before adding more colour, it may appear to be dry, but it won't be below the surface, as oil paint takes a long time to dry thoroughly. If you then add thin paint on top, which will dry more quickly, strange things may eventually happen, as the layers dry at a different rate. Over a period of time, the paint may wrinkle and sink, or even crack on the surface. Another reason not to do this is because it just doesn't look very good.

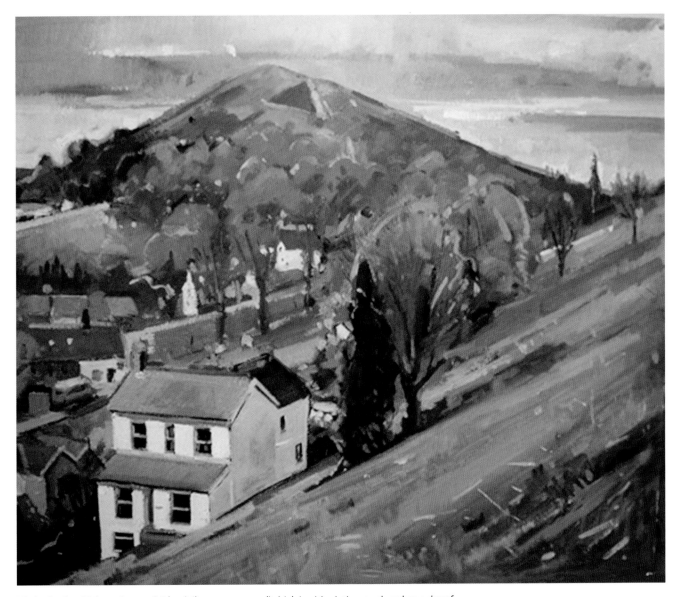

Wyche Cutting, Malvern, Antony Bridge (oil on canvas panel). A 'plein air' painting produced on a day of sparse sunshine, but one in which the autumnal glow of the season has been captured by the choice of colours. The diagonal brushstrokes describing the steep hill lead your eye initially to the houses below, and then up to the hills beyond. By adding some cool blues to the primarily warm colour range, the artist has created a sense of harmony.

You won't have a problem with slow drying times where acrylic is concerned, so providing you keep the paint fairly thin to begin with, you can over-paint with subsequent layers of colour fairly soon after each one has been applied.

Working 'alla prima' is a term used when you produce a painting in one 'hit'. In other words, the paint is applied wet-on-wet without waiting for it to dry before adding another colour, and so the painting is finished in one session. Painting in this way results in a fresh and spontaneous look to a picture, which is particularly appropriate for working 'en plein air'.

The colours used in this painting were Titanium White, Oxide of Chromium, Yellow Ochre, Winsor Violet, Burnt Sienna and Viridian.

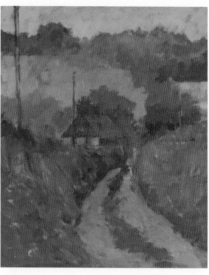

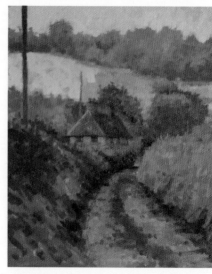

STAGE 1
The board was first painted with a thin wash of Burnt Sienna with a little Payne's Grey added. This was then wiped with a rag because too much paint had been applied and it was taking too long to dry. The building in this scene was actually facing in a different direction, so that the left-hand side of the house was the side that was visible. This looked rather awkward, so it was turned so that it was parallel with the track. Initially drawn out in pencil, the house was too far over to the right, so this was altered, as was the position of the track – and as can be seen from this image, it was then drawn out in thin paint.

STAGE 2
The sky was painted first with a mixture of Titanium White, Burnt Sienna and Winsor Violet, and the track was painted in a slightly lighter version of the same colour. The paint was kept thin at this stage, so that the original drawing could still be seen.

STAGE 3
A variety of greens were mixed up on the palette, consisting of varying amounts of Oxide of Chromium, Burnt Sienna, Yellow Ochre and Titanium White. The house was painted with Burnt Sienna and Titanium White. At this stage the tonal arrangement of the painting has already been set, so the next task was to refine some of the colours and details.

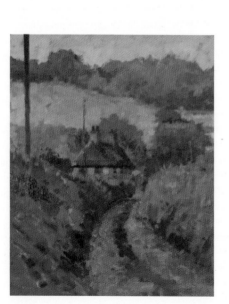

STAGE 4
The sky was looking rather dull, so the colour of this was altered to a mix that resulted in a slightly pinker colour, which was also added to the track. Some Winsor Violet was added to the distant hills to suggest a degree of aerial perspective, and more detail was added to the house. The form of the two steep banks was defined with the addition of more variety in the greens, with some stronger tone painted at the base where the bank meets the track.

STAGE 5
Some lighter greens have been introduced around the painting, especially to the field behind the house. Some deeper shadow has been painted under the bank, which becomes more of a hedge in front of the house.

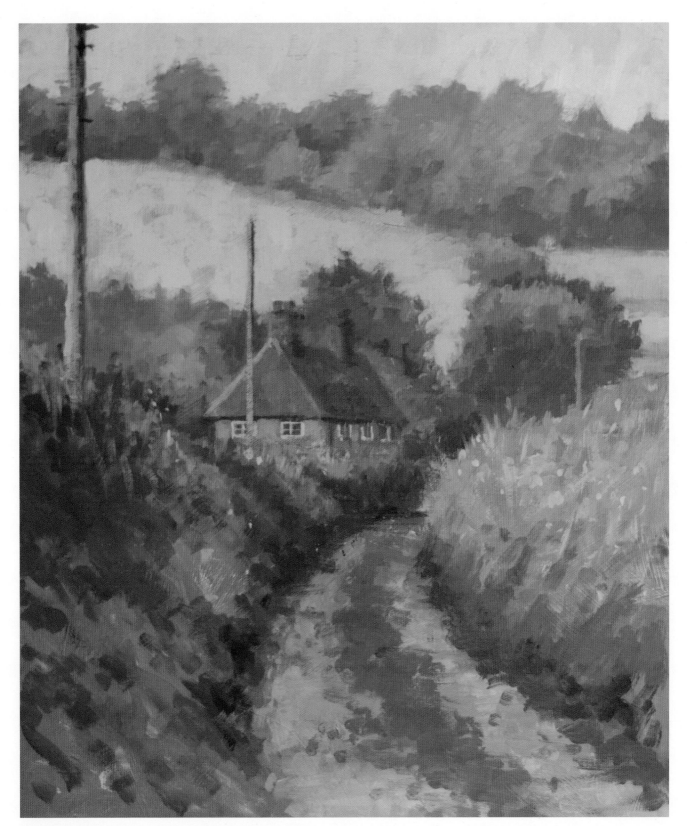

FINISHED PAINTING

St Abbs, Kevin Scully (oil on board). The sky colour has reverted to the original, more subdued colour, as it was beginning to compete with the rest of the painting. Some flowers were added to the hedgerow, and the telegraph poles and windows were finalized. Detail has been kept to a minimum, and a self-imposed time constraint meant that the painting was completed in about one-and-a-half hours.

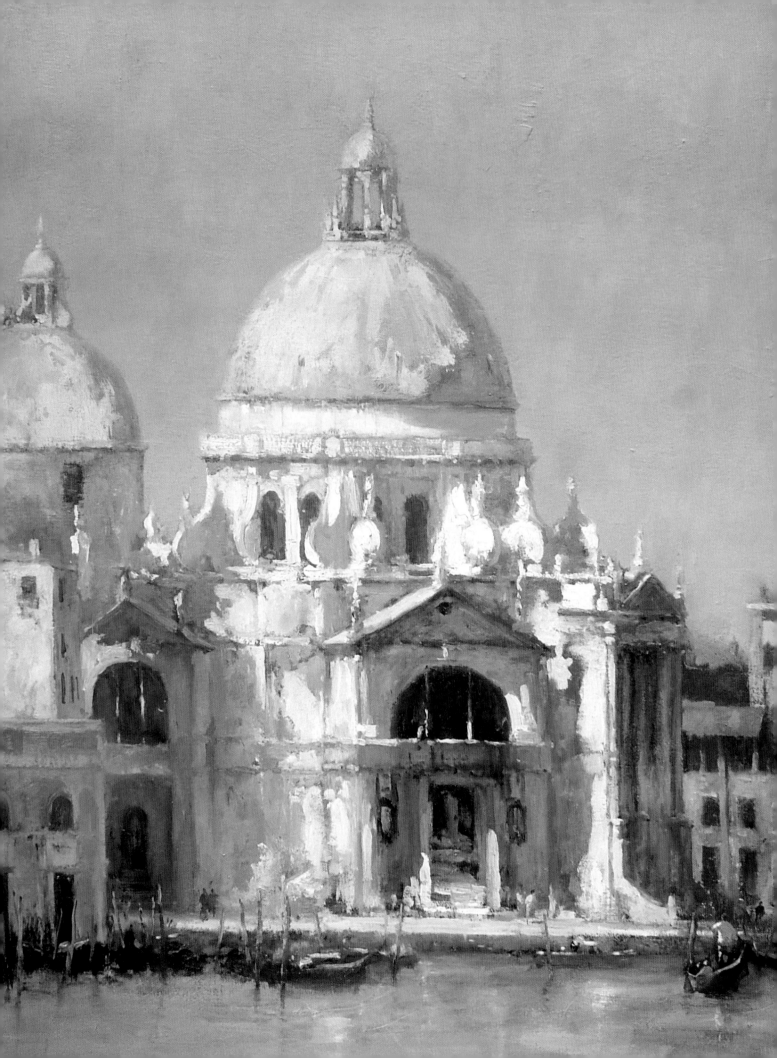

Opportunities for Drawing and Painting

There are countless opportunities open to people who want to leave the studio and venture forth into the great outside world. The subjects at your disposal are endless, and there is enough out there to keep you going for a lifetime – and how you go about it is entirely up to you.

Going it Alone

If you are a self-motivated person and are quite happy to do your own thing, you can set your own agenda and take yourself off to wherever you wish. As a free agent you will be able to merge into the background more easily when drawing on location, and you will be able to spend as long or as short a time as you wish in any one place. If you are attracted to fine and intricate architecture, you could spend a whole day tucked in a corner without anyone wanting you to do otherwise. Or if you like to draw fast and furiously, and don't intend staying in one spot for too long, you can take off in a flash.

Santa Maria Della Salute in all her Glory, Kasey Sealy (oil on canvas). The artist has made several painting trips to Venice over the years and never tires of it, as there is always a new area to discover. The atmospheric light effects are forever inspirational. In this piece he was particularly drawn to the shape of the dome and the effect of light and shadow on the cream, and the white and grey façades of the buildings, which always give paintings of Venice a certain kind of majesty.

Joining a Group

Being with like-minded artists can offer you support and inspiration, as well as companionship, so this is perhaps something to consider. It may be just a group of friends, or it may be an art club where painting days are organized in different locations throughout the year. One of the advantages of this is that your forays are organized for you, and you don't have to go looking for places to paint. These groups usually consist of painters of mixed ability, and as well as learning from other people, you can impart some of your knowledge and experience to them. There is also a social element associated with art groups, get-togethers, group exhibitions and visits to galleries, as well as demonstrations and critiques by visiting professional artists.

'Plein-Air' Workshops and Courses

Short painting courses that run from anything between one and five days will allow you to fully immerse yourself in painting. They may be close to home, or they may take place in another part of the country, and often combine sessions of both working outside and studio-based tuition. There is much to be said in favour of these workshops, as they take you into unknown territory both physically and creatively. They can

Goats at Jahangiri Mahal, Orchha, Felicity House (pastel, underpainted in watercolour on Colourfix card). This massive structure was almost too large to fit on to even the largest size available of Colourfix card that the artist had with her whilst travelling. Indian buildings, with their splendid architectural detail, are a joy to paint, but as you have to work quickly in India this one has been treated loosely. As the light changes so swiftly, not all the details were included, so merely an impression of them was suggested. The pastel and pastel pencils were perfect for combining broad sweeps of different colours, with just a hint of detail on the amazing, weatherworn stone walls. The goats and cattle in the foreground give an immediate sense of scale. When painting this, the artist was surrounded by child goatherds and their friends, all looking on in fascination. She didn't engage in too much conversation, however, as more and more people would have turned up to see the spectacle.

Evening Harbour, Kevin Scully (pastel on Canson Mi-Teintes Sand pastel paper). There is no real focal point in this painting, except perhaps the bright reflection on the water in the centre of the image. The intent was to convey the hazy light at this particular time of day, when all the colours become diffused, and boats and shadows appear as one.

Drawing and Painting Holidays

You may even consider taking things a step further by booking yourself on to a painting holiday abroad, where not only will you be in the company of like-minded people, but you will also be savouring the delights of foreign culture, food and possibly sunshine. Immersing yourself in art in an alternative and nurturing environment, and amongst new people, can be quite a challenge, but it will also be invigorating and rewarding.

It would be a good idea to embark on a painting holiday with some clear aims in mind. Most painting holidays will be non-specific, so you will be free to work in whichever medium you wish. It may be that you simply want to spend the entire holiday drawing, but would like to concentrate on a particular aspect or technique that you are having difficulty with. If this is the case, make sure that the tutor is willing and able to guide you along the route you wish to take. It's always advisable to get in contact with the tutor beforehand so that you can talk through different aspects of the holiday, and also to let them know exactly what it is that you wish to gain from the experience.

Particular Locations

Consider carefully where the painting holiday is going to be based. If you like the sun and are able to cope with some fairly high temperatures, then you might like to travel to one of

provide you with the chance to learn new skills, and enable you to sharpen up on old ones. You may be new to drawing or painting, or you may be someone who has studied art in the past but is now a little 'rusty' and is looking to rekindle their interest. There are excellent tutors who may not draw or paint in the way that you like to, but will be able to steer you along a course suitable for your individual needs. But ideally look for a course that is run by a tutor whose work you do like, as this will help to keep you motivated and inspired.

These courses can be quite specific, so if your primary love is seascapes, you should be able to find one that concentrates entirely on this area of painting. You might find one that is even more specific, which may be advertised as 'Painting Seascapes in Pastel', or 'Painting Buildings in Watercolour'. Others will be non-specific, so you will be able to choose your own medium, or even try something that is entirely new to you.

Sketchbook drawing, Kevin Scully. A rather simple and graphic image that defines the different textures of the two main elements in the composition, by drawing each of them using a different technique.

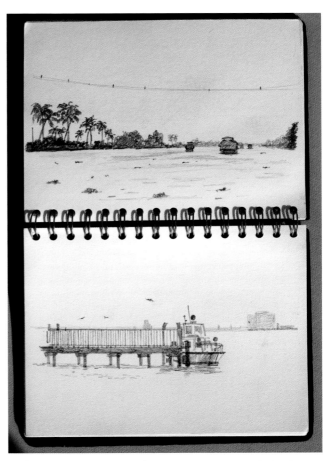

Kerala sketchbook, Kevin Scully. There is often no need to include any superfluous detail in a sketch, and it's far better just to concentrate on what has caught your attention in the first place, and not be tempted into describing every single detail.

the more far away, exotic places. Holidays to these locations normally take place in the cooler, more temperate months when it's possible to paint outside without wilting in the heat. Travelling to these countries is fine providing you don't mind flying, and all that flying involves. You will be rather restricted if this is the case, but it may be possible to reach your destination by other ways, providing it's not too far away. Reasonable distances can be covered quite comfortably by car, boat, coach or rail, or by a combination of these means of travel.

If heat and sunshine don't really appeal to you, there are many other locations that probably would. In colder climates there will be different subjects to paint, which you may find equally inspiring. You might be more stimulated by spectacular or atmospheric skies, or wild and windy deserted beaches, than by palm trees and camel markets. Painting in foreign cities also has its attractions, and the holiday may include trips to some exciting art galleries and museums as part of the whole art experience.

There are some painting holidays based in places that you may not really have thought about ever visiting, but don't discount them entirely. If the location has been closely investigated and thoroughly researched, there will probably be

some fantastic and inspiring places in which to paint. There may be other places that you would like to visit, but wouldn't dream of going to on your own. It is reassuring to know that someone has already been there, perhaps several times, and knows the place well, so has tracked down some suitable painting locations. Most of the people who run painting holidays will also arrange transfers from airports and stations, and transport to and from painting locations throughout the trip. Suitable accommodation will also be included, and a guide who speaks the local language. Having everything already set up allows you more time to draw and paint.

Some painting holidays take the form of a sort of house party, where everyone stays together in a large villa set in extensive grounds. There may be occasional trips out, but generally all meals are taken there, and most of the tuition and painting takes place in and around the house. There will probably be extensive countryside views, and plenty of smaller areas of interest to paint, either inside, or within striking distance of the house.

As a little light relief from basic pencil drawings, try using a coloured pencil. In this sketch, the dark blue pencil adds a little weight to the bulky stone wall, concrete blocks and the deep shade in the grass.

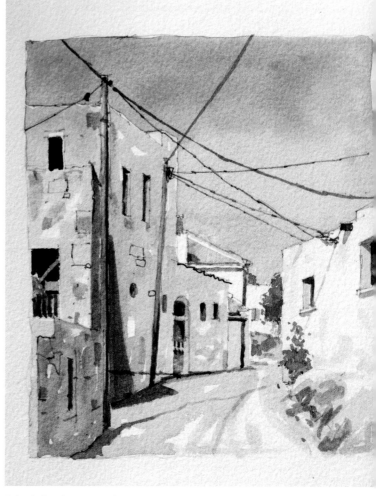

Gokcebel, Turkey watercolour sketchbook, Kevin Scully. A sketch for a future oil painting, which had to be hurriedly finished because the parked bus that had been providing shade on this extremely hot day, suddenly moved off.

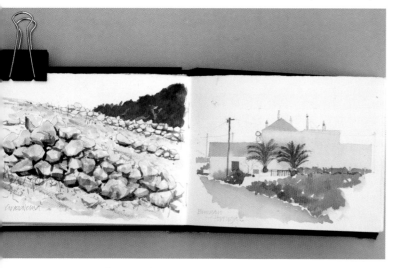

Watercolour sketchbook, Kevin Scully. Even the most humble of subjects can be used as the basis for some simple watercolour sketches, which may or may not be turned into finished paintings one day.

This kind of arrangement may appeal to you, but you might begin to feel a little claustrophobic after a while, especially if you fall out with one or two of the guests. It also seems a shame to go to a foreign country and not immerse yourself more in aspects of the colourful, local life that exists in the restaurants, shops and bars found in the villages. The house-party set-up described above often appeals to a painting group of friends who already know each other, and who consequently know what they might expect.

You don't necessarily need to go on a painting holiday alone, or even with other members of a painting group or art club. Depending on the type of holiday and location, your non-painting friend or partner can join you and either come along with you when you go out on painting trips, or simply 'do their own thing', which may be sightseeing or just relaxing. There are also holidays that cater for two activities, which accommodate partners who may want to learn photography with a tutor, or how to cook regional cuisine, or go walking with a group, led by a local guide.

As well as learning from the tutor, it is an invaluable experience watching how other artists tackle a subject, and sometimes much can be learned from them. There may be a great disparity in the ages of your fellow painters with whom you find yourself spending the week – but whether they are younger or older, you will be sharing a common interest.

A Personal Journal

You could take this opportunity to produce a personal memento of your holiday in a sketchbook, which might contain not only paintings and drawings, but also annotations, a collage of receipts, travel and entrance tickets, restaurant business cards and pressed flowers. Long after your holiday is over these items gathered together will bring back memories far more vivid than taking a hundred images with a digital camera. Be sure to date your work and to note where it was painted or drawn, because if you have been on trips to many different places, particularly if their names are unpronounceable, you will quickly forget what they were called.

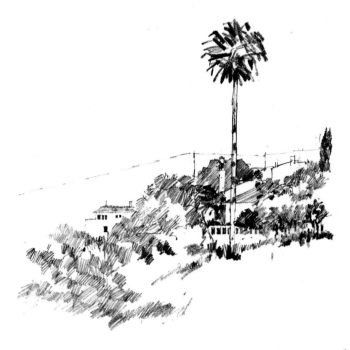

Nerja, Spain; Kevin Scully (sketchbook drawing). A sketch drawn using a 6B pencil. The hatched shading has been used to indicate the various levels of foliage growing on the hillside.

Urban Sketchers

Until fairly recently, sketchbooks were always thought of as either a convenient way for artists to collect material for studio-based paintings, or simply as a book of personal, visual observations and doodlings. They were seldom looked at by anyone other than their owners, and even then only occasionally. But this has changed, because now that so many people possess a computer, drawings in sketchbooks can be scanned in and circulated worldwide through social media and blogs.

It has now become evident that people all over the world are busily filling mountains of sketchbooks with drawings, and sharing these with other enthusiasts with a similar interest. Many of these sketchers are linked via an international network of artists called 'Urban Sketchers', through which people display their work and are offered support. They also organize urban sketching workshops in cities throughout the world, presided over by professional tutors, architects and artists.

Sketchcrawl

Sketchcrawl describes an event where groups of people meet up in a city and spend a day walking around and recording everything around them. As the concept of these gatherings has developed, there are many such groups who have developed their own individual way of operating. They may go off individually and meet up later to show each other what they have been sketching, or they may keep together and draw from the same location. Some may not meet up again at the end of the day, but instead will post their images on line, where other people's drawings can be shared and discussed.

Joining one of these groups may be perfect for you if you are apprehensive about wandering around a city on your own.

Paint-Outs

On a slightly more serious and competitive level are 'paint-outs'. These are events held worldwide where artists gather to paint in a specified location. In open paint-outs, artists simply have to register before they take part, but in other categories there is a selection process that takes place where artists may have to submit a résumé, together with a number of images of their work. In these 'juried entry' competitions, applications are presented to a committee that presides over the verdict regarding who is allowed to compete. Other competitions are by invitation only, and it is relatively difficult to take part in these paint-outs. There are often prizes and awards on offer, and sometimes these comprise quite substantial amounts of money.

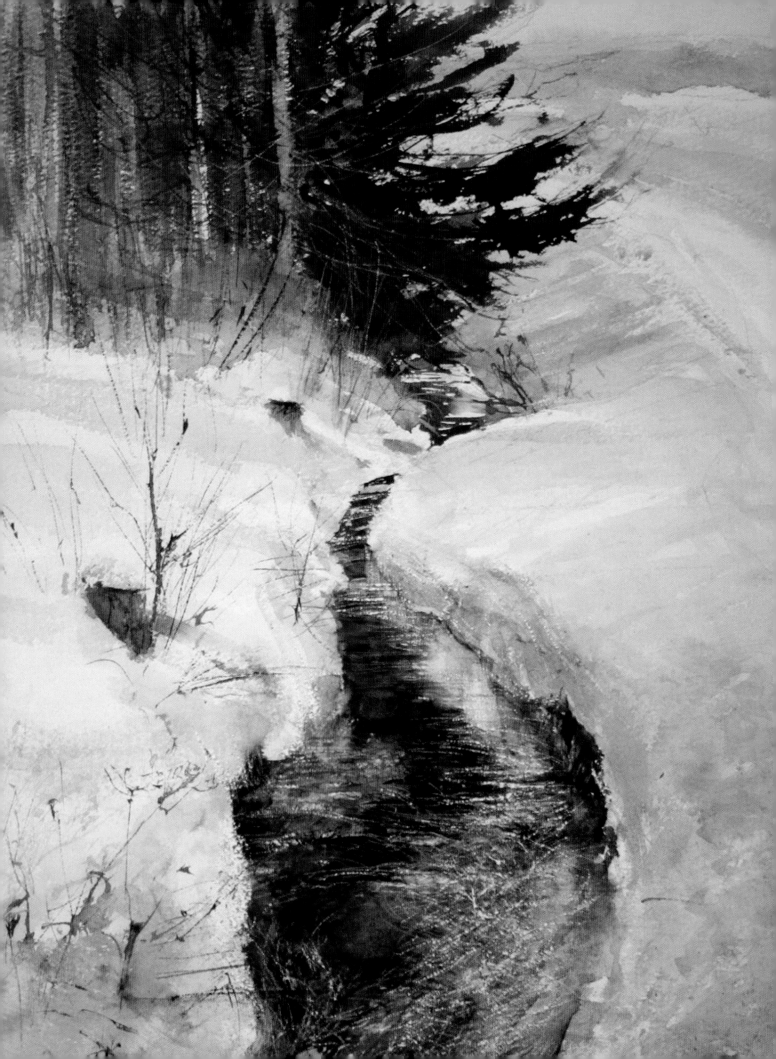

Practicalities

*Sunshine is delicious, rain is refreshing, wind braces us up, snow is
exhilarating; there is really no such thing as bad weather, only different
kinds of good weather.*

JOHN RUSKIN

Unless you plan on trekking up the Amazon or cycling through Mongolia looking for subject matter, there is very little special kit that you will need when facing the elements. In normal weather, if there is such a thing, all you will require is your drawing or painting equipment.

Be Prepared

If rain-drenched suburban streets are the kind of thing that inspires you, then you will obviously have to be prepared. You might be lucky enough to find a doorway for shelter, but there is the possibility that even then you won't be spared at least some rain landing on you, and possibly your work. If you don't mind looking like a deep-sea fisherman, you could go for a waterproof coat with hood, which will definitely keep you dry, but could be rather restricting physically. If you are working at an easel, you can attach an umbrella to it by using a clamp, and if the umbrella is large enough, it will keep both you and your work dry.

Alternatively you could simply sit in a café, in a seat by the window, and draw or paint from there. Sitting in the passenger seat of a car will give you a reasonable amount of elbow room if you're just working in a sketchbook, but you'll have to open the window a little to prevent the windscreen from misting up. If you are going to be out in the rain for any length of time, you will eventually get cold, so you'll need something warm to put on, and wear some sensible shoes to stop your feet from getting wet.

If a rain-swept windy moorland scene appeals to you, you could kit yourself out in rainproof clothes and shoes – but if you're working at an easel you will need to anchor it somehow, to prevent it from taking off. Presumably you will have arrived at the spot by car, so there are a few things that you could bring with you. A rock or a couple of bricks in a sturdy bag suspended from your easel should keep it secured sufficiently, and if the wind is really threatening to blow your masterpiece away you could secure it further by attaching the easel to the ground with ropes and tent pegs. This all sounds rather drastic, but it's better to be safe than sorry, as many a painting has been ruined because it has landed in the mud or wet grass.

Winter Stream, John Owen (watercolour).

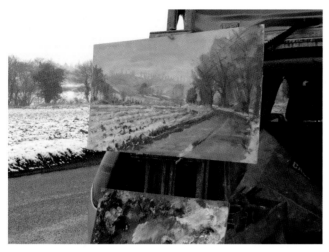

Snow Scene, Wiston Road, Roy Connelly (oil on board). In this photograph, the car's open tailgate gave some protection to the artist's canvas and palette from the falling snow. It is quite possible to work outside in inclement conditions, and bad weather can often give you some very dramatic subject matter. As well as protecting the canvas, it's wise to try to be as comfortable as possible when painting outside.

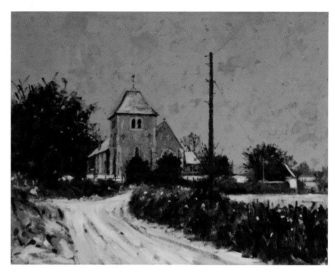

St Mary the Virgin, Aldworth, Kevin Scully (oil on board). Another scene that is often painted, this time on a bitterly cold day when winter had cast its shadow on everything. The fading light was leaving the scene devoid of all colour except brown, and a featureless grey sky.

Antony Bridge painting in the Malvern Hills at a temperature of minus 12 degrees. A certain dedication to painting 'en plein air' is required when braving this kind of extreme climate, where the artist is undoubtedly experiencing first hand the sensation of immersing himself in these atmospheric conditions.

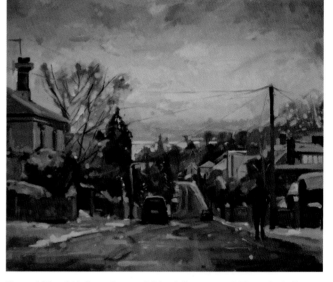

Hornyold Road, Malvern, Antony Bridge (oil on canvas). The arrival of snow can create many exciting subjects for a painting, when you may encounter some rather unexpected colour combinations that don't compare with those experienced in any other weather conditions. Depending on the light and the time of day, the sky may appear to be grey, yellow, pink, green or a combination of several different colours not generally seen in normal circumstances. On this day, the conditions made the roads unsuitable for cars, so the artist was able to stand in the road to paint this atmospheric, suburban scene.

If the ground underfoot is wet, you could use a waterproof groundsheet to keep your materials dry. If you have an estate car, the open tailgate will provide extra shelter, and you could tie your easel to it. You can also paint from the comfort of your car, providing you are in a place that will allow you to park it facing in the right direction.

Painting in Snow

If you are extra hardy, there are many delights to be discovered in a snowy landscape. If the sun is shining there will be some fantastic colours displayed in the shadows and reflections, and you will often find blues, mauves and pinks cast upon a blanket of white snow. On some days it may not feel particularly cold with temperatures some degrees above freezing, but you will still have to wrap up warmly, because as the sun disappears the temperatures will drop sharply. Even if the sun's rays are strong enough to keep you feeling comfortable

Winter Stream, John Owen (watercolour). The artist painted this standing on a piece of neoprene, knee-deep in snow. The interest lay in the character of the water, the rocks and the streambed, the reflection of the snow-covered bank, and the contrasting feathery, spiked branches of the pines. All the surface movement of the water was scratched out carefully with a fine-bladed scalpel, but he had to wait ages until the paint had hardened, because scratching out too soon results in ugly black lines instead of crisp lively ones.

whilst working, you will probably be standing on snow, so your feet will soon freeze unless you are wearing thermal socks and appropriate footwear. If you must stand on snow, a groundsheet or thermal blanket under your feet will stop them from freezing.

Cold fingers can be a major problem, because it's impossible to paint well if your hands are frozen. There are thermal gloves on the market that are thin enough to allow you to operate with a reasonable amount of dexterity. An alternative to these are fingerless gloves, which won't stop your fingers from getting cold, but will enable you to manipulate your pencil or brush with a degree of control almost as well as without wearing any gloves at all.

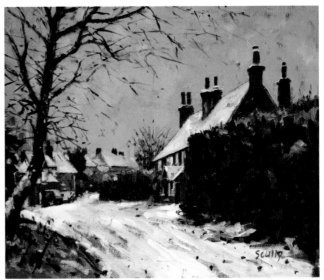

Bell Lane, Aldworth, Kevin Scully (oil on board). This was painted on a cold day when the snow on the ground was beginning to turn brown. It was one of a series of paintings completed during a period when the snow stayed around for about a week, without any sunshine to promote a thaw, and the landscape remained bleached of all colour.

If there's a biting wind, your face will get cold and your eyes will water, unless you cover up well. Wearing a balaclava, or wrapping a scarf round your face will keep it nice and warm, and you can top this off with a woolly hat pulled down over your ears. Providing you have left enough space uncovered so that you can see, you will now be ready for action.

Whilst it's possible to paint in a snow-clad landscape, providing you can keep warm enough for a reasonably prolonged period, painting when snow is actually falling is extremely difficult, and you would have to be quite dedicated to do so. Attempting to use any medium other than oil paint would be foolhardy, and even oil paint in very cold weather will eventually begin to stiffen up and become difficult to move around on your painting. Adding a little medium such as Liquin to it will improve matters for a while, and maybe long enough for you to complete your painting. But snow landing on your painting will make matters worse, and it may freeze if the temperature drops low enough. Trying to paint in a blizzard is impossible and madness. If watering eyes, a running nose and frostbite don't really appeal to you, you can always sit in a car with the heater on.

If it's really cold, water-based paints won't dry properly and may even freeze, and if that's the case your water will be frozen anyway, so painting will be ruled out altogether.

If the weather is mild, you won't have to spend time worrying about keeping warm or keeping cool, which means you will be able to concentrate fully on the job in hand.

Painting in Sunshine

Just try going outside and painting things on the spot! All sorts of things happen then. I had to pick off a good hundred or more flies from [my] canvases ... not to mention dust and sand [nor] the fact that if one carries them through heath and hedgerows for a couple of hours, a branch or two is likely to scratch them ... and that the effects one wants to capture change as the day wears on.

VINCENT VAN GOGH

Painting in sunshine is less of a problem, and most people are likely to be attracted to drawing and painting in a warm or temperate climate rather than in a cold one. In a warmer or hot climate you are more likely to be bothered by the light conditions. Ideally you should position yourself where you will be able to work in a balanced and unchanging light source. The glare of direct sunlight on your work, especially if you are working on white paper, can be blinding, and not conducive to a relaxed experience. If you are just drawing in black and white or in a different colour, there is no reason why you can't simply sit in the shade, but if you are painting, the ideal spot in which to position yourself and your painting is in a fairly light position in neither deep shade nor direct sun.

Your palette, too, should be positioned neither in shade nor in direct sunlight. A colour will appear to be different if it is mixed on your palette in the sun and is then applied to your paper or canvas which is in the shade. This often happens when painting in oil or acrylic, when a palette is balanced horizontally on the pull-out drawer of a French easel and your working surface is vertical, which results in differing amounts of light falling on the two surfaces. To combat this, hold your palette in a more vertical position when matching colours.

Alternatively, you can buy or make a palette that is constructed of two sections hinged together, so that half of it can be positioned on the same vertical plane as your painting – or you could simply prop up your palette vertically against your easel. If you want to paint a scene that is directly in front of you, but it means you or your painting will be in either shade or sun, simply turn the easel until you find a position for it in a balanced light. This may mean that you're going to be working sideways on and not facing your subject, but this is no great hardship.

Remember also that if you are painting in oils, a colour mixed on a wooden palette wearing a patina of age, won't look the same when applied to the toned ground of your painting – so the colour you've mixed on your palette may still look different when applied to your canvas or board. So

it follows that unless you tone your working surface in exactly the same colour as your palette, you are not going to achieve perfection. Art isn't an exact science, so we are not seeking perfection anyway. If you are working in acrylic and using a white 'stay wet' palette or a grey tear-off palette the difference will be greater still.

Of course, when working in pastels you won't have to worry about colour mixing on a palette because you won't have one, and instead your colour mixing will take place directly on your painting. However, where you position yourself is of the same importance whatever medium you're painting in.

If your viewpoint determines that you have to be in the sun when working, you should do so under an umbrella, and preferably one that is white, as a coloured one will cast a tinted shadow over your painting, and make it difficult to match colours.

Sunglasses are useful if you are merely drawing, but next to useless if you are painting, as their tinted lenses will alter the colours that you see and you may end up with an orange- or pink-tinted painting – so it's better just to squint if the light is too bright for you.

Even if you like to stand, you might like to sit down for a rest occasionally, so a stool or a folding chair is worth taking along, especially if you are going by car.

Health and Safety

I work even in the middle of the day, in the full sunshine, and I enjoy it like a cicada.

VINCENT VAN GOGH

Whilst drawing and painting doesn't fall into the same category of pastimes as extreme sports, there are certain precautions you should take to ensure your own safety and well-being. If you are just painting in your local park, the following advice may not be relevant, but if you have chosen somewhere more remote, and particularly if you are going to be on your own, there are a few things that you should consider.

If it's really sunny and hot, you should apply suntan lotion and wear a hat to cover your head, especially if you don't have a lot of hair to protect it. A hat is advisable anyway, as too much direct sun on your head may cause problems if you plan to be standing or sitting out in it for a long period of time.

In hot climates insects can be a nuisance, so if they really bother you, be sure to take along some insect repellent. If they are attracted to your painting so much that they land in the paint, they can be carefully removed with the corner of a

painting or a penknife. To be extra cautious, you could also carry a small first aid kit with you in case of minor accidents. You should include in this any medication that you might need. If you like oil paint but your skin doesn't, you can wear a pair of the thin disposable gloves, the kind favoured by members of the medical profession.

There are several 'all-in-one', folding mini toolkits available that contain a knife, pliers, screwdriver and other useful gadgets that come in handy from time to time. A knife has obvious uses, but pliers are extremely useful for opening tubes of paint whose caps are otherwise impossible to remove. A screwdriver attachment will come into its own when the screws in your easel have become loose and need tightening.

Include a fully charged mobile phone for emergencies, and some drinking water and food to help keep you sustained if there is none available nearby.

It may seem obvious, but there are certain places that are potentially dangerous in which to paint. It would be unwise to set up your easel on a beach beneath a sign that announces 'Danger from Falling Rocks', or at the end of a harbour wall during a storm at sea, or at the edge of a cliff top in an 80mph wind. These are extremes, of course, but even painting in fairly mundane locations can have its hazards. If you are perched on a stool on a wobbly rock, it's all too easy to become so immersed in your drawing that you forget the precarious position you've adopted when you lean over to wash out your brush, and tumble from the stool.

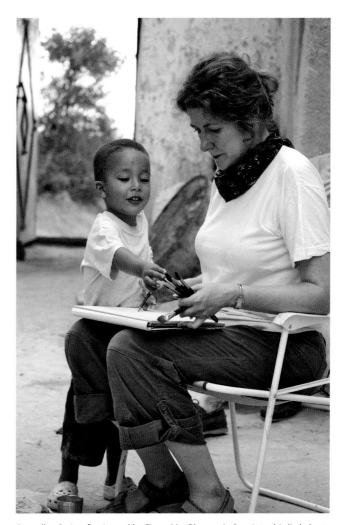

As well as being fascinated by Fiona MacPherson's drawing, this little boy was rather keen on the artist's very expensive sable watercolour brushes.

Unwelcome Advice and Attention

No one would have the courage to walk up to a writer and ask to look at the last few pages of his manuscript, but they feel perfectly comfortable staring over an artist's shoulder while he is trying to paint.

ROBERT GENN

If you are in a fairly public place, you may at some stage be approached by a member of the public who is curious to know what you're up to. This curiosity is perfectly natural, of course, but at times can be both irritating and distracting. Some people love to see artists at work, because to them the whole business is a complete mystery. If you are a very sociable person and don't mind talking about what you're doing, and are willing to carry on a conversation with an admiring stranger, then perhaps you don't mind these interruptions. Some people can't resist the temptation to tell you about a member of their family who likes painting cats, and suggests that this is what you should be painting instead of that rusty old barge. They may also give you some advice about the colour of the sky you've just painted, and how you could improve it. All this guidance is often well meant, but can also be rather annoying.

There are various tactics you can employ to minimize these intrusions, such as pretending you are deaf, or simply telling people to go away, but that is probably not in your nature. There are more subtle ways to keep people at arm's length or even further away. Even if you're not motivated to listen to music on an ipod when painting, by inserting a pair of earphones it seems people are less inclined to bother you, assuming that you are doubly engrossed. If this doesn't appeal to you, or just doesn't stop someone trying to engage you in conversation, you can briefly but politely say that you have very little time in which to finish what you're doing and don't wish to be disturbed.

This isn't something they see every day, so these boys are obviously transfixed by what the artist is doing at this oasis in Morocco.

Common Mistakes

If you are in a different country where drawing or painting in public is not normal behaviour, you may get even more attention than you really wanted, especially from children. On a recent trip abroad I attracted the notice of three children who were intruding a little too much, so I produced a very simple little sketch for each of them to take home. When they ran off home to show their mother, I resumed what I had been previously doing, in peace. That was until they came back again with three other children in tow who also wanted me to draw them something!

In certain countries where poverty is an issue, it is unfortunate to have to say that there is also a risk of children stealing your materials, possibly just for the fun of it, or more likely because they don't have much. Here again you might be tempted to hand out a few coloured pencils or sheets of paper, only to find that five minutes later you are surrounded by children with their hands out wanting the same. Word travels fast in some countries.

But this is all part of life, and by observing and experiencing real life and the way that people live both at home and in other countries, it can enrich our own. By taking time out to sit and draw what you see, you are recording your own feelings and reactions to what's happening around you, and this can change the way in which you view the world.

Some people will go to extraordinary lengths to take a peek at your work even if you are backed up against a wall, and there are those who want to take a photograph of you painting, or just a photograph of the painting itself. If they ask you if this is OK, you may of course not mind them doing so, but if you don't want them to, you can refuse, saying that your painting is to be reproduced as limited edition prints, and if they would like one it is going to cost them a reasonable amount of money. But you might not want to be in too much of a hurry to shun someone's attention, because they might love your picture so much that they offer to buy it once you've finished it!

'Plein-air' Organizations

There has been almost an epidemic of 'plein-air' organizations springing up in recent years, and now they are fairly widespread throughout the world. Their aim is to promote painting outside as the norm, as opposed to painting in the studio. As well as local and national groups, there are international groups that link them all together. The United States has been at the forefront of this movement for some time, with many groups operating nationwide. Here in particular, these events attract a great number of participants, some who enter with a competitive spirit, and some who enter just for the fun of it. They also attract a great number of spectators, who come to watch some brilliant artists in action, and no doubt many of them go away inspired to take to the great outdoors with their paints.

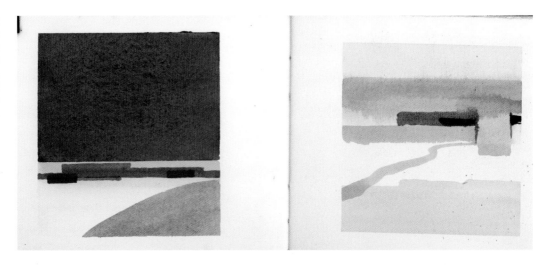

Sketchbook, Kevin Scully. A sketchbook is somewhere where you can experiment with ideas – these can be simple little images, painted for consideration at a later date.

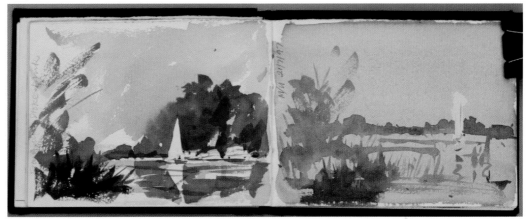

In Summary

Perhaps the most wonderful thing about drawing and painting is the way in which each individual artist sees things differently. If a group of artists is placed in front of exactly the same scene, each individual will interpret it in their own way, and each will compose their picture differently. One may home in on its perceived abstract shapes, disregarding a need for a realistic interpretation, and another may be attracted to some fine detail. There will be those who strive for realism, matching shapes and colours as accurately as they can, and others who have no pre-conceived plan and just launch themselves into the picture with enthusiastic gusto. There may even be some who strive to emulate another artist's work – but no matter how they try, their own individual style will slowly evolve and will eventually prevail.

The work of some artists relates directly to their character, and this can often be observed when a larger-than-life individual is let loose with a set of paints and a paintbrush. He or she is more likely to produce a painting that is bold in form, colour and execution than someone who is more reserved and thoughtful. There are many individuals who automatically draw or paint in a particular way that is directly related to their character, but are keen to produce work that is not. Many will be heard expressing the wish to paint in a far looser way, and to a lesser extent there are those who would love to be able to adopt a more careful and considered approach.

There is nothing wrong with admiring other artists' work, and much can be learned from the way in which they go about their business, but developing your own individual style is far more important. Drawing and painting is rather like handwriting, and the way that we write as a teenager is rarely the same as the way we write as an adult. And so it is with drawing and painting. If you examine the early paintings of well known artists, and compare them with those they produced in later life, there is usually a slow progression from one style into another, which has often taken many years to evolve. If you are comfortable producing detailed watercolour paintings in miniature of flowers, it is almost impossible to completely change overnight into someone who paints enormous abstract murals in acrylics.

Antony Bridge painting at sunset. The pochade box used here is one that contains all the necessary equipment needed to capture this fleeting scene on a small panel in oils.

Many of the most highly regarded artists of all time showed a progression in the way they painted that was a slow transition from one style into another, but still produced work that was different to anybody else's. It was based on that individual's own 'handwriting', and although some may have been influenced by others along the way, their own individuality triumphed. You only need look at the work of Egon Schiele, Gustav Klimt, El Greco, Monet, L. S. Lowry, Modigliani and Van Gogh. It is also worth reflecting on the fact that many of these artists weren't happy with the work they produced, works that are generally regarded as masterpieces today. So having a style that is completely different from someone else's is something to be nurtured and developed, and not fretted over.

Not every painting is going to be successful. Although many famous artists would be reticent about admitting it, they will have abandoned, painted over, or simply thrown away some of their work because they considered the end result was a disappointment or even a complete disaster. This is particularly true of watercolour artists.

If you find that your enthusiasm is waning, try changing things round a little. There are, of course, artists who are happy painting the same subject matter in the same medium, day in and day out, but if you feel the need for greater inspiration, switch mediums for a while. If you prefer pastels, but things aren't going so well, get out the oil paints or acrylics; or if your watercolours are looking a little sad, experiment with some pens and markers for a change. The results with these different mediums may not be an unrivalled success, but you will probably find that when you switch back to your favoured medium, you will approach it with invigorated zeal.

If your landscapes are looking a little jaded, find a river or some other stretch of water that contains boats and some human activity. If you like to paint moody and evocative interiors, change your colour range, and instead adopt a bold and expressive approach. You might even find that a new line of attack suits your individual style far better than the one you have been following.

You could change the scale of your paintings, so if you like to work small, try increasing the size, and vice versa if you normally paint on a larger scale. You could try a change in format, and experiment with an elongated landscape ratio, or even a square. You might even consider changing the way you make marks with a pencil or pen, and the way you apply paint – for example, if you are naturally tentative, be vigorous in your approach. Every mistake made is something learned.

If things are really not going well at all, give yourself a rest. There is nothing more soul destroying than plodding on with grim determination, regardless of the mess you are making.

As long as you keep challenging yourself, you will eventually strike a balance between your natural individuality and a degree of innovative progression. Think of every drawing and painting as an experiment, another stage in your progression along the path towards that next work. If you fail to experiment and take risks, progress will be slow – so throw caution to the wind and get out there and paint!

I would like to dedicate this book to all those plein-air artists, famous and not so famous, both present and past, whose work I have admired during the long process of writing this book, who have taken up their sketchbooks and paints and braved sunshine and showers, wind and rain to pursue their goal of capturing their own personal record and experience of the world. In particular I would like to thank Adebanji Alade, Roy Connelly, Antony Bridge, Roger Dellar, Jenny Halstead, Felicity House, Colin Moore, John Owen, Kasey Sealy and Deborah Tilby.

I would also like to thank the following establishments for allowing me to use their images for reproduction: Art Gallery of Ballarat (*An Early Taste for Literature*); National Gallery of Australia (*Impressionists' Camp*); The National Gallery of Art, Washington (*Salisbury Cathedral from Lower Marsh Close*; *The Japanese Footbridge*; *Flood at Port-Marly*; *Rouen Cathedral, West Façade*; *The Bridge at Argenteuil*; *Ships Riding on the Seine at Rouen*; *The Towpath*; *The Ramparts at Aigues-Mortes*; *Houses in Provence: The Riaux Valley near L'Estaque*).

Contributors

Adebanji Alade www.adebanjialade.co.uk
Roy Connelly www.royconnelly.com
Antony Bridge www.antonybridge.co.uk
Roger Dellar www.rogerdellar.com
Jenny Halstead www.jennyhalstead.co.uk
Felicity House www.felicityhouse.eu
Colin Moore www.colinmoore.uk.com
John Owen www.owen.at
Kasey Sealy www.kaseysealy.com.au
Deborah Tilby www.deborahtilby.com

Groups and Organizations

Australian Plein-Air Artists Group:
 www.australianpleinair.com
Plein Air America: www.pleinairpaintersofamerica.com
Plein Air Brotherhood: www.pleinairbrotherhood
Plein Eire: www.pleineire.ning.com
Sketchcrawl: www.sketchcrawl.com
Urban Sketchers: www.urbansketchers.org

List of Art Suppliers

Alla Prima: alla-prima-pochade.myshopify
Artwork Essentials: www.artworkessentials.com
Atlantis Art Materials & Art Supplies:
 www.atlantisart.co.uk
Best Brella: bestbrella.com
Cheap Joe's: www.cheapjoes.com
Craig Young: www.watercolorpaintboxcompany.com
C. Roberson & Co: www.robco.co.uk
Dakota Art Pastels: dakotapastels.com
Daler Rowney: www.daler-rowney.com
Eckersley's Art & Craft: www.eckersleys.com.au
Guerilla Painter: www.guerillapainter.com
Heilman Designs: www.heilmandesigns.com
Jackson's Art Supplies: www.jacksonart.com
Jullian: www.jullian.co.uk
Ken Bromley: www.artsupplies.co.uk
L. Cornelissen & Son: www.cornelissen.com
Open Box M, Inc.: www.openboxm.com
Pochade: www.pochade.co.uk
SAA: www.saa.co.uk
The Art Shop: www.theartshop.com.au
U. S. Art Supply: www.usartsupply.com
Velbon: www.velbon.co.uk
Winsor & Newton: www.winsornewton.com